THE
MAKING OF AMERICA
SERIES

COLUMBUS
THE STORY OF A CITY

D1072942

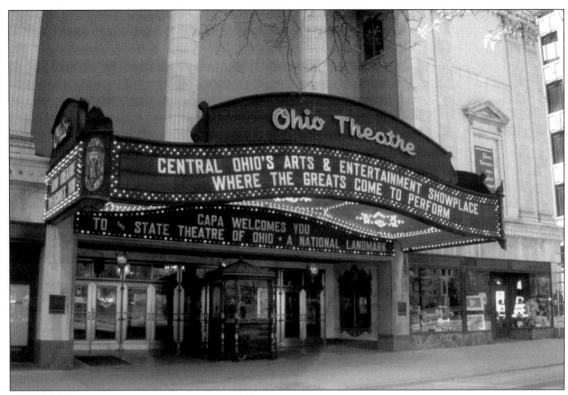

The Ohio Theatre was designed by Thomas Lamb and built on the site of the original Columbus City Hall in 1928. Built to be a movie palace, the building was threatened with destruction in the 1960s but was saved and renovated to become the home of the Columbus Association for the Performing Arts (CAPA). (Author's Collection.)

Front Cover: *On November 11, 1918, the guns went silent across Europe bringing to an end the carnage that came to be called the Great War. We called it World War I and it was a struggle that changed America and Columbus, Ohio forever. On that day, crowds of happy people poured into the streets and began a very lengthy and very noisy celebration. It was not the first memorable day in the city's history and it would not be the last, but it was one of the best. (Columbus Metropolitan Library.)*

THE
MAKING OF AMERICA
SERIES

COLUMBUS
THE STORY OF A CITY

ED LENTZ

ARCADIA

Published by Arcadia Publishing,
an imprint of Tempus Publishing, Inc.
2 Cumberland Street
Charleston, SC 29401

Printed in Great Britain.

Library of Congress Catalog Card Number: 2003102275

For all general information contact Arcadia Publishing at:
Telephone 843-853-2070
Fax 843-853-0044
E-Mail sales@arcadiapublishing.com

For customer service and orders:
Toll-Free 1-888-313-2665

Visit us on the Internet at http://www.arcadiapublishing.com

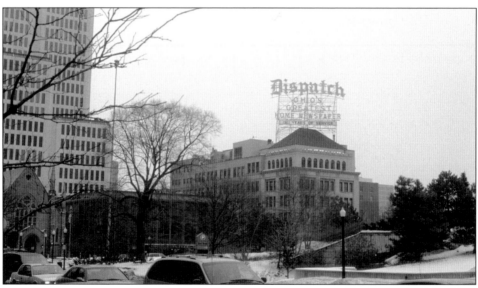

The Columbus Dispatch *was founded in 1871 and had a lot of competition. In those days it did not take much to start a paper, and many people tried it. In 1905, Robert F. and Harry P. Wolfe of Columbus, having made some money in the shoe business, decided to get into newspapers. They bought the* Dispatch *and made it—as the sign says—"Ohio's Greatest Home Newspaper." (Author's Collection.)*

CONTENTS

ACKNOWLEDGMENTS

Some of the people who have had a hand in the making of this book are quite aware of their participation since I have been intruding on their time and patience for some time for all sorts of information of greater or lesser significance. Other people may be less aware of their role but it has been just as vital nonetheless.

First, a very emphatic thank you must be extended to the tireless staff of the History, Biography and Travel Division of the Columbus Metropolitan Library's Main Branch. In particular, special thanks must go to Sam Rashon for good advice as well as helpful information. Most of the pictures in this book came from this place, and a large portion of the research was done there as well. A number of pictures were provided by all sorts of other very helpful people and organizations, and their unstinting and patient help is gratefully appreciated. There are some other very good libraries in central Ohio as well and over the years I have haunted most of them. Of these special mention should be made of the Grandview Public Library, the Grove City Public Library, the Ohio Historical Society Archives Library Division, the Ohio State University Libraries and University Archives, the State Library of Ohio, the Martha Kinney Cooper Ohioana Library, the Urbana University Library, the Upper Arlington Public Library, the Westerville Public Library, and the Worthington Public Library.

Second, there are some special people to be thanked as well. I need to acknowledge the untiring efforts of a group of local people who collect and occasionally write about local history. Some, like Myron Siefert and Dan Prugh, are no longer with us. Others, like Sandy Andromeda, Dick Barrett, Bruce Burch, Thomas Burke, Michael Frush, Laura Mueller, Phil Sheridan, and Vernon Pack, are still bringing together the materials that make stories like mine more interesting and building the collections that will provide the basis of tomorrow's retelling of the tale. Any value, any beauty, any truth this book has is due to the wonderful insights offered by all of the people who have helped me along the way. Any errors are mine and mine alone.

To my exquisitely patient and endlessly understanding wife, Andrea, and children, Temple and Wheeler—you have lived with this book as long as I, and it is your book as much as it is mine. Finally, to the people of Columbus and central Ohio: my thanks for giving me a very good story to tell.

INTRODUCTION

Why on Earth would anybody want to spend more than 30 years teaching and writing and learning about the history of Columbus, Ohio? The short answer is that it is an endlessly interesting place. Columbus and central Ohio are something of a mirror of America. We often spend a lot of time reading and hearing about the biggest cities in America—New York, Chicago, and Los Angeles in particular get much of the attention. This is not to say they are not interesting. But they are not America, and they are not likely to be any time soon.

For most of our history, most of our people lived on or near the land. It is only in the last century that many of us have begun to drift toward cities. But the cities we move to are not the huge cities. They are cities like Savannah and San Antonio and Denver and Dubuque. They are the medium-sized cities of America. They are cities like Columbus. Cities like these are not only where most of us live. They are remarkable places in their own right. This place—settled in its current form for only a few hundred years—has played a large part in producing one of the most powerful, affluent, and complex societies in human history.

Much of American history has passed through Columbus, Ohio. We began on the edge of the moving frontier, a small, isolated village in the heart of what was then the American West. Within a generation we had become the breadbasket of the country and a center of transportation and trade serving the entire nation. When the War between the States broke out, Ohio provided more troops per capita than any other state, and Columbus was one of the major centers for the mobilization and training of those men. In the years following the war, Columbus became an industrial powerhouse as well as the political center of a state that would eventually send seven native sons to the White House. And although none of the seven were born in Columbus, all of them spent more than a little time here.

Eventually, in the twentieth century, Columbus and Ohio would be shunted aside from center stage as the industrial heartland of America became the Rustbelt. Many people wondered if this part of the world would ever regain its lost glory. Of course, we are in the process of doing just that. The things that made us successful and produced our greatness in the first place—our resources, our location, and our people, especially our people—are with us still. And they are just as enterprising and innovative as they have always been.

This story has a large cast of characters, some of whom are well worth remembering because of the things they did and the way they did them. But the real heroes and heroines of the story of Columbus are the thousands of men and women—young and old, black and white and brown and red and yellow—whose combined effort have made this town what it is today. When we remember politicians, we are also remembering the people whose views they represent and who gave them the power they hold. When we remember soldiers and sailors and members of our other services, we also remember the people who made the weapons they use and who often suffered with them in the cauldron of war. When we remember a singer, a dancer, or a writer who delights us, we are also remembering the hearts and souls of the people whose spirits are lifted. In other words, the story of the past is a mirror not simply of some of us but of all of us.

Writing a story like this is a humbling experience. One becomes rapidly aware just how little can be said in the limits of a single volume for a general audience. Alfred Lee in 1892 took more than 1,500 pages to tell the story of the city in its first century. Even he left a great deal out. So by necessity, much of the story of Columbus has been left unsaid in this volume; however, I have tried in my own way to tell a bit of what I think it is important to remember about this place and its people.

More than 30 years ago, I accompanied two remarkable men to lunch one day in the restaurant upstairs at the old Union Department Store where City Center is today. One of them was Ben Hayes, longtime columnist of *Columbus Citizen Journal*, and the other was Doral Chenoweth, the Grumpy Gourmet-to-be of the *Columbus Dispatch*. Ben Hayes showed me how much there was yet to learn about the history of this city, so I learned it. Later, Doral Chenoweth convinced me to write about it for the popular press, so I did that, too.

In a very real sense, the road to this book began that day in a search for a past I could call my own. It has been a long journey and a good one. Now join me, if you will, and hear a few of the stories I have learned along the way.

1. A Place and Its People

People have been living in central Ohio for a very long time. As to how long a very long time really is, we simply do not know. We do know that about 11,000 to 12,000 years ago people began drifting into the Ohio country, that land between Lake Erie and the Ohio River that now constitutes most of Ohio state and a healthy portion of Indiana and Pennsylvania as well.

A World of Ice and After

We know that people were here because we have found traces of their passing that seem to date to about that time. These were nomadic peoples who lived off the land and followed herds of animals from whom they obtained sustenance. Because they did not stay in one place for very long and because there were not that many of them, we do not know too much about these people. But we do know they were here because from time to time we find one of their arrowheads or some other tantalizing evidence of their passing.

Could these archaic people have been here even earlier? Yes, it is quite possible that they might well have been here. Theories about the first Americans—who they were, how they got here and how long they have been around—are constantly evolving. For a long time, historians and anthropologists believed that native Americans were Asian immigrants who crossed a then-existing ice bridge between Russia and Alaska about 50,000 years ago. In recent years we have come to see that it is possible that people may have been here even earlier after crossing one ocean or the other in homemade boats. In any case, people have been in North America for some time.

They were not in central Ohio, however, for much of that time for a very simple reason. The whole area was smothered under a massive sheet of ice that had progressed south across the face of North America in the most recent or Wisconsin Ice Age. The ice sheet covered most of the state, stopping only when it reached what is now southeastern Ohio, leaving the Appalachian hills of that area a striking reminder of what much of the rest of the state looked like prior to the ice age.

It is difficult to understate the influence of the glacier. It literally changed the face of the land and made Ohio what it is today. To this day it is quite easy to see

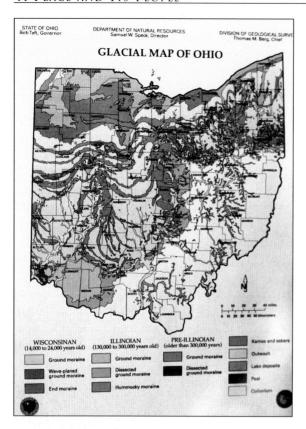

Glaciers have drifted across Ohio many times in the past. Each time they greatly change the landscape. The most recent one—some 11,000 years ago—was no exception. (Ohio Department of Natural Resources.)

where the glacier stopped in the hills of the southeast or in the characteristic large outcroppings of gravel and rock called moraines in southern and southwest Ohio. The ice age rearranged the landscape of this part of the world, and it did it in a way that would prove to be quite helpful to the people who followed in its wake. Huge amounts of topsoil were pushed in front of the ice and deposited here, making Ohio one of the best places on earth to grow crops. The ice also scraped away the soil in other parts of the state bringing deposits of stone, coal, and oil much closer to the surface. This too would prove to be a key to success for a variety of businesses that would come along later.

The ice also removed most remaining evidence, if any, of previous occupants of central Ohio. As we have seen, the earliest occupants after the ice were largely nomadic and left little behind. It is fair to assume that any predecessors who might have been here were probably few in number and left little impact on the land.

PEOPLING OHIO

Today it is very difficult to easily understand this land that native Americans found in the wake of the retreating ice sheet. It was a land that had been rubbed raw and rearranged by the ice and the cold that accompanied it. Some scholars of the

period think it may have resembled the high desert country of the far western United States: a dry, sparse land with ever increasing forests of evergreen and some hardwood trees. The widest variety of wildlife occupied this country. Some of the types, like bear, deer, and wolf, can still be found. Some, like the mastodon and saber-toothed tiger, are totally extinct. Others, like the mountain lion, buffalo, and elk, can still be found elsewhere but not in the wild in Ohio. And some species, like the passenger pigeon, were here when people arrived but were eventually totally exterminated by persons indifferent to their fate.

With the warming of the land, the varieties of animal and plant life multiplied and forests of deciduous trees of both hard and soft wood—maple, oak, hickory, walnut, poplar, and cottonwood—began to thrive. One of these trees, a variety of horse chestnut, would be so favored in a later period for furniture and other domestic uses that it came to be identified with the people who used it frequently. Although the tree has been almost eliminated from the state because of its popularity, the people of Ohio today still call themselves by its name: Buckeye.

Within a few hundred years, a vast forest began to cover much of what is now Ohio. It was a dense, dark, and deep forest in many places, with trees that reached 100 feet or more into the sky and often grew to be 30, 40, or even 50 feet in diameter. Some sycamore trees, which often rot from the inside out, were said to

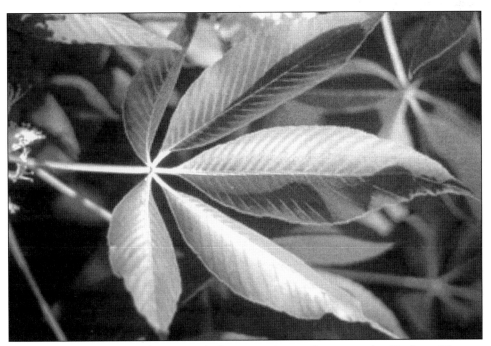

Ohioans are called "Buckeyes" and the name is a reference to the Buckeye Tree—a variation of the Horse Chestnut. Stories vary as to how the name of a tree came to be given the residents of a state. But by 1820, it was in common use across the state. (Ohio Department of Natural Resources.)

be big enough inside their base to provide a home for a family of six, eight, or even ten people. This massive old-growth forest was interlaced with thickets of vines and underbrush that often made passage through the woods impossible except by following stream beds or animal trails.

But central Ohio was not entirely one thick, unrelenting forest. The land immediately adjacent to both major rivers and minor streams flooded often and created flood plains of quite rich soil. Forest fires, tornadoes, or other natural disasters would from time to time level whole areas to the bare ground and prairies of shoulder high grasses would follow in their wake. And uneven or imperfect drainage would often render whole regions wetlands, like the Great Black Swamp of northeastern Ohio or the cranberry bogs at central Ohio's Buckeye Lake.

By the time we reach the period about 1,500 years before the current era, the land had reseeded and repopulated itself with the widest variety of plant and animal life and with increasing numbers of the wandering hunters whose lifestyle had remained the same for generations. But this was about to change.

The Mound Builders

Sometime around 1,000 years before the current era, important changes began to take place in how people lived in the valleys of the Ohio River and its tributaries. We cannot be much more precise than that for several reasons. One is that the people whom we are describing did not have any written language that we know of, so much of what we do know is based on simple things they left behind. Another reason for our lack of precision is that experts who have spent lifetimes studying these vanished people disagree among themselves—sometimes quite strongly—as to when one period started and another ended. And finally, as far as we can tell, many of the changes we are talking about happened over a long period of time.

This much is certain. Beginning about 2,500 to 3,000 years ago, man-made earthen mounds began to arise in the Ohio heartland. Built in forests as well as on prairies, on hills as well as in valleys, the mounds seem initially to have been used for burial and ceremonial purposes. Many of the oldest mounds were quite small: 5–10 feet high and 20–30 feet in diameter. With the passage of time the mounds got bigger. Sometimes they got bigger by adding more layers to existing mounds. In other cases whole new larger mounds were built.

In Montgomery County, a huge earthen mound stood more than 100 feet high. Near what is now Grave Creek, West Virginia, was another, and stretching up the valleys of the rivers that emptied into the Ohio were many more—some of them 30, 40, or 50 feet tall. It seemed at once to be some sort of vast signaling system. Complementing the large mounds were enclosures of various sizes on major hills and ridges throughout the area. They resembled forts. There were also elaborate enclosures made in precise geometric shapes of circles and squares. These too were built on a gigantic scale hundreds of yards across and linked to one another by well defined paths.

The Newark earthworks is a huge ceremonial center located near Newark, Ohio. Recent research suggests there may have been a prehistoric road connecting this site to another Hopewell center at Chillicothe, Ohio. Much of the site has been lost, but the surviving portion is administered by the Ohio Historical Society. (Author's Collection.)

Then there were the figures. In Licking County, near the massive Newark earthworks, was a mound built in the shape of an animal. It came to be called Alligator Mound, but it was probably a panther. In Adams County along the Ohio River was a low mound that stretched along for hundreds of feet, forming an effigy of a gigantic snake. The great serpent mound was and remains one of the great mysteries of the Midwest. "Who were the people who built these elaborate mounds?" wondered the Europeans who came along later. The question captured their imagination and has not let go to this day.

The explorers looked around and saw only historic Native-American tribes living in relatively primitive homes and not sure themselves who had built the mounds, or so they said. Over the next few generations, several theories were put forth as to who had built the mounds. The great cultures of Mexico and Peru had built the mounds. Viking explorers had built them. For a time it was even quite seriously believed that the ten lost tribes of Israel had made it to America and for reasons not altogether clear had constructed the mounds in lieu of a new temple.

It was easy to see why early settlers wanted someone else to have built the mounds. For if the people being displaced had built them, it made it all the more difficult to justify their expulsion. And if the civilization that had built the mounds was as sophisticated as it sometimes seems, how can its successors justify

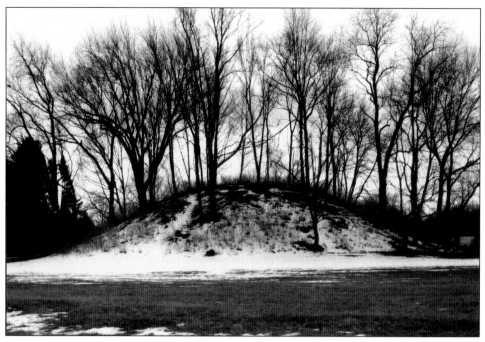

North and west of the intersection of Routes 161 and 315 on a high bluff overlooking the Olentangy River is the Jeffers Mound, one of the largest surviving prehistoric earthworks in the state. Elements of an earthen perimeter wall that once surrounded the site also remain in the area. (Author's Collection.)

the systematic destruction of the remnants of this society? Because destroy it they had. In the years after European conquest of the Ohio country, literally thousands of mounds were found in the Ohio valley. In and around Columbus and Franklin County there were hundreds of them. By the mid-nineteenth century, most of them were gone, plowed under, torn away, and removed from sight. Today less than 1 percent of the mounds remain.

What we do know of the prehistoric peoples of Ohio has come from the nothing less than amazing work that has been done by American archaeologists in little more than a century and a half since scientific anthropology and archaeology emerged as academic disciplines. Today archaeologists often find themselves in the center of controversies. Native-American groups consider the excavation of prehistoric grave sites to be both a sacrilege and a travesty and would like it stopped. They ask, "How would you like it if I dug up your relatives, studied their bones for years and would not give them back?"

In their defense, archaeologists point out that the only way we will ever learn about the silent societies of the prehistoric past is to let the mute remains speak to people scientifically trained to listen to what they have to say. This is what archaeologists do and have done for decades. Because they have, we have learned a lot about the moundbuilders, both who they are and what became of them.

First, let us settle who these people were not. They were not Vikings, or Egyptians, or Chinese sailors, or lost Israelis. They were not refugees from Atlantis or from an errant flying saucer. There have been and still are books that argue in favor of all these groups, and sometimes some of them working together, to build the mounds of Ohio. The builders of the mounds were Native Americans. This we do know from the examination of skeletal remains from many mounds over many years. While it is arguably regrettable that we had to dig up graves to learn this truth, learn it we have.

We have learned a lot more as well. Eventually, people began to settle down in the Ohio country. The nomadic lifestyles that characterized so much of the way people had lived for centuries since the retreat of the ice were changing. People were beginning to stay in one place for longer and longer periods of time. Part of this was due to the mastering of crop growth, especially along river valleys. The early Mound Builders were not totally sedentary farmers. They still followed the herds and their villages often were seasonal. But these early Mound Builders whom we call the Adena people began to drift to one important emphasis on the permanence of place. They began to build mounds for the dead.

It is reasonably clear that these people were not the first to do this in the Ohio valley; another culture to the west called the Red Ocher people had been doing it a bit earlier. But the Adena took the practice and made it their own. Named for a site excavated at the Adena homestead of Governor Thomas Worthington near Chillicothe, the Adena people controlled most of the southern two thirds of Ohio for several hundred years. In that time, their villages became more permanent, their numbers increased, and some of their mounds became quite large indeed. Eventually the Adena were displaced by a new culture called the Hopewell. Again this is not what these people called themselves. We do not know what they called themselves. Rather we have named them for the Hopewell family farm near Chillicothe where archaeologists found them more than a century ago.

If the Adena were a simple people linked to the land by their mounds, the Hopewell were a much more sophisticated group. Building on the heritage of the Adena, the Hopewell built a society between 100 A.D. and 500 A.D. based around the ceremonial and religious as well as sepulchral use of earthworks. The elaborate geometric earthworks at Newark and Chillicothe were built to be centers of a Hopewell society that looked at death in a much more systematic, religious, and even ritualistic way than the Adena seem to have done. Elaborate ceremonies involving ornamentation and decoration of both the living and the dead highlighted the lives of these relatively permanent villages and the Hopewells' increasingly complex lives.

Between 500 and 1000 A.D., the Hopewell were displaced, supplanted, or absorbed by a new group called the Cole Culture, which itself was displaced by a newer group called the Fort Ancient Culture. These later groups rather obviously were having a more and more difficult time coping with the perils of life in prehistoric America.

As the name suggests, the Fort Ancient people seem to have found themselves fighting with more people, more often, and with less success than their forebears. Many of the great hill forts still to be found in southern Ohio date from this period. Some of the places later settlers called "forts," such as Fort Ancient, were actually huge village sites. Other places looked like forts and were. Remains of the later Mound Builders also show increased signs of disease and nutritional problems. In short, these were societies with a lot of problems.

By the early 1600s when the Europeans arrived, the Mound Builders were gone. The question as to what happened to these people still tantalizes us today. Were the Mound Builders wiped out in apocalyptic wars? Did they weaken after a period of epidemic disease and fall prey to stronger rivals? Did they move away and leave the valley to others? Or were they absorbed by the people who followed them? While we still do not know for certain the answers to these questions, the odds are that the final conclusion will probably agree to all of the above.

THE MOUND OF MOUND STREET

Much of the legacy of the Mound Builders has been totally eradicated from the central Ohio landscape. The story of Mound Street and its mound is instructive in this regard. When settlers first came into the newly established capital city of Columbus, they encountered a 40-foot-high burial mound directly at the intersection of High Street and a major cross street in the middle of downtown. Not surprisingly, the cross street came to be called Mound Street. Rather than try to remove the mound, early residents of the town simply curved High Street around it. A local physician named Dr. Young built a double sized frame house on the 100-foot flat summit of the mound and lived quite happily in a grove of mature locust trees located there. Along the sides of the mound in several places were oak trees with trunks 3 and 4 feet in diameter.

Eventually, the demands of a growing city began to clash with the presence of the good doctor's idyllic retreat. As early as 1812, clay had been removed from the edges of the mound to make bricks for local buildings. And by the 1830s the need to widen High Street became too obvious to ignore. When the mound was rather unscientifically removed, a number of skeletal remains were found. One man found a skull so large it fit easily over his own head. Other people found a variety of artifacts, according to newspaper accounts of the time. None of these artifacts or remains have survived into our time. If they have, they remain quietly in private hands.

However, a bit of the Mound Street mound is still with us. Clay from the mound was used to make bricks for the original Ohio Statehouse, which stood at the northeast corner of State and High Streets. When that building burned in 1852, most of the bricks in the destroyed building were salvaged and used again in the construction of the new statehouse in the center of Statehouse Square. They are still there.

Despite the march of urbanization and the indifference of many to the loss, several prehistoric sites in central Ohio have managed to survive into the new millennium. The Shrum or Campbell Mound on McKinley Avenue is an Adena mound administered by the Ohio Historical Society. The large Jeffers Mound west of Worthington sits in the middle of a residential subdivision, and several mound sites continue to be preserved in public parks as well as in private hands. A large section of the Ohio Historical Center at Seventeenth Avenue and Interstate 71 and several of its sites are devoted to Ohio archaeology and are well worth a visit. But most of the heritage of Ohio's prehistoric peoples was lost over the first 200 years of statehood. This much, however, is clear. By 1650, when French and English explorers began to find Ohio and make it their own, the Mound Builders and their heirs were gone. We seek them still in the mounds they left behind.

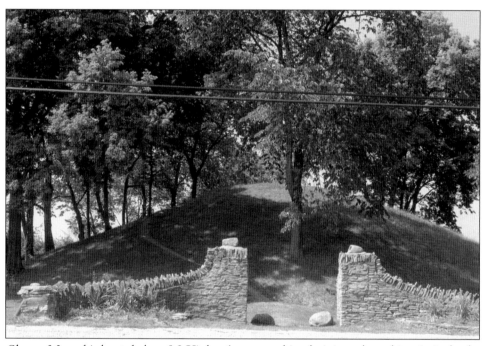

Shrum Mound is located along McKinley Avenue and is administered as a historic site by the Ohio Historical Society. It is one of the best preserved remaining prehistoric sites in central Ohio. (Author's Collection.)

2. War on the Frontier

The names are a very real part of central Ohio. The names that Native Americans called themselves and their land are still with us. We can see them in counties and towns and villages and streets with names like Delaware, Miami, and Huron. These are names that we have come to call, with our imperfect English, the people who followed the Mound Builders.

We call them the historic Indian tribes because they came into Ohio at a time when their contact with French and English traders, trappers, and frontiersmen left a historical written record of who they were, how they dressed and acted and lived, and how they fought and died to protect the land between the lakes and the great river to the south. But these are not the names they called themselves. The people we call the Miami called themselves the Twightee. The Delawares called themselves Leni Lenape or "real people," and the Hurons of Ohio named themselves after the turtle of their creation story and the clan to which many belonged: the Wendat. We changed that name to Wyandotte or Wyandot to make it easier to pronounce.

We can still find the real names that Native Americans lived by, if not in their own names, then in the names they gave to the land and especially to the rivers. Ohio itself is an Iroquois word meaning roughly "great river." Scioto is a Wyandot word whose root is related to the word for deer. Often pronounced Scionto or Scionta, the word has been asserted to mean "hairy river" as well. In molting season, thousands of deer came to the river to drink and literally left behind a fur coat in the water. From this came the description that gave the river its name.

Olentangy is probably also a Wyandot word meaning "river at rest." In other parts of the state, this word is translated as "stillwater." Interestingly, this was not the name Native Americans gave this particular stream. Their Olentangy was farther to the east of the river that joins with the Scioto at Columbus. When settlers moved into the area they found that fine sharpening stones could be made from the rock outcroppings near the stream and came to call it Whetstone Creek. In fact, north of Columbus and Delaware, it is still called by that name. In the 1830s, the Ohio legislature, perhaps with some wistful remorse at having removed most of the Native American people from Ohio, decided to change the

names of several rivers back to "Indian names." It was at that time that the southern reaches of Whetstone Creek became the Olentangy.

We have seen by the names they left behind that Wyandots and Delaware were living in central Ohio in the last several hundred years. They were not the only people to do so in the wake of the Mound Builders.

THE TRIBES OF CENTRAL OHIO

The years between 1500 and 1650 are shadowy ones in Ohio's story. It is clear from archaeological evidence that the great Mound Builder cultures were in transition in this period. The reasons for this transition are not as clear. Overpopulation, epidemic disease, continuing warfare, or most likely a combination of all of these led the Mound Builder societies to move away, merge with interlopers, or simply fade away.

Who replaced them, especially in central Ohio, is not fully clear. We do know that by 1650 the balance of power had changed when French woodsmen or *couriers du bois* and missionary priests began to visit the lands south of Lake Erie.

The mighty Iroquois Confederacy, having ended generations of bloody conflict among its five nations, had swept out of its home in central New York state and made the Ohio country its own. Many people living in Ohio chose to flee before the onslaught. Others like the Erie, or Cat Nation, who chose to stand and fight, were virtually annihilated along the shores of the lake that bears their name.

For the next couple of generations, until well into the early 1700s, the Iroquois held Ohio as their own by tolerating the nations that remained subservient and ruthlessly dealing with the people who challenged this most efficient and effective of native confederacies. But eventually the Iroquois (or Houdenosaunee, as they called themselves) found themselves under increasing, inexorable pressure from French expansion to the north and English intrusion to the east and south. Caught in the cauldron of hostility between two great European nations grasping for empire, the Iroquois left the Ohio country to its own devices and spent more time, energy, and effort to protect their homeland.

Since Ohio, like nature, abhors a vacuum, it would not be long before other near neighbors began to move back into the state. From the west came Miamis or Twightees who gave the great rivers of western Ohio their name. The Wyandot Hurons drifted into the state from their northern homelands around the Great Lakes. Ottawas, Chippewas, and occasional Potawatomis moved south as well. Most of these people lived in northwest or north central Ohio, but their settlements often reached as far south as Columbus.

In the south along the Scioto River lived the Shawnee. A fearsome and numerous warrior culture, the Shawnee outnumbered many of their other Native-American counterparts after their arrival from the Carolinas to what is now Kentucky, Tennessee, West Virginia, and Ohio. Living in the south and east were the Delawares. These were the people who met William Penn when he arrived in America in the 1680s. Originally settled around the river that bears their

name, the Delawares had been pushed across Pennsylvania by encroaching settlement. By the early 1700s, they too were in Ohio. Lastly, there were the Mingo. The Mingo were composed of a little bit of everyone. They were mostly Senecas who did not join their Iroquois brothers in the return to New York. Mingo camps welcomed many other people as well and often consisted of a hodgepodge of various tribal affiliations and loyalties. They are a decided presence in central Ohio.

THE ENDLESS STRUGGLE

Central Ohio might have been a much different place had the various tribes who succeeded the Iroquois not moved around quite as much as they did or bumped into each other quite as often as they did. But they did. It would have been well if they had decided to mutually defend the land against all interlopers as ruthlessly as the Iroquois once had. But they didn't.

The intruders came. At first there were only a few French explorers and trappers and the occasional priest who accompanied them. Then occasionally British frontiersmen penetrated beyond the great mountains to the east as well and followed the Ohio River south and west. After a time, these new people ventured deeper and deeper into Ohio along the course of its interior rivers or along the paths that both animals and men had made.

If a traveler approached the place that came to be called the Forks of the Scioto from the more southern Shawnee village called Salt Lick Town near where Georgesville Road crosses the river today, he almost inevitably came by the path that followed the High Banks on the river's west side. Variously called the High Trail, the Great Trail, or the Scioto Trail, it was little more than a 4-foot-wide dirt track through the forests and fields, but this trace that led to the Forks was one of the great highways of the Midwest. The direct extension of the Warrior's Path that led into the heart of Kentucky, the trail left central Ohio and wended its way north until it finally ended at Sandusky Bay near today's Cedar Point.

If one followed a runner along this road north, it would become rapidly clear that whatever central Ohio had been to the Mound Builders—and it was a special place indeed—it was a meeting ground for the historic Indian nations as well. The Shawnees controlled most of the land to the south in the great Pickaway Plains. Their closest village was only 2 miles south of the Forks. At the Forks there were occasionally Mingo and Delaware villages. Just to the north of the Forks, the Wyandots held sway along the upper reaches of the Scioto. Farther to the north along the Olentangy, other Mingo and Delaware villages existed.

By 1750, the French and English had been struggling for position, advantage, and eventually control of North America for almost a century and a half. Most of this struggle had taken place further to the east and south as the English consolidated their hold on their Atlantic colonies and the French established themselves along the Great Lakes and Mississippi Valley. But now these competitors, having eliminated direct challengers to empire like the Dutch and

It has many different names—Mackachack, Mackochee, and Macocheek, among others. Here on a plain by a creek near what is now West Liberty, the people of the Shawnee nation lived and died. Even today, as empty as it is, it is still a place of quiet greatness. (Author's Collection.)

marginalized indirect adversaries like the Spanish, were coming into closer and closer contact with each other.

Spurred by the needs of growing populations and lured by tales of the almost limitless wealth of the Midwest, the challengers were slowly becoming antagonists. Native Americans in central Ohio now found themselves between the lines of the coming struggle.

THE FRENCH AND INDIAN WAR

In 1749, responding to what was regarded as English trespass on his territory, the French governor of Canada sent an officer named Celeron de Bienville south into the Ohio valley to warn away English intruders. Celeron and his men left tin plates nailed to trees and lead plates buried in the ground claiming all of the Ohio country for France. The English ignored them, tore down the plates, and continued to advance. Because the English kept coming, and one of them came to central Ohio, we have our first written description of the place that would later become Franklin County.

Christopher Gist was retained by the Virginia Land Company to explore its claimed land holdings in the Ohio valley. Gist was young, able, resourceful, and observant, like many of the people who lived along the frontier. But unlike most

21

of his friends and neighbors, Gist could also read and write. Because he could, he left a record of what he saw when he passed through central Ohio. Washington Irving, the tale spinner of Sleepy Hollow fame, later described what Gist wrote of this land:

> It was rich and level, watered with streams and rivulets, and clad with noble forests of hickory, walnut, ash, poplar, sugar maple and wild cherry trees. Occasionally there were spacious plains . . . and buffaloes thirty or forty at a time . . . Deer elk, and wild turkeys abounded.

It was, said Christopher Gist, a place where "nothing is wanted but cultivation to make this a most delightful country."

Having traveled more than 300 miles from his home, Gist left central Ohio with his friends and traveled to a Miami village called Pickawillany where Piqua, Ohio, is today, and there he helped start a war that would change America forever. At Pickawillany lived several hundred Miamis under the leadership of a chief called La Demoiselle, or Dragonfly by the French and Old Britain by the English. Originally favorable to the French, Old Britain was becoming increasingly friendly to the English traders who lived and worked in and near his village. Gist sealed the relationship by entering into a treaty with the Miamis. He also sealed the fate of Old Britain.

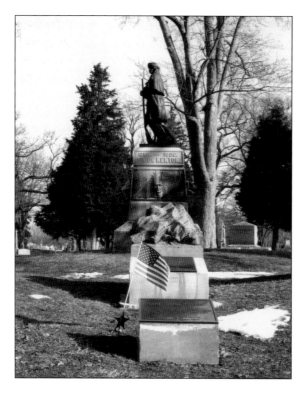

Simon Kenton is Ohio's answer to Daniel Boone. A close friend of the Kentuckian, Kenton forged an enviable record in his own right as a pioneer and frontiersman. Captured by Native Americans, Kenton ran the gauntlet more than once and survived.. He knew central Ohio well and visited here often until his death in 1836. This statue in Urbana marks his grave. (Author's Collection.)

Enraged at the behavior of the Pickawillany people, the French sent Pierre Langlade at the head of a force of several Frenchmen and more than 300 of their Chippewa, Ottawa, and other Indian allies to attack the Miamis. On June 21, 1752, the French attacked and took the fort. In the process, one English trader and Old Britain were killed. The body of the chief and the trader were boiled and eaten by some of the more cannibalistic gourmands among the victors.

Two more years passed before full scale war came to the frontier. When it did, it sealed the fate of France in North America. But perhaps the ultimate irony of this titanic struggle was that, with the exception of the Pickawillany attack that arguably started the whole thing, little of the war was fought in the land that was the real prize of the whole contest: the land north and west of the Ohio River.

The war itself came back to eastern America and gained a life of its own in Europe. Ultimately the conflict was resolved on the Plains of Abraham outside Quebec in 1759 when General Wolfe led his British forces against the French armies of the Marquis De Montcalm. At the end of the day, Wolfe and Montcalm were both dead, Britain was victorious, and France had lost an empire.

By the terms of the agreement to end the war, France surrendered most of its claims to Canada and eastern North America to the British. The immensely profitable business of fur trading with the Indians now became a British business. Many French people stayed on in America after the war in major settlements at Quebec and in more limited ones at places like Cahokia and Vincennes in the Northwest Territory. But for the French, much of the story of America from this point on would be someone else's story.

Many Native Americans who had been friends of the French accepted the loss philosophically and decided to become trading partners with the English. Others were not as forgiving. Chief among them was an Ottawa warrior we have come to call Pontiac. In 1763, as the French and Indian War was winding down, Pontiac led an immensely successful assault on most of the major forts and settlements now occupied by the British. Pontiac was a rarity among Native Americans. By diplomacy, rhetoric, and exhortation, he persuaded large numbers of Native Americans who did not like each other very much to unite in overthrowing the English.

One of the places Pontiac's warriors attacked was a small trading post at the Forks of the Scioto manned by English traders. One of the Pennsylvania traders, Matthew McCrea, was killed, and another, Patrick Allison, who was away at the time, managed to escape. Goods worth more than £6,480 were lost and never recovered. Although no one thought too much about it then, McCrea achieved a rare distinction by his demise. He became the first person whose name we know to die on the site of what would become Columbus. Pontiac's revolt spread terror along the frontier and most British posts in the hinterlands were captured and destroyed.

Most, but not all. To be successful, Pontiac's forces had to capture both Fort Detroit and Fort Pitt, the new English fort where Pittsburgh is today. Pontiac was unable to capture either place. Ultimately, his revolt faded away in the face of

renewed attacks by new English armies sent to the frontier and in the face of an early use of biological warfare. Anxious to end the uprising, British commander Lord Jeffrey Amherst had smallpox-laden blankets delivered to his enemies. The combination of combat and pestilence was more than the rebellious Native Americans could handle. Pontiac moved from town after his revolt collapsed. He eventually drifted into alcoholic decline in the ancient Mound Builder city of Cahokia, where he was murdered a few years later.

For a brief time, peace returned to the western territories. But it was a fragile peace and would not last.

DUNMORE'S WAR

In the wake of Pontiac's revolt, the British government tried desperately to exploit the fur trade by keeping the Native American peoples happy. To accomplish this, the British banned settlement north and west of the Ohio River in the hope that colonial settlers would stay away.

In 1774, a Mingo leader with the anglicized name of Logan was devastated by a horrific crime. Much of his family was savagely and despicably murdered by frontiersmen who considered Native Americans to be simply an impediment to their progress. Infuriated by his loss, Logan led a revolt that mobilized hundreds of warriors and brought havoc once again to the frontier. In one sense, Logan's loss and the violence that followed were a great help to another man.

Lord Dunmore, the royal governor of Virginia, was a man with a problem in 1774. Rebellious colonists had become increasingly restive. Chafing under growing taxes and other governmental restrictions, the colonies were moving more rapidly toward open defiance of Britain. To Dunmore, the revolt in the west was a heaven-sent opportunity to get people's minds on something else. Dunmore formed a huge army of several thousand men and set out for Ohio. One wing of the army under Colonel John Bowman moved down the Ohio and met more than 1,000 warriors in a large, chaotic, but ultimately successful battle at what is now Point Pleasant, West Virginia. Dunmore took his wing of the army and marched to the Pickaway Plains near modern Circleville, Ohio. There he formed an encampment he called Camp Charlotte and settled in to wait for Bowman.

While he was waiting, he sent William Crawford and about 240 mounted volunteers on a raid against a Mingo camp at the Forks of the Scioto. Crawford wrote a letter to his friend George Washington and described what happened as his dismounted men surrounded the town and began the attack at dawn:

> Unfortunately one of our men was discovered by an Indian who lay, out from the town some distance, by a log which the man was creeping up to. This obliged the man to kill the Indian. This happened before daylight, which did us much damage, as the chief part of the Indians

Moluntha and his wife, the statuesque Grenadier Squaw, held forth over Shawnee-controlled Central Ohio for most of the generation prior to the American Revolution. Until his betrayal and untimely death, he was arguably one of the most significant Native American leaders in Ohio. (Author's Collection.)

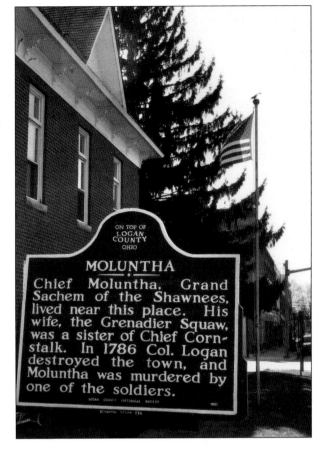

made their escape in the dark. But we got fourteen prisoners, killed six of the enemy and wounded many more. We got all of their baggage and horses, ten of their guns and two hundred white prisoners.

A Native-American account of the same battle noted that most of the men in the town were away hunting and only a few old men were still there:

> One Indian woman seized her child of five or six years of age and rushed down the bank to the river and to the wooded island opposite, when she was shot down at the farther bank. The child was unhurt amid the shower of balls and escaped into the thicket and hid in a large hollow sycamore standing in the middle of the island, where the child was found alive two days afterward when the warriors of the tribe returned.

This was the end of the only major battle fought on the site of Columbus in the more than 60 years of armed struggle to wrest control of central Ohio from Native Americans.

THE REVOLUTIONARY YEARS

Shortly after Lord Dunmore returned to Virginia, he discovered that the rebellion he had tried so hard to avoid was underway in earnest. In the wake of the opening shots at Lexington and Concord in early 1775, it was not long before most of British North America was engulfed in war. Because the territory north and west of the Ohio River was so critically important to the war's success, it should not be surprising that the region was fought over fiercely. What is surprising, however, is how remarkably little of the struggle occurred in central Ohio.

Native-American warriors in general and Shawnees in particular sharply contested colonial intrusion into western Virginia and Kentucky and launched numerous raids against settlements there from their villages along the Muskingum, Scioto, and Miami Rivers. Colonial armies struck back with massive raids against Native-American villages in Ohio. Some of these raids were quite successful, such as those led by George and Benjamin Logan against towns where modern Springfield and Xenia are today. Others were less successful, such as William Crawford's unlucky excursion along the upper reaches of the Olentangy, which led to his defeat, capture, and slow death by burning by Delawares seeking revenge for the death of their own elsewhere in Ohio.

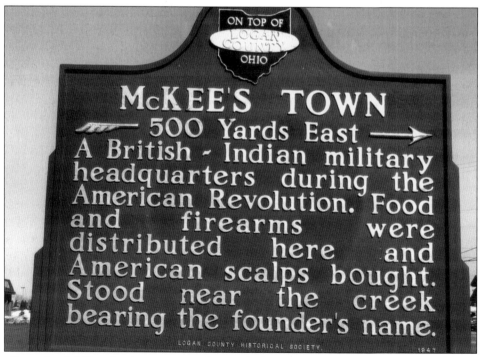

Alexander McKee lived in a town he modestly named for himself south of modern Bellefontaine in the years before and during the American Revolution. It was definitely not the place to be if one favored the Revolution. (Author's Collection.)

Yet central Ohio was remarkably untouched by the war that swirled around it. This is not to say there was not an occasional incident or two where the rivers met. The Mingo camp burned by Crawford had never been rebuilt and the village site was generally abandoned through most of the revolution, but people still stopped to rest and camp here while moving through central Ohio. One of them, a Virginia trader named John Edwards, was killed on September 3, 1775. Traveling north to Sandusky with goods for the Brevard and Dodge trading company, Edwards had stopped to rest at the Forks. A Wyandot warrior killed him there while he slept.

Word of the killing reached the main Wyandot camp a few days later. At the time, Richard Butler, a messenger from the Continental Congress, was in the camp trying to convince the Wyandots to come to a major American peace conference at Fort Pitt. Butler's diplomacy and common sense kept the situation from escalating and the Wyandots attended the Fort Pitt conference. Traveling home, Butler stopped at the Forks on September 8, 1775, presumably to see the site of the Edwards killing. He noted that the village was abandoned and only one log house was still standing. He spent the night in that cabin and moved on in the morning. This was one of the few mentions of anything happening at the Forks of the Scioto during the Revolutionary period.

A NEW NATION AT WAR

Flushed with success at having defeated one of the greatest military powers on Earth, the newly formed United States recognized soon after its victory over Britain in 1783 that it was facing several major problems. The country had an army of several thousand men who had not been paid in years. The new nation had little if any money to pay them. But it did have a lot of vacant real estate in the land north of the Ohio River. Plans were made quite early to find a way to survey and settle this new Northwest Territory. The Great Survey was finally accomplished under the terms of the Land Ordinance of 1785, which set up a way of measuring land in rectangular townships still in use across the United States.

Then a means of governing the new land had to be devised. This was accomplished by the Ordinance of 1787, which set forth the government of the Northwest Territory and outlined the steps to be taken for an area to become a state. The ordinance also forbade slavery north of the Ohio River, promoted the establishment of schools, and generally guaranteed certain civil rights that the drafters of the Constitution, then working in Philadelphia, incorporated into their work as well. What all of these ordinances did not do, however, was forestall another Indian war.

In 1788, soon after the ordinances were passed, permanent settlements were established north of the Ohio River at Marietta and at Fort Washington, where Cincinnati is today. Elaborate plans were made for more settlements to be built farther north along the inland rivers.

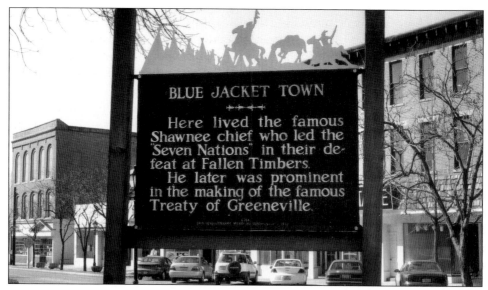

BLUE JACKET TOWN

Here lived the famous Shawnee chief who led the "Seven Nations" in their defeat at Fallen Timbers. He later was prominent in the making of the famous Treaty of Greeneville.

From his village near what is now Bellefontaine, Ohio, Blue Jacket of the Shawnee brought forth a host that helped defeat Arthur St. Clair and Josiah Harmar and made life at least moderately difficult for Anthony Wayne. (Author's Collection.)

In 1790, General Josiah Harmar led an army north through western Ohio to find Native-American villages and destroy them. The campaign was unsuccessful. Harmar found few people to fight and did not fare all that well against the ones he did find. As an experienced military officer himself, Northwest Territory Governor General Arthur St. Clair felt he could do a better job than Harmar in finding and defeating Native Americans. In 1791, he took a large army north through western Ohio to do just that. He failed spectacularly.

St. Clair's defeat in November 1791 remains the worst defeat ever suffered by an American army at the hands of Native Americans. More than 700 soldiers and 250 women and children who accompanied the army were killed. The rest of the army was routed by a force of Native Americans led by the brilliant Miami war chief Little Turtle and his able associate, Blue Jacket of the Shawnee. Threatened with court martial, St. Clair was helped by his old friend George Washington. Although St. Clair remained the governor of the Northwest Territory, never again would he lead an army.

President Washington now had a serious problem. What little army America had was now mostly dead beside a creek in northwest Ohio. He needed not only a new army but also a man to lead it. The man he found was Mad Anthony Wayne. Wayne had made his name as the man who led an assault against the British fort at Stony Point up a sheer cliff in the middle of a rainstorm. Many wondered if he could organize, equip, and lead a new army to victory.

He could and he did. In 1794, Wayne moved north, building forts every few miles as he went. One of the forts was built where St. Clair had been defeated and

was called Fort Recovery. Within a few weeks, Wayne was poised to strike against the principal Native-American towns of northwest Ohio. Blue Jacket sought the counsel and participation of Little Turtle in the battle to come. Blue Jacket and hundreds of others fought Wayne at a place called Fallen Timbers near Toledo. The battle was over in less than an hour. Wayne won.

In 1795, Anthony Wayne called the leaders of the major Indian nations together at Fort Greenville to negotiate a new treaty of peace. Previous treaties at Fort Stanwix, Fort Mcintosh, and Fort Finney had not halted the Indian Wars in Ohio. Perhaps the new treaty could do what the others had not.

It could and it did. The Treaty of Greenville drew a line separating what is now Ohio into two parts. One part, now the southern two-thirds of the state, was forever reserved for American settlement. The other part, the northern third, was forever reserved for Native-American population. "Forever," in this case, was until 1842 when the last of the Wyandots were forcibly removed from Ohio. In the wake of this peace, the land at the Forks of the Scioto, swept by war and abandoned since the beginning of the Revolution, began to be settled once again. It has been settled ever since.

The Treaty of Greenville was the pivotal event in the opening of the Ohio Country to settlement from the east and south. Tribal representatives met at Fort Greenville and agreed to cede the southern two-thirds of what is now Ohio to the United States. As part of a commemorative celebration in later years, a small reminder of Fort Greenville was erected in a public park in the city of Greenville. (Author's Collection.)

3. THE FIRST SETTLEMENT

In the fall of 1795, only a few short months after the Treaty of Greenville was signed, a young man made his way up the Scioto River valley. Carefully moving up the western side of the river, the traveler was accompanied by a small band of friends and associates. Dressed in the rough clothing characteristic of the frontier and armed to the teeth as most men were in those days, they traveled light, moving rapidly to cover as much ground as they could before the cold autumn winds began to warn of another hard Ohio winter coming soon.

The men were surveyors. They were bringing something much more important than the hunter's skill or the soldier's courage to the Ohio country. They were bringing the stuff of civilization itself. The lines these men drew are lines that still exist to mark the boundaries of farms and homes and the very state itself. The streams they named—Boke's Creek, Mill Creek, and Darby Creek—are the names these places carry today.

The leader was called Lucas Sullivant. He came into central Ohio, like so many who would follow him, to stay only briefly and then move on. Instead he stayed here for the rest of his life. More than any other single individual, he is responsible for the first permanent American settlement in central Ohio. In a very real way, the story of the first American town at the Forks of the Scioto is Lucas Sullivant's story. To understand one, one must understand the other.

SULLIVANT'S CHANCE

There was nothing in the early history of Lucas Sullivant that would suggest that he was destined for greatness. But the times into which he was born were filled with ever increasing strife, confusion, and chaos. It was a time when men's mettle was tested. Those who were found wanting were left behind. Those who had the drive and the discipline to succeed often went on to greatness.

Lucas Sullivant certainly did. He was born in 1765 in the back country of what is now Virginia. His family had come to America from northern Ireland many years before. Somewhere along the way, this particular wing of the Sullivan clan added an extra 't' to the end of their name, giving it a flair and a special identity that it would keep from that point on.

Michael Sullivant and Hannah Lucas married and moved off into the wilderness of what came to be Mecklenberg County in western Virginia and prospered, at least initially. Their family grew to include three children: Lucas, Michael, and Anne. Their farm became a prosperous one worked by numerous slaves. But Michael Sullivant the elder was, in the terms of one of his heirs, of a "social disposition—careless and dissipated," and after his death at a relatively young age, most of his property was sold to satisfy creditors. Hannah Sullivant and her children ended up on a small farmstead with a simple home. Lucas Sullivant received his initial education from his mother by the light cast from burning pine knots in the fireplace.

In the years after the death of Michael Sullivant, his son and namesake Michael drowned in a river crossing accident, and his daughter Anne married one of the Lucas clan and moved away. Lucas Sullivant stayed on the farm to support his mother until her death in 1781. Then, at the age of 16, Lucas Sullivant found himself on his own.

At this point the American Revolution had been underway for six years and it was not clear when it might end. The British continued to do their best to encourage their Indian allies to make as much trouble as possible along the frontier. In 1781, that was precisely what was happening in the western counties of Virginia. So young Sullivant went west on an expedition to quell the violence. The campaign itself was uneventful and in the end inconsequential as far as the war was concerned, but Sullivant made a number of friends and important contacts.

One of these was Colonel William Starling, with whose family Sullivant would have a long association. Over the next several years, Sullivant acquired further education and learned the trade of surveying. It was at this time, as the Revolution was ending and the new nation was sorting out its destiny, that Lucas Sullivant began to sort out his own. That future looked to him increasingly likely to be found north of the Ohio River. He was not alone in this belief.

Moving North

In 1784, Colonel Richard C. Anderson was appointed surveyor general of the Virginia Military lands located north of the Ohio River. In relatively short order, the colonel appointed a number of men to be his deputy surveyors and undertake the actual measurement of the new land. They were a remarkable group of men, independent, bright, and extremely self reliant, and included people like Nathaniel Massie and Duncan McArthur, who would figure importantly in other aspects of Ohio history.

The group also included Lucas Sullivant. Not yet 20 years old, Sullivant had by this point proven himself an able frontiersman as well as a competent surveyor. He was young, energetic, and simply very good at what he did. Assigned the northern reaches of the district, Sullivant and his survey party were initially driven back several times by hostile forces of Native Americans. But by 1795, Sullivant

and one of his survey parties of about 20 men had reached what is now Franklin County. It had not been an easy life over the previous years by any means.

For most of the 1790s, the threat and reality of direct and deadly conflict with hostile Native Americans was always present. Sullivant, who preferred to avoid contact and conflict and get on with his task, often had his work cut out for him. On one occasion, he told his men not to fire their weapons for fear of alerting nearby Native Americans. Unable to resist the temptation of a flight of wild turkeys, however, a number of men opened fire and, as predicted, drew an attack by nearby warriors. Sullivant took his large glass-faced compass, which was attached to a sturdy staff, and tossed it into a nearby treetop. He then unslung his light shotgun and fired at an Indian advancing upon him with tomahawk raised. Sullivant then turned and fled for his life. Years later, one of his heirs found the compass in the tree, retrieved it, and kept it as a family heirloom.

Often the dangers faced by the survey parties were just as much from the privations of life in an untamed land as from confrontations with other people. Wolves were a constant menace. The rattlesnakes that populated the caves in the limestone cliffs along the river were impressive as they sunned themselves by the thousands. But they were probably not as frightening to Sullivant as the snake he once found curled on his chest when he awoke from a sound sleep.

On other occasions there was no food to be had at all. On one trip, the men had gone virtually without food for two days. On the third day, Sullivant told the cook

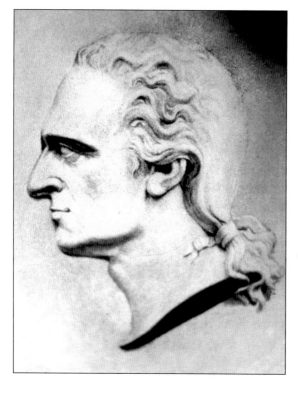

Lucas Sullivant was, in the words of his sons, "a man of great energy, firm will and strong attachments." He came into central Ohio as a surveyor and stayed to establish Franklinton, the first permanent settlement north of Chillicothe in 1797. More than most, he was and remains in a class by himself. (Columbus Metropolitan Library.)

to scour the camp for bones or scraps of meat that had been fed to the animals. Upon their return, the survey team found a large pot of meaty soup bubbling on the fire. The ravenous men devoured the food and, upon emptying the pot, asked the cook what had been in it. He proudly announced that the men had supped on skunk soup. Some men laughed, some men swore they would kill the cook, and at least one man promptly lost the dinner he had just consumed. Sullivant later remarked that, personally, he thought the soup was first-rate.

Because the surveying system relied so heavily on landmarks, many of them came to be named by the surveyor. A good example is Boke's Creek along the upper reaches of the Scioto. It was named for Arthur Boke, one of Sullivant's scouts and hunters, and a friend. Later Boke fathered a child out of wedlock with an African-American woman who had been a slave in Kentucky before being brought to Ohio. Abandoned in infancy by his mother, the child was raised by the Sullivant family, given the name of the selfsame Arthur Boke, and buried in the family cemetery plot after long years of service to the family.

Lucas Sullivant may have come from the land the slaveholders made, but after his time in mapping Ohio, he was no longer one of them. Like most of his fellow surveyors working in a profession that saw a lot of a very poor country, Sullivant took most of his pay in land. The land he liked best was at the Forks of the Scioto and Olentangy Rivers. It was low ground and flooded from time to time, unlike the land across the river on the bluffs or High Banks. But that land was not part of the Virginia Military District. And in any case there was high ground a few miles to the west that was equally high and dry. In the years immediately after the Greenville Treaty of 1795, Sullivant claimed most of the land on the west side of the river all the way out to what would become known as Sullivant's Hill to the west. It encompassed several thousand acres and was a commanding location.

All that was needed to make success begin to happen in the heart of Ohio was a town. And in the late summer of 1797, Lucas Sullivant began to lay out his town at the place he most wanted to be.

FRANKLINTON

Lucas Sullivant called his town Franklinton because he was a great admirer of Benjamin Franklin. In time, the country around his town would carry the same name. Perhaps it says something about Lucas Sullivant. In a time when men had no qualms about naming forts and towns and even whole regions after themselves, Lucas Sullivant chose to name the place—a place he had come to love and would never leave for long—after a man he had never met but whose ideas and example were important to him. It was to be a place not of today but tomorrow, not of men's desires but their dreams.

It is interesting to note that the town sits directly at the forks of the Scioto. This was understandable since Sullivant wanted to be as close as possible to the reason for his town's location. But it was unfortunate as well. Before the first public sale of lots could be held and when there were only a few people living at the site, the

entire town was washed away in a flood in early 1798. It was not the first time the rivers had overflowed their banks and wrought havoc in central Ohio, and it would by no means be the last.

Undeterred by this event, Sullivant promptly moved the entire town several hundred yards to the west to relatively higher ground and resurveyed the entire street plan to the new location. Sullivant then opened the town lots to sale and waited for people to arrive to buy a part of his new place to live. He had a long wait. Franklinton, such as it was, was on the edge of a moving frontier. Situated less than 30 miles from the Greenville Treaty Line and well removed from established settlements along the Ohio at Marietta and Cincinnati, Franklinton was deep in Indian country with no close neighbors at all. It should not be too surprising that many people, lured to Ohio by the promise of cheap land and boundless opportunity, might wish to live a little closer to other people.

Nevertheless, people had come. Joseph Dixon and his wife arrived in the fall of 1797 and were the first to build a cabin. The McIlvaines, Samuel and Margaret, joined them soon after. Both families built barricades of their wagons to live behind until their cabins were built. Both families saw much of what they had built washed away in the flood. But they stayed and built again in the new town plat. Anxious to see more arrivals, Sullivant set aside one street and called it Gift Street. New arrivals could settle on that street and their town lot was free, a gift from Lucas Sullivant. Slowly but surely people continued to arrive. Joseph Foos and his wife Lydia arrived in 1798, as did the Deardurff and Skidmore families. In fact, if one wanders about old Franklinton today and looks at the street names, many are of these older families.

In 1801, Lucas Sullivant returned to Kentucky, married Sarah Starling, the 20-year-old daughter of his old friend Colonel Starling, and departed for Franklinton to take up a new life in the town he had brought into being. He was 35 years old, and it was time to settle down. As with most other things he did, when Sullivant decided to settle down he did so with the same energy, enthusiasm, and dedication that was to many something of a wonder to behold. He built the first brick house in the new town, on the southwest corner of the public square. Across the way was the courthouse and across the street was the jail. When his young wife expressed interest in having a proper church in the town, Sullivant built one. The crude log building served the community well for a number of years and soon the yard around the church became the first cemetery in the frontier community. The church building is gone now. It was used for grain storage in the War of 1812, and when the grain got wet and expanded, the building literally burst its seams.

The old Franklinton graveyard remains along River Street as the final resting place for many of the earliest residents of central Ohio. The church community survived and prospered in several different forms and locations as the First Presbyterian Church under the leadership after 1810 of its noted minister, the Reverend James Hoge. Hoge and his wife also opened the first school in Franklinton in their home, seeing a need not met elsewhere.

Sullivant built his town with the help of his friends and neighbors. Joseph Foos, a firm believer in an organized militia, opened a tavern and ran the first ferry across the bridgeless river. David Deardurff's house became the first post office. After his 1808 arrival, Dr. Lincoln Goodale found no one could really afford to pay much for a doctor, so he opened a store and made first a living and then his fortune in commercial enterprise. While the town was being built up economically, it was also losing a bit of its frontier edge. Yet the transition was by no means painless. Sarah Starling, in addition to giving birth to three sons along the way and maintaining a large household, also had to deal with a few problems unique to her time.

On one occasion, a local hunt had flushed a black bear from hiding, and the hunters drove the animal back into the village in hot pursuit. There a local man named Corbus of considerable size and strength undertook to kill the bear with his bare hands. Either because the bear was by this time quite exhausted or because Corbus was a truly remarkable fellow (or both), the burly frontiersman actually succeeded in killing the bear, much to the astonishment and amusement of his semi-inebriated friends.

Watching all of this from across the river, undoubtedly with no little amusement, was John Brickell. In some ways Brickell was truly one of the first permanent residents of the area. Born in 1784, he had been captured by Native Americans when he was a child of ten. Brought to the Mingo village where Spring Street and Neil Avenue meet today, he had lived for several

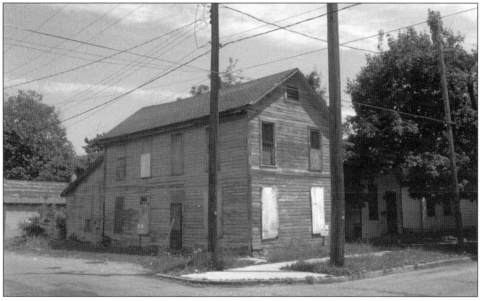

The David Deardurff house is the oldest standing structure in downtown Columbus. Built in 1807, the black walnut, two-story log house was the area's first post office. Even empty and forlorn as it has been for some time, it is still an impressive structure. (Author's Collection.)

It is very difficult today to get an idea what the Forks of the Scioto looked like in the frontier period. This picture was taken by the author precariously balanced in a rowboat at the Forks in 1977 before roads and restaurants intervened. This view looks north toward the place where the Olentangy meets the Scioto. (Author's collection.)

years as a captive. Freed by the prisoner exchange after the Treaty of Greenville, Brickell returned to the East. In 1797, he came back to Ohio. The Indian village was gone, so Brickell built a cabin on the site, took a wife, and lived there for the rest of his life. Accustomed to buckskins, he was never too comfortable without them until his death in 1844. His recounting of his adventures among the Indians is one of the great captive narratives of the frontier period. Brickell always claimed that the secret to his long life was never wearing stockings:

> In 1797, I came to this place that is now Columbus, Ohio, and have resided here ever since; generally enjoying good health, it never having cost me a dollar in my life for medical aid; and without ever having to wear anything like a stocking inside of my moccasin, shoe or boots, from the time I went among the Indians to this day; and I can say what few can at this day, that my feet are never cold.

As the community grew in size and population, this sort of frontier amusement was becoming increasingly less frequent and the characters who lived this way increasingly less common. By 1810, the town had more than 500 residents and was beginning to acquire at least some of the substance and reality of the civilization many of its residents had left behind.

Some of this raising of the village's cultural level was observed firsthand, and assisted a bit, by a remarkable young man named Lyne Starling. Starling rode into Franklinton in the late summer of 1806 to visit his sister Sarah, who happened to be the wife of Lucas Sullivant. It was not clear exactly how long he would stay. He had tried "reading law" but had not proven successful in the undertaking. Now he was looking for something new to occupy his time and thought his sister's settlement might fit the bill.

While he made up his mind, he undoubtedly turned a few heads. Just 23 years old, Lyne Starling stood 6 foot 6 inches, was strikingly handsome, well dressed, and obviously articulate and well-educated. He was also the scion of one of the great families of Kentucky. He would obviously make a great match if the right girl could catch his eye. Unfortunately, that girl proved very hard to find. In September, he wrote home and said as much:

> There is no agreeable society of any kind in this place, not a single girl worth a cent, none handsome[,] agreeable, sensible, or accomplished, but all proud as Lucifer. For my part, I am determined to have nothing to do with them or they of me, for they never speak of me without an ill-natured remark and never invite me to their parties.

But he decided to stay. Assisted by his brother-in-law, he held minor clerical positions in the local courts for a time, but soon turned his attention to making

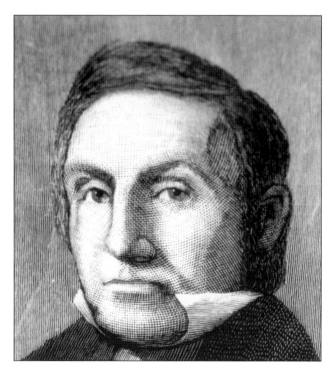

Lyne Starling was the brother-in-law of Lucas Sullivant. He came north into Ohio to seek his fortune in Franklinton. He became one of the four proprietors of the new state capital across the river. The handsome 6 foot 6 inch bachelor left most of his estate to found Starling Medical College in Columbus. (Columbus Metropolitan Library.)

money in business. In farming, shipping, and later in land speculation, Lyne Starling proved to have a remarkable talent for making a lot of money relatively easily. By 1810, he had become quite wealthy in his own right and begun to cast an eye over the vast expanse of empty land across the river to the east. He also noted that the caliber of society was beginning to improve:

> I am still in the land of the living but so involved in business that I very seldom think of dying or marrying. Very few changes have taken place. The town and the society in it are both improving and I think in a few years it will be more agreeable living here than in Kentucky.

There was still some considerable distance to go before the town would really be settled down. Many years later jurist Gustavus Swan remembered what Franklinton was like when he arrived in 1811:

> Goods were imported, principally from Philadelphia in wagons, and our exports consisting of horses, cattle and hogs carried themselves to market. The mail was brought to us once a week on horseback, if not prevented by high water. I feel safe in saying that there was not in the

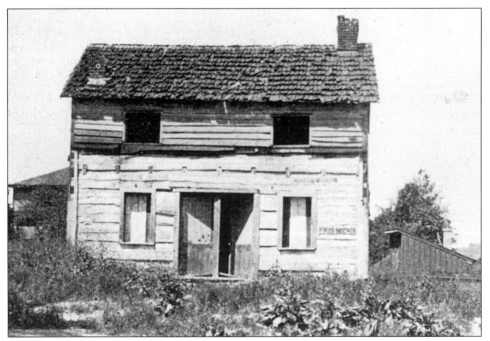

David Beers was an early settler of the area near the Glen Echo Ravine on the north side of the city. His 1804 log house, shown in this picture in its original location, was moved to a house lot near Norwich Avenue and High Street where it remains today with some other log houses. (Columbus Metropolitan Library.)

county, a chair for every two persons, not a knife and fork for every four. The proportion of the rough population was very large. With that class to say he would fight was to praise a man; and it was against him if he refused to drink. . . . There was one virtue, that of hospitality, which was not confined to any class.

Slowly the frontier village was becoming a rather civilized place. Part of the problem of course was that the better things in life were not all that easily acquired, as the travels of Lucas Sullivant show. Many years later, one of his sons remembered those journeys:

Once a year, at least, his business called him to make a trip on horseback over the mountains to the federal city of Philadelphia from which he brought back such supplies and gifts as he deemed most acceptable to his young wife. On one of the first of these trips he brought on a pack mule, carefully protected from wind and weather, an important contribution to the household furniture, no less a thing indeed than a Brussels carpet, sufficient to cover the floor of the large front room of their dwelling. Oh the delight and comfort of that proud possession in a country where the log cabins of the straggling little settlements usually only had puncheon floors. To his own little son he brought something still more rare and equally costly—one orange—the first to find its way to the west.

By 1810, Lucas Sullivant could look with pride and satisfaction on the town he had brought into being. Franklinton was well positioned in the middle of the state to become a major center of transportation and trade. It was a time of plenty and the future looked peaceful and bright. Unfortunately, in short order, all of this was about to change.

4. THE INFANT CITY

While Lucas Sullivant and his fellow settlers of Franklinton and points nearby were intrepidly carving out a home for themselves in the midst of a perilous frontier, the vast area surrounding them north and west of the Ohio River was changing rapidly as well.

STATEHOOD AND AFTER

Once the object of colonial contention, this region came to be called the Northwest Territory by the newly formed government of the United States. In these early years of the new American experiment, the country was governed under a rather cumbersome charter called the Articles of Confederation. While some said any form of government was better than nothing, others were beginning to wonder as requirements for unanimous consent to levy a tax, raise an army, or do any number of things often brought government to a halt.

One thing could be agreed upon: something had to be done with the Northwest Territory. This vast area offered land to pay the country's veterans, land to sell for profit, and land to expand a growing nation. So something was done. On March 1, 1803, Ohio became the first of what would eventually be all or part of five states carved from the territory. The first Ohio Constitution is an interesting admixture of parts of the Northwest Ordinance (banning slavery and favoring education) and the Federal Constitution (checks and balances, separation of powers) with a few innovations of its own (a weak governor and courts, a very strong legislature). To the shock and wonder of many, including not a few of the people who wrote it, it actually worked.

The first legislature met in Chillicothe in a two-story brick building that provided ample space for the entire state government. The new statehouse and the small town around it sat in the literal shadow of Adena, the home of Thomas Worthington and one of the towering figures of early Ohio. A close friend of Thomas Jefferson, Worthington considered himself something of a Renaissance man, and his home reflected his myriad and diverse tastes in art, architecture, and culture. But the Ohio General Assembly was not in Chillicothe to take advantage of Thomas Worthington's library or his kitchen, though the members

often did both. The Assembly was here so that Thomas Worthington and his friends could keep an eye on it. Worthington's brother-in-law was the first governor, Edward Tiffin.

In fact, the emergence of Ohio as a state in the form it then had and still has is largely due to two factors. The first was the success of Colonel Richard Anderson in getting much of the Virginia Military District surveyed quickly by people like Lucas Sullivant and then settled even more quickly in places like the lonely village of Franklinton. The second factor was the steadfast determination of people like Worthington and Tiffin to make the state a reflection of their interests, their desires, and their dreams of an American future. By 1800, there was more than one way to dream the American Dream.

In Ohio that split was seen in the clash between Arthur St. Clair, the governor of the Northwest Territory in Cincinnati, and his allies, like Rufus Putnam in Marietta and the forces of Thomas Worthington and his friends in Chillicothe. The political struggle was long, vituperative, and occasionally vicious. After the accession of Jefferson to the presidency in 1800, what came to be called the "Chillicothe Junto" won and a new state was brought into being. It should not be too surprising then that the capital was placed not in the major population centers along the Ohio River but in tiny Chillicothe, deep in the heart of the Ohio wilderness.

THE CAPITAL CONTEST

It should also not be too surprising to discover that many people were not terribly happy with the choice of location. For the first five years of the state's history, the legislature met in Chillicothe. Sessions were mercifully brief and the legislation passed, while important, was certainly not of the same caliber as the Constitution which gave the legislature its life. While the passage of time improved both the amenities and social life of frontier Chillicothe, the smoothing of the town's rough edges did little to stop the growing chorus of complaint about the capital being in Chillicothe at all.

In the end, the Chillicothe coterie acceded to the wishes of their fellow citizens and moved the capital to Zanesville in 1808. It was a complex arrangement with many quid pro quos on both sides. In the end, Zanesville did not work any better than Chillicothe to provide a location easy and convenient to most Ohioans. By 1810, the Ohio General Assembly was back in Chillicothe.

Under continuing and even more shrill entreaties to move the capital to the center of the state, the legislature did what it usually does when faced with a dilemma that it cannot easily resolve: it appointed a committee. The committee of five men dutifully began to wander around central Ohio looking at sites for a possible capital. With their coming, a virtual contest developed as small towns, owners of empty land, and the widest variety of speculators began to throw proposals to the committee. No one should have been surprised. The biggest business in frontier Ohio was not agriculture and it certainly wasn't industry. It

was not even hunting and trapping, although both activities took up a lot of time. The biggest business in frontier Ohio was land speculation.

Lucas Sullivant was one of the biggest landowners in the state, but his fervent wish was to have the capital located in Franklinton. Other men who were prominent in and owned large pieces of Delaware, Circleville, Newark, and elsewhere had similar wishes.

The committee dutifully visited most of these places and patiently listened as the important citizens of the towns offered the legislature money, land, and all sorts of other inducements of value to pick their town. Some places were ruled out rather quickly. Franklinton, sitting in the flood plain, was still rather wet from a recent deluge and not terribly attractive to the committee. Other towns had a bit too much land and not enough money to build buildings or promised a lot more than the committee thought they could deliver.

In the end, the committee returned to Chillicothe and proposed that the capital be moved to the high ground on the Scioto's west bank about 10 miles northwest of Franklinton. The site was advantageous and hardly anyone lived there. The

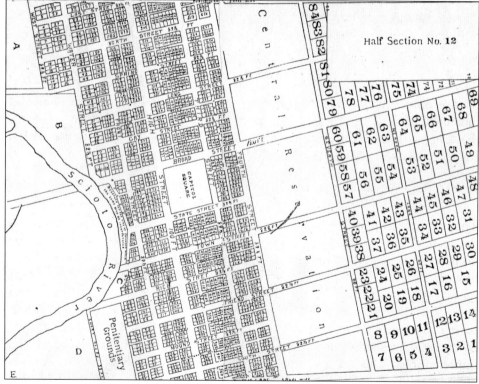

The plat of Columbus was laid out by Joel Wright in early 1812. It is a flexible plan, following the lay and contours of the land but also with outlots and reserve land to the right of the map. The streets are laid out 12 degrees west of true north to line up with the streets of Franklinton. (Columbus Metropolitan Library.)

families who did offered land and labor if the legislature would come and make them rich by its very presence. It was a good place for a town of some sort, and eventually one would be located there and call itself Dublin after the capital of Ireland. But that would be later. For now, the legislature cordially accepted the report of its committee and did what a legislature often does with such reports—it ignored it and moved on to another proposal.

When it became clear to Lucas Sullivant that the legislature would not relocate to Franklinton, he threw his considerable support behind a syndicate consisting of his brother-in-law Lyne Starling and three other men named John Kerr, James Johnston, and Alexander McLaughlin. These four men had managed to assemble a large contiguous quantity of virtually empty land on the high ground opposite Franklinton. This place was known as the Refugee Tract and stretched from Fifth Avenue on the north to Refugee Road on the south and from the river east for many miles. It had been set aside for people from Nova Scotia who lost property because of their loyalty to the cause of the American Revolution. A few, like the Taylor family, actually made it to Ohio and settled in a township they named after their home in Truro Township, Nova Scotia.

Most of the refugees, destitute and abandoned, sold their land warrants for whatever they could get to land speculators who then sold and resold them to other investors and speculators. In this manner, the four proprietors had acquired the land they offered to the legislature. In addition to the land for public buildings, the group proposed to spend up to $50,000—a huge sum in those days—to build structures and make other improvements. It was an offer that became tantalizingly easy to accept. In any case, the Ohio General Assembly did just that and, on February 14, 1812, agreed to a proposal to build a new capital on the "High Banks opposite Franklinton at the Forks of the Scioto known as Wolf's Ridge." Columbus, Ohio was about to be born.

A NEW CAPITAL CITY

The political struggle to settle the issue of the capital's location was spirited to say the least. Many people realized that fortunes could be made or lost on the decision. A final compromise by the proprietors of Columbus turned the tide, however, by including a phrase that kept the capital at the Forks until May 1, 1840, "and from thence until otherwise provided by the law." This satisfied several opponents that a new capital might go elsewhere in the future, and the bill was passed. A similar struggle soon emerged over what to call the new capital city. Many legislators leaned toward "Ohio City" as something both descriptive and unpretentious. This was an important point to frontier politicians who were as often laughed off a stage as defeated in logical debate. But there immediately arose an alternative that would demonstrate yet again what one man firm in his beliefs can do to turn aside the floodtide of history.

Joseph Foos was an early settler of Franklinton. A local militia officer and legislator representing the Franklinton area, General Foos owned a local tavern.

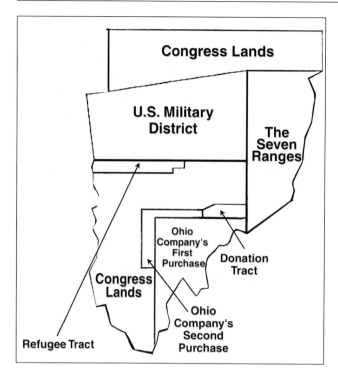

The land where Columbus was founded was mostly empty in 1812 because it lay in the Refugee Tract. Set aside for residents of Nova Scotia who supported the Revolution, it was empty because most of the recipients never made it to Ohio. Instead, they sold their land warrants to others who held the land for a suitable purpose—like a state capital. (Ohio Auditor of State's Office.)

The general was also an ardent admirer of Christopher Columbus. There is an enduring local legend—without a single shred of documentary evidence to support it—that Foos invited most of the legislature to his inn to discuss the issue of the town's name in depth over liberal quantities of the rather potent house libation. Regardless of how he did it, it is clear that Foos made his point. On February 20, 1812, the Ohio General Assembly selected Columbus over Ohio City as the name of the new town.

Now it was time to build a new city. The legislature appointed Joel Wright of Warren County to be Director of Columbus and thereby to survey and lay out the new town. Ably assisted by Joseph Vance of Franklin County, Wright did so in the early months of 1812. The new town did not look very much like Franklinton. Laid out more in the style of a rectangular grid, the new town set aside 10 acres for a statehouse, where the Statehouse still is, and 10 acres for a penitentiary, where the Cultural Arts Center is now. However, the town plan did have one thing in common with Franklinton. The streets were laid out to line up with those of the village across the river. In doing so, they too would be laid out 12 degrees west of true north.

The original town plat ran from North Public Lane (Nationwide Boulevard) to South Public Lane (Livingston Avenue) and from the river to East Public Lane (Parsons Avenue). In the midst of all of this was a swamp where Grant Avenue is today, where the proprietors set aside a reserve for themselves. Their thinking may have been that no one would initially buy such land, but if the town succeeded,

that land would be strategically located to make the proprietors a small fortune. In the meantime, the proprietors of Columbus would make money through sales of lots around the land and buildings they had just given the legislature.

The new town did not look like much. The crest of the High Banks was covered with a dense hardwood forest and except for the Indian path called the High Trail (which later became High Street) and the huge mound at the intersection of Mound and High, there was not much to see. Streets only existed on paper and in the few blaze marks made on trees to mark their future location. It was hard to see a capital city here except in the mind's eye. Many years later, an account described what a canoeist might have seen ascending the river as the town came into being:

> On his left hand was a broad plain bounded on the west by a low range of wooded hills. . . . Along the water's edge grew many wild plum trees, whose blossoms filled the air with a pleasant perfume. On the right bank of the river was a sharply inclined bluff covered by a sturdy growth of timber.. . . . South of the mound which gave Mound Street its name [lay] a small cleared field in which was the pioneer home of John McGowan.

> On the incline of the bluff, not far from the present crossing of Front and State Streets, stood a round log cabin, surrounded by a small clearing and occupied by a man named Deardurff and his family.. . . . Farther north . . . on the banks of small stream [where Spring Street is today] were the ruins of an old saw mill built by Robert Ballentine about 1800. Near it were the ruins of distillery built by Robert White about the same time. Near . . . stood the cabin of John Brickell who had been captured by the Indians.

On April 18, 1812, signs had been posted and advertisements published advertising the new town. Noting that lots would be sold for three days in June at the site, the notice went on to state:

> The town of Columbus is situated on an elevated and beautiful site, on the east side of the Scioto River immediately below the junction of the Whetstone Branch, and opposite to Franklinton, the seat of justice of Franklin County. . . . An excellent road may be made from Lower Sandusky Town to the mouth of the Little Scioto, a distance of about sixty miles. This will render the communication from the lakes to the Ohio River very easy by which route an immense trade must, at a day not very distant, be carried on which will make the country on the Scioto River rich and populous.

On June 18, 1812, the land sales began. Numerous lots were sold for prices ranging from $200 to $1,000, mostly in the area near Broad and High Streets. In

The original buildings on Statehouse Square stood close to the northeast corner of State and High Streets. To the right is the Statehouse. To the left is the Supreme Court Building. In the middle is the very first state office building. This view, published in the 1850s, shows Capitol Square as it appeared in the 1820s. (Columbus Metropolitan Library.)

short order, trees began to be felled in great numbers and cabins built on the purchased town sites. Underbrush and excess wood was burned, but the stumps of the giant trees remained in the roads, in the yards, and throughout the town for many years. Front Street quickly emerged as the main residential street and remained that way for a number of years. Most of the new settlers of Columbus did not complete their work as the fall ended and winter began. They left their work aside and returned to their former homes or roamed across the river in Franklinton with the intention to return in the spring.

As winter approached, there were a few people living in their new homes. John Collett had built a two story brick tavern near the corner of State and High in September, and the Worthington Manufacturing Company was putting together a brick store stocking dry goods, hardware, and groceries near Broad and High. There was not much else. And there would not be much else for a while because the outside world was preparing to intervene once again in the lives of the people of central Ohio. On the very day the land sales began, the United States, tiring of the seizure of its sailors on the high seas, exasperated by continuing military occupation of forts on American soil, and fearful of possible continuing Indian depredations along the frontier, declared war on Great Britain. The great rematch between Britain and America, foreseen since the end of the Revolution, was about to begin. More so even than in the first encounter, this war would be fought and won or lost in the West.

THE WAR OF 1812

The United States had been wrestling with Great Britain over a number of issues for many years. In addition to the specific complaints of impressment, occupation, and running guns to the Indians, many Americans, especially in the West, felt that it was time to rid North America of Britain's presence once and for all. It was a bold dream, but many thought it a possible one. Europe was locked in a series of costly and deadly conflicts centered around either promoting or deterring the arrogant aspirations of Napoleon Bonaparte. A war in America would be difficult for Britain to fight under such conditions.

William Henry Harrison had achieved a messy, bloody, and costly 1811 victory against a charismatic Shawnee leader called the Prophet and his allies at Tippecanoe Creek in Indiana. At the moment the Indian nations were no longer as potent a threat as they once had been. Finally, the growing strength of the American economy, the stability of its society, and the sheer growth in numbers of people who called themselves American persuaded many that an American victory was inevitable.

It was the wrong conclusion to reach. Britain at this point was one of the most powerful military and naval powers on earth. It should also be noted that many Americans were by no means Warhawks. Many New Englanders in particular

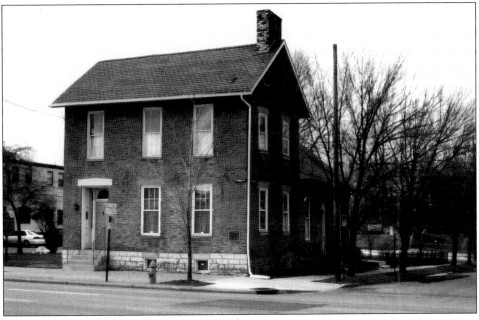

This place is often called Harrison House because it was (falsely) reputed to be William Henry Harrison's headquarters in the War of 1812. The Oberdier House was built in 1808 and is the oldest standing brick structure in downtown Columbus. It is currently the home of the Franklin County Genealogical and Historical Society. (Author's Collection.)

were tied to Great Britain by links of commerce, society, and cultural preference. Enough of these people were so upset by the possibility of war that a convention at Hartford, Connecticut, proposed secession from the Union. Although the secessionists failed, the very fact of their existence pointed out the division of Americans over the Great Britain issue.

In any case, as the war began, Westerners felt confident of early and easy victory. A large army of local militias and army regulars formed in Urbana and marched north to take Detroit and seize the Great Lakes for the United States. At Detroit, commanding British General William Brock ordered Michigan Governor and American General William Hull, commander of the numerically superior American army, to surrender immediately. Otherwise, Brock would turn the Indians loose and who knows what might happen? To the absolute astonishment and consternation of his men, Hull complied and surrendered the entire army without a fight.

As might be imagined, President Madison, most of the country, and especially the citizens of Ohio were not amused. Now the entirety of Ohio was open to attack by the British and their Indian allies. Many people living in isolated frontier farmsteads and small hamlets deserted their homes and rushed to larger towns. In Franklinton, a stockade and defensive ditch was dug around the courthouse, supplies were gathered, and the wait for an inevitable attack began. The attack did not immediately come.

With Hull in disgrace, the task of making a new American army fell to Anthony Wayne's former aide-de-camp and later governor of the Indiana Territory, William Henry Harrison. Harrison wasted little time putting his army together. Rushing from town to town, Harrison and his staff set up recruiting stations, made arrangements for arms and supplies, and oversaw the creation of new forts, which stretched across the state about 30 miles north of Columbus along and near the Greenville Treaty line.

Through most of this time in late 1812 and early 1813, Columbus continued slowly but surely to build itself up—clearing land, constructing cabins, and building bridges across the creeks where Spring Street and Interstate 70 pass through the town today. But it was to Franklinton that General Harrison journeyed in search of both men and supplies to build his army. Harrison stayed in several places in Franklinton on the different occasions when he was in the town. One of them may have been the Oberdier House on East Broad Street, now called the Harrison House. Once reputed to have been his headquarters, the site was saved and renovated in 1975 thanks partly to savings fueled by that reputation. It is clear that the building never was Harrison's headquarters—that building was a modest one-story house torn down some years ago—but the house does serve as a symbol of the role central Ohio played in the story of Harrison and the army he led.

It was an important role indeed. Over the course of early 1813, it became clear that several things needed to be done to insure an American victory. One piece in the puzzle of American recovery was the Ohio Indian tribes. In order for a new American army to invade Canada successfully and not be cut off from its base, the

Ohio Indian tribes had to stay out of the fray. On June 21, 1813, Harrison held a conference with representatives of many of the major tribes at Franklinton. These were the people who had fought against Harmar, St. Clair, and Wayne and might fight against the Americans once again.

They chose not to. Tarhe, principal spokesman for the Wyandots, pledged his support in the coming struggle. Representatives of the Shawnee, Delaware, and Seneca did the same. There was great celebration in Franklinton and across Ohio as the word spread that the Ohio tribes would not rally to Tecumseh's call to war. Two other things needed to be done to insure American success. Lake Erie had to come under American control. In a stunning victory, Oliver Hazard Perry and a small fleet of American ships did just that in the Battle of Lake Erie. American forts in northern Ohio also had to hold against British and Indian attacks. At places like Fort Meigs and Fort Stephenson, with the help of volunteer militias and regular troops from central Ohio, the American forts were protected from aggression. In late 1813, Harrison and his army took Detroit and successfully invaded Canada. They met a combined British and Indian force at the Battle of the Thames and defeated it. The great Shawnee war leader Tecumseh was killed in the battle as well.

Tarhe, "The Crane," was a Wyandot leader who had fought for years in many different wars against both English and American armies. His decision not to fight in the War of 1812 was made at a peace conference in Franklinton in July 1813. It was critically important to the ultimate success of William Henry Harrison in his struggle against the British and their Indian allies. (Columbus Metropolitan Library.)

Through all of these trying times, Columbus and Franklinton together served as a mobilization and supply center. In the wake of American victories, British prisoners were marched south and kept in a makeshift prison on a sandbar in the middle of the Scioto that came to be called British Island. Continued flooding removed the island over the years and not a single bit of it remains. Because of the need for men, food, and supplies, large numbers of people continued to arrive in the area. A number of people already here, such as Dr. Lincoln Goodale, Lyne Starling, and Joseph Foos, made a lot of money providing for the needs of the armies. And with the end of the war, the tiny capital city of Columbus began to grow again as well.

In the summer of 1817, President James Monroe and a sizable group of associates undertook a lengthy horseback tour of much of what was then the West. Arriving in Columbus, he complimented the "Infant City" on its success to date and on its likely prospects for the future. Then, after refreshing themselves, the sunburned and road weary party moved on to its next itinerary stop. Monroe was the first sitting President to visit Columbus, but he would not be the last.

THE TERRIBLE TWENTIES

Columbus had changed a lot since the beginning of the War of 1812. Christian Heyl, an immigrant German baker, came to Columbus in 1813 to bake for the armies then in Franklinton. He later remembered:

> We went on to the cabin at the southeast corner of Rich and High Streets . . . and built a fire. My widowed sister cooked some supper and I think it was the best meal I ever ate in Columbus. The first winter that I was in Columbus, I had my firewood very convenient, as I cut it off the lot where I lived. My cabin was divided into three rooms or more properly three stalls. A widowed sister kept house for me and having fixed up the old cabin pretty comfortable I carried on the baking business quite briskly.

Heyl later married, built a hotel on the site of the cabin and "kept a hotel there for 28 years." But for most of the people who were either already here or who arrived shortly after the war, the decade of the 1820s was a very difficult time.

Perhaps it should not be too surprising that a bust would follow the boom. Land prices, indeed the prices for everything, had been artificially inflated during the war. After the war, demand fell off and the markets for many things simply collapsed. Unable to pay installments due on land sales, many properties were sold for what they would bring—often cents on the dollar or even less. Lots that had once sold for $200 hit the block for $20 or less. Many people simply gave up and moved on, but new people continued to come to Columbus as well. Among them were David Deshler and his wife Elizabeth, who was called Betsy by just about everyone. Young and recently married, the Deshlers arrived in Columbus with high hopes. A cabinetmaker by trade, Deshler paid $1,000 for a lot at a time

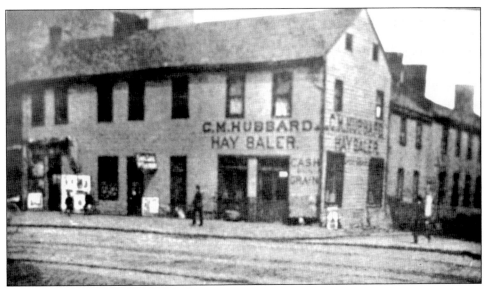

Christian Heyl arrived in Columbus shortly after the end of the War of 1812. He built a cabin, which served as a home, a bakery, and an inn. Ultimately it became the Swan Tavern, which had seen better days by the time this picture was made in the late 1800s. (Columbus Metropolitan Library.)

when most of the town's lots were only a few hundred dollars or so. Deshler felt it would be worth something some day. It was part of the northwest corner of Broad and High Streets.

We know a lot about the Deshlers because Betsy Green Deshler sent a set of letters back to her home in Easton, Pennsylvania. Luckily, the letters survived. They tell a gripping story of optimism in the face of great odds in the new city:

> October 2, 1817
> I have very good neighbors. People here are remarkably kind to strangers. . . . Our house is getting along very well.
> February 3, 1820
> David works every day and for the past five months has not got one dollar in money. All the work that is done in Columbus is for trade. Trade and no money. It makes it very difficult to get along.
> August 10, 1823
> Our town is at present nothing but a scene of trouble sickness and death [*sic*]. If you go to the door at midnight you see a light in almost every house, for watching the sick and the dead.
> November 20, 1824
> . . . all sick, all trouble, everybody dying, and, as a poor Negro says, "everybody look sorry, corn look sorry, and even de sun look sorry, and nobody make me feel glad."

And then things began to look up.

> October 4, 1826
> You can't imagine how much handsomer it looks in Ohio than at Easton.
> November 26, 1826
> Our town is quite healthy and very lively. Provisions are plentiful and cheap.

In less than a year, Betsy Green Deshler was dead. Ten weeks after giving birth to her son William, she died of complications of childbirth and simple exhaustion. She was 30 years old. David Deshler would remarry, stay at Broad and High, and eventually become a banker. We shall meet the Deshlers again.

But we will not meet many of the people who came first to the Forks of the Scioto. The 1820s were a period of economic hardship, epidemic disease, and great privation. It was also a time of transition. The regular flooding of the Scioto and Olentangy River valleys in the spring would often leave deep water in the fields in the rich bottomlands along the rivers. The standing water bred

When David Deshler paid more than $1,000 for a town lot in 1818, most local people thought he had made a mistake. The cabinet maker and future banker thought it might be worth something someday. It was part of the northwest corner of Broad and High Streets. (Columbus Metropolitan Library.)

mosquitoes, which carried malarial fevers. Called the shaking ague, the bilious fever, or simply "catching one's death," the deadly epidemics began to carry off young and old, rich and poor, pioneer and newcomer alike.

John Kerr, one of the four proprietors of Columbus and one of its first mayors, died in 1824 and was buried in the Old North Graveyard where the North Market is today. The other proprietors fared variously. Lyne Starling made several fortunes over a long career. Never having married, he left much of his wealth to found a medical college named after him. Alexander McLaughlin, once quite wealthy, lost his money in the 1820s and ended up teaching in a country school. He died in the 1830s. James Johnston lost his money at about the same time and moved to Pittsburgh, where he lived in quiet if genteel poverty until his death in 1842.

Across the river, Lucas Sullivant died as well from the recurring fevers on August 8, 1823, at the age of 58. Since the end of the war, Sullivant had continued to build his town as well as much of central Ohio. From his home or from his land office, built across the street from his house in 1822, Sullivant sold land and supervised a veritable plethora of projects—the first bridge across the river at Broad Street in 1816, the first courthouse, the first jail, the first church, and the first school, as well as a variety of businesses.

Toward the end of his life, his son remembered, he would talk with other early settlers about how far they had come and how much remained to be done, never doubting that it would get done. In the months before his death he walked often to the crest of the ridge west of his town—the place then called Sullivant's Hill that we call the Hilltop today—and gaze at what he and his neighbors had accomplished. But on his last walk with his son, he did not look back but ahead, saying that he fully expected "to see steam wagons" on the prairie in a few years.

Buried first in the old Franklinton graveyard, Lucas Sullivant was later removed to Greenlawn Cemetery and buried beneath a remarkably simple column that bears a bas relief portrait of the man who literally transformed central Ohio. Lucas Sullivant did not live to see the steam wagons come to Columbus, but he was right. They were coming, and with them were coming new roads, new people, and a new Columbus as well.

5. The Crossroads Capital

In 1832, the village of Columbus had roughly 2,000 people living within the community limits. While this was an improvement over the few hundred people who had hung on through the fevers, floods, and economic collapses of the 1820s, it was still a pretty small town. In 1834, Columbus had a population of more than 5,000, was recognized as a city, and was one of the fastest growing places in Ohio. Clearly something was happening here. Actually more than one thing was happening and these things were all happening at once.

Boats and Byways

Unlike the Muskingum River, which was being navigated by steamboats by the 1840s, and the Ohio River, which has been a major conduit of people and goods for most of its recent history, the upper reaches of the Scioto had a few problems. Most of these problems were not obvious to early settlers. Lucas Sullivant had built his town where two rivers meet because he felt that would make as obvious a place for a town of new American settlers as it had for the historic and prehistoric Native Americans who had preceded them. Indeed, many of the first arrivals in frontier Franklinton arrived by canoe from Circleville, Chillicothe, and points south. The muscle it must have taken to paddle a fully loaded canoe upstream against a reasonably strong current for 60 miles or so still boggles the mind.

If one could paddle a canoe up or down the river, why couldn't one float a 20 foot by 60 foot flatboat loaded with 60 tons of grain, goods, and noisy, unhappy animals down the same river? All one had to do was reach the Ohio and then follow it to the Mississippi and New Orleans to make one's fortune. After selling his goods and the boat for its lumber, a now wealthy frontier farmer would simply walk back home along the Natchez trace, dodging or disposing of robbers and other ne'er-do-wells along the way. At least, this was the theory.

Like many things in life, it did not quite work out that way. Suffice to say, in the early years of central Ohio settlement, a number of people tried their luck at floating goods to the Ohio. A few actually succeeded. Most did not. This meant that the only real means of getting goods to markets was along the web of animal

and Indian trails that were soon being widened enough to be called roads. Of course, this assumes that one really wanted to call a 6-foot-wide dirt track through the woods a road.

Some people did. In 1816, as the War of 1812 wound down, a man named Adam Zinn started running a wagon and coach service on the higher and drier trails of central Ohio. It was successful enough to be able to keep running and attract some traffic along some of the more traveled paths. It also attracted the attention of some of the more notable men in the story of Columbus.

COACH, CANAL, AND CABOOSE

William Neil came to Columbus in 1818 from Kentucky by way of Urbana. He opened an inn across the street from the capitol building on High Street. It was not much of an inn, a rather extended cabin to be precise. But it was a start. Along the way Billy Neil made the acquaintance of most of the small town's residents. He became especially close to Adam Zinn and came to share his belief that the future lay in stagecoaches.

Billy Neil brought a special flair to the stagecoach business. He was rough, he was loud, and he was absolutely fearless. More importantly he had that special quality—rare then as much as now—of being able to instill absolute loyalty in the people he liked and stark terror in the people he did not. William Neil was an

William "Billy" Neil came to Columbus in 1818. He made his money in stagecoaches, becoming known as the Stagecoach King. He invested his profits in land—his farm later became the campus of The Ohio State University—and buildings. Three Neil House Hotels stood across from the Statehouse until the last one was removed in 1974. (Columbus Metropolitan Library.)

essentially straightforward man, but he was also a ruthless one. This combination of boundless energy and endless ambition served him well. In a few short years, the dozens of stagecoach lines caroming around the state had been reduced to only a few, and William Neil owned all or part of many of them. By the early 1840s, he had become William Neil, "The Stagecoach King."

Distrusting banks—perhaps for good reason—Neil put most of his money into land. His tavern on High Street became the first of what would eventually be three Neil House Hotels on that site. For more than a century, it was *the* place to stay in downtown Columbus. Even more important than the hotel to Neil were his investments in land. When he had come to town for the first time, he had stayed at the farm of Joseph Vance north of the city. Vance had assisted Joel Wright in laying out the city and had a long and interesting career as a soldier, farmer, and civic leader. After Vance's death in 1824 of the same fever that killed Lucas Sullivant, William Neil acquired the farm and never sold it.

The Neil Farm was a showplace in Columbus. Beginning just north of First Avenue, it stretched north to Lane Avenue and included most of the land between High Street and the Olentangy River. One approached the farm by driving up Neil's private lane, which we today call Neil Avenue. William's wife Hannah was a formidable person in her own right.

Hannah Schwing Neil was the soft leather glove on the strong hand of William Neil. A believer in the absolute necessity of helping the unfortunate, she was one of the great early leaders of organized charity in Columbus. A founder of the Columbus Female Benevolent Society, the oldest continuing charity in the city, Hannah Neil also founded what came to be called the Hannah Neil Mission and Home for the Friendless.

This view looks south on High from Broad Street in 1846. On the left are the state buildings and across the street is the first Neil House Hotel. (Columbus Metropolitan Library.)

Hannah Neil was the wife of the Stagecoach King and one of the early leaders of organized charity in the city. The Hannah Neil Mission and Home for the Friendless is named for her. (Columbus Metropolitan Library.)

William and Hannah Neil lived on their great estate or in their fashionable town house on Statehouse Square until the farm house burned in 1863. Hannah contracted pneumonia and died shortly thereafter. A friend writing a few years later remembered her fondly:

> She had wealth and position and commanded respect yet she was rarely found among the gay and the joyous. In daylight and darkness, she was in the lonely alleys and the byplaces among the miserable and the destitute. She did not upbraid the suffering wicked. It was enough for her to know that they were fallen. She did her duty nobly and well and verily, verily she has her reward. She has gone home.

William Neil died in 1870, and his home became the site of the newly formed Ohio Agricultural and Mechanical College, now the Ohio State University. Long before his death, Neil had sold off most of his stagecoach lines and begun to invest in other forms of transportation, one of which was the pet project of another remarkable man, Alfred Kelley.

Alfred Kelley had come to Columbus to represent Cleveland in the legislature in 1816. By the end of his long career in 1859, he was representing Columbus and had served longer than most men ever would in the General Assembly. Alfred Kelley was an austere but genteel man and probably one of the brightest men ever to serve his state. The father of Ohio's banking system, Kelley also fostered a wide variety of enterprises and was quite successful in luring new business to the state. In 1839, he built his magnificent Greek Revival mansion "way out in the country" adjacent to where Memorial Hall sits today on East Broad Street.

The ruling passion in Alfred Kelley's life was not stagecoaches; it was canals. In New York State, Governor De Witt Clinton and his friends had taken an old idea—manmade waterways—and made it their own. The Erie Canal changed the face of commerce in America and made New York the commercial powerhouse of America. Kelley wanted to do the same thing in Ohio. It was not an easy task. Convincing the legislature to support the idea was quite difficult. Raising the money to build it from European and American bankers was not easy either. Even the actual construction itself was a formidable feat. But beginning in 1827, the great system began to emerge—the Miami and Erie Canal in Western Ohio linking Toledo to the Ohio River and the Ohio and Erie tying Cleveland to Portsmouth in eastern Ohio. Columbus was linked to the Ohio and Erie by a "feeder canal" via Canal Winchester and Lockbourne. Entering the city from the south, the canal emptied into the Scioto near the place where Bicentennial Park is today.

It was an undertaking like nothing anyone had ever seen in Ohio before and a dangerous one as well. Hundreds of men became quite ill digging through the malarial swamps of the state. Dozens died and many of them were buried where they fell along the side of the canal. There were other dangers as well. In the great economic downturn of 1837, Ohio found itself unable to pay the interest on its canal bonds. Kelley realized that if the canal failed, assuredly Ohio would fail as well. So he pledged his great house as collateral to ensure the payment of canal bonds through the hard times. His mansion soon became known as "the house that saved Ohio."

Thus, roads and canals came together to assure the success of Columbus. Neil's stagecoach lines and the needs of farmers to get their crops and stock to market produced a usable road system, the capstone of which was the great Cumberland or National Road that reached Columbus from Baltimore in 1831. In 1833, the Ohio Canal was completed into the city as well. Suddenly people and goods were moving more quickly and easily in and out of Columbus than at any other time in its history. By 1834, Columbus was a capital city in truth as well as name.

The irony of both the canal and National Road is that as much as they helped and as difficult as it was to build them, their age of preeminence was quite brief. In less than 30 years, the railroad, that next great innovation, supplanted both as the greatest mode of transportation of its time. The canals continued to struggle along until well into the twentieth century and the National Road—in one form or another—is with us still. But the railroad was the future. No two men knew this better than Neil and Kelley. Billy Neil moved most of his coaches to Kansas

in 1848 and sold them a few years later. The golden age of the stagecoach in the opening of the west would be someone else's story. Neil was looking for something new.

So was Alfred Kelley. The two men joined with several others to sponsor the first railroad into the city. In 1850, the Columbus and Xenia Railroad sent its first train from Xenia across a sturdy covered bridge over the Scioto and into the crude, wooden, barnlike terminal located on High Street where the Hyatt Regency is today. A new age was being born. The people bringing it into being were not only men like Neil and Kelley. There were new people here as well, a great many of them, and they were making the city their own.

A CHANGING CITY

Columbus was anything but quiet. The town was growing extremely rapidly, spurred by the arrival of the canal and National Road. The very shape of the city was changing as well.

Even recent additions to the city were being moved. The original Ohio Penitentiary was located on 10 acres where the Cultural Arts Center stands today. When it became clear that the National Road would enter Columbus along Friend Street from the east, the response from state and city leaders was quick and to the point. Friend Street (named for its Quaker settlers) was changed to Main Street, and

Alfred Kelley came to Columbus in 1816 to represent Cleveland in the legislature. Later representing Columbus, he is considered the father of Ohio's banking system and the father of its canal system. (Columbus Metropolitan Library.)

the penitentiary was moved to a new site "out in the country" along west Spring Street. The move was long overdue since the old prison was an overcrowded nightmare. Yet, as it turned out, the prison did not need to move at all.

Learning that National Road would entirely miss the town's business district, local merchants lobbied for a change of route. As a compromise, the National Road entered Columbus on Main Street, traveled north on High for a few blocks, and left town on Broad Street. This rather convoluted arrangement lasted for almost a century and more than anything else made High Street the main business avenue of the city.

Statehouse Square was changing as well. The brick two-story statehouse, built with clay from the great mound, had been completed on the northeast corner of State and High Streets in 1816. Soon it was joined by a long two-story building facing High Street for state offices and a substantial Supreme Court building to the north of it that was topped by a large wooden dome. The dome, for reasons unknown now, was painted a very bright and garish green. By the mid-1830s, wood rot had taken its toll and the dome had fallen off the building. Showing

The National Road reached Columbus in the early 1830s and was a major factor in spurring the growth of the city. Mile markers like this one regularly told travelers where they were. A few still remain in various places near Columbus. (Author's Collection.)

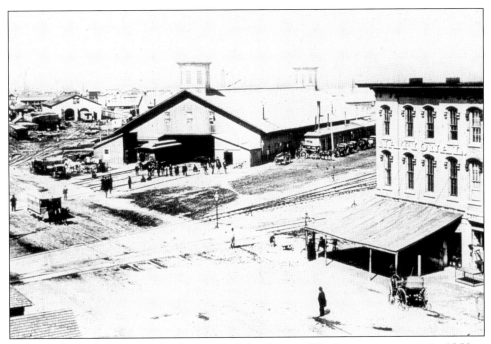

The first railroad to enter Columbus—the Columbus and Xenia—came to town in 1850. It ended up at this "station" where the Hyatt Regency stands today. This picture was taken about 1870 looking northeast. (Columbus Metropolitan Library.)

commendable parsimony as well as taste, the decision was made not to replace the dome.

A person who had seen Columbus only a few years earlier would have been surprised by how much the town had changed. Most of the stumps had been removed from the major intersections. Garbage and other more objectionable wastes were no longer lining the gutters of Statehouse Square—a series of cholera epidemics in the 1830s prompted periodic and very thorough cleanups. And the number and variety of shops along High Street were really quite diverse. But the thing that would have struck the latter-day visitor most was the large number of people not just visiting but living here—people he did not know and people who "talked funny."

A FOREIGN PRESENCE

The immigrants had arrived. Most of the early settlers of central Ohio came from eastern and southern America. They were the heirs of English, French, Scots-Irish, and occasionally other western Europeans, or they were Native Americans who stayed behind or former slaves whose freedom was recent or long standing. These were the people who initially made Columbus their home. The white easterners and southerners sorted themselves out by economic and social class,

When the National Road arrived in Columbus along Main Street, the decision was made to move the penitentiary. A modern and progressive institution for its time, the new "pen" was built "out in the country" along Spring Street. This view was made about 1855 and shows the railroad bridge across the Scioto as well. (Columbus Metropolitan Library.)

those of greatest wealth and power living away from the noise and bustle of High Street. This meant the upper class of people lived along Front Street or along Third Street near Statehouse Square. Folks of lesser means lived closer to where they worked or owned their businesses, William Neil in his inn, David Deshler in his carpentry shop, and so on.

Those with least influence were relegated to the edges of the town. Most blacks lived along a ravine south of the Mound Street mound politely called "Negro Hollow" and derisively something similar but less flattering. Thieves, gamblers, and other ne'er-do-wells gathered at the Jonesburgh community where Cleveland Avenue crosses Mt. Vernon Avenue today. The other outcasts of the city—the poor, the weak, and the abandoned—gathered near the city limits, where the Hannah Neil Mission and Home for the Friendless at Main Street and Parsons Avenue stands today as the home of the Ohio Arts Council.

For most of the first two decades of the capital's history, this is who we were. Then things began to change. Things changed because masses of people left their homes in Europe and answered what seemed to be the call of new hope in the land of America. These new immigrants, who arrived by the tens of thousands, came from many places, but most of them came from Ireland and Germany.

The Irish migration was relatively simple to explain. The Irish had been under the oppressive rule of their British neighbors for many years. Since the Protestant

Reformation of the mid-1500s, Protestant intrusion into predominately Catholic Ireland had been particularly discouraging. By the mid-1830s, a growth in population combined with repressive politics to induce many to leave Ireland forever. A devastating potato famine in the late 1840s compounded the Irish tragedy and sent even more people from their homeland.

Many Irish immigrants escaped from the drudgery of their menial lives within one generation or gave much of what they had to insure that their children escaped. But for the first generation, there was in most American towns of any size an Irish village with its main street, often called "Irish Broadway." In Columbus, that Irish Broadway was first called North Public Lane, then Naghten Street, and today it is called Nationwide Boulevard. Stretching south for a couple of blocks and north for several more from this street was the largest concentration of Irish residents in central Ohio.

The story of the Germans in Columbus is a little more complicated. But then some would say that the Germans are by nature a little more complicated than most. Part of the problem with understanding German migration stems from the fact that Germany in its modern form did not exist when all of this was happening. A unified Germany did not emerge until the late 1800s when the efforts of Bismarck and others led to the first successful reunion of German states since the Middle Ages. Prior to this, Germany was really a series of separate states—some quite large and some ridiculously small—sharing a common language, culture, and heritage in central Europe.

Unlike the Irish, a large number of German immigrants left with more than a little money and an intent to farm in America as they had in Europe. Great farming communities in the West and Midwest sprang up around concentrations of German immigrants. But many Germans migrated to the cities as well, particularly the new cities of the Midwest. Cincinnati by 1840 had one of the largest concentrations of German-speaking people anywhere in America. Places like Dayton, Columbus, and Cleveland were not far behind. By 1850, throughout much of the Midwest, recent German immigrants comprised 40–50 percent of the population.

In Columbus, the Germans settled on the south side of the capital city. Separated from the downtown by a deep ravine along a rushing creek, the Germans developed a community of their own that came to be called *Die Alte Sud Ende* or The Old South End. The Germans came to South Columbus because the land was cheap—very cheap—and most German immigrants did not have that much money to build their tidy little brick homes and cottages. So the real question should be why this land was so cheap.

Again, there were a number of reasons. South Public Lane (Livingston Avenue) was the city limits. Land outside the city limits was usually cheaper than land within. Furthermore, the district was separated from the town by the deep ravine carrying the stream called Peters Run. Along Peters Run, in addition to the black community already mentioned, lived the extended Peters family whose business was tanning. Next to operating a slaughterhouse, tanning is probably one of the

most olfactorily disgusting businesses imaginable, and most of the distinctive scents of this trade wafted over South Columbus.

If this were not enough, there was always the river. By the 1830s, the Scioto was no longer the picturesque, sparkling riparian delight of the frontier period. It was essentially an open sewer carrying most of what had been excreted—personally or corporately—by the people living upstream. When the city finally decided to solve its sewage problems in the 1850s and clean up the river a bit, it did so by building a huge intercepting sewer. The sewer surfaced in the ravine carrying Peters Run and had to be carried over the feeder canal (another open sewer in its own right). To save money the sewer was carried over the canal to empty into the Scioto River by an open wooden trough more than a city block long. On a hot summer day, the combined effect of the river, the canal, the sewer, and the tanneries demonstrated why land prices on the south end were quite inexpensive.

The Germans moved in anyway and made the area their own. Like most ethnic communities, the Germans built homes and churches, published newspapers, and started businesses to serve the specific needs of their neighbors as well as the city at large. In the case of the Germans, one business in particular deserves mention. Germans as a rule, unlike many of their more puritanical neighbors, did not consider beer to be a failing as much as it was simply a food. So there were breweries in German Village from a very early period. Since beer didn't keep very well, there were quite a few of them. After the Civil War, when methods to keep beer longer and ship it farther became available, some of these little breweries founded by people named Hoster, Born, and Schlee became very big breweries indeed.

The German community also included a passion for education and social organizations. German schools sprang up quickly, and many of them operated using the most advanced ideas. In 1838, young Louisa Frankenberg stopped briefly in Columbus. A student of a man in Germany named Froebel, Frankenberg is believed to have founded the first kindergarten in America here in Columbus. After leaving for a time, she returned and operated her "children's garden" for a number of years. Hers was not the only educational innovation. The Lutheran Theological Seminary was founded in the Village in the 1830s and its secular offshoot, Capital University, was conceived here as well.

Then there were the singing societies. German immigrants loved to sing and keep fit. They were not the only people to form singing groups like Mannerchor and athletic clubs like the Turnverein, but there were more of them with more members than was the case with most recent immigrants. The clubs promoted fellowship and community pride and strongly reinforced the German identity of the newcomers. Eventually, the results of this ethnic pride were not all pleasant.

One might wonder if earlier residents of Columbus accepted all of this new ethnic diversity with equanimity. Some did, but many did not. By the early 1850s, the American Party had gained great support in much of America. Anti-Catholic and anti-immigrant, the party considered itself "American" but was never quite clear what exactly that meant. Wallowing in paranoid fear, members of the group were admonished to say to strangers who asked about their beliefs that they

German immigrants brought a love of beer and brewing with them from the old country. One of the more successful of the several breweries on the South End of the city was the one opened by the Hoster family in the 1830s. It is shown here much later in the 1800s after it had become a quite successful enterprise. (Columbus Metropolitan Library.)

"know nothing" of the movement. Half in anger and half in jest, the American Party members came to be called Know-Nothings. It would only be a matter of time before the two sides would clash.

In Columbus, the confrontation came on July 4, 1855. Lacking an ethnic national holiday like St. Patrick's Day, the Germans had taken the Fourth and made it their own. Each year on the Fourth of July, the German community held a long parade through downtown Columbus. The parade ended at Stewart's Grove on the South End where an all day and all night picnic and dance was held. In the few years prior to 1855, groups of the curious, the mischievous, and the Know-Nothing nasty had hurled insults and an occasional rotten egg at the passing parade.

Fearing a more violent assault in 1855, many members of the singing societies and sport clubs armed themselves. As the parade moved east up the Town Street hill from the river to make a turn on High Street, the leading groups came under a heavy assault of rocks and other garbage. The Germans returned the barrage rock for rock until gunfire rang out. It was never clear who exactly had fired first. When the smoke cleared, Henry Foster, one of the rock-throwing pranksters, was dead. Although 30 of the marchers were arrested and later indicted, at trial none were convicted. To this day, no one knows with certainty who killed Henry Foster.

The positive aspect of the deadly Fourth of July was that both friends and foes of the immigrants became convinced that the antagonism had gone far enough and that the people of Columbus had to learn to live one with another for better or worse.

A PLEASANT REFINEMENT

The simple fact was that Columbus was no longer a frontier village. It was a town of considerable size and complexity with all of the problems and possibilities that come with such things. Some of the problems were not particularly attractive. In 1844, Columbus held its first public execution since William Henry Harrison had ordered a private named Fish shot for desertion in Franklinton in the War of 1812. The frontier firing squad was, said one observer, "an awful sight." Its 1844 sequel was not very pretty either.

A white man named William Clark had killed a prison guard named Cyrus Sells with an axe while trying to escape from the penitentiary. A black woman prisoner named Esther Foster had beaten another woman prisoner to death with a shovel. Mostly for reasons of economy, they were hanged together on a gallows erected along the Scioto riverfront. A huge, noisy, and rather drunken crowd gathered to watch. In the confusion, a horse panicked and trampled a "well-known citizen of the town, Mr. Sullivan Sweet." From this point on, executions tended to be held more privately.

For all of this violence, Columbus was also becoming a more pleasant place as it became less of a village and more of a civil society. Even with its increasing sophistication, Columbus was still a place where people lived close to where they worked, walked from home to work, school, church, and market, and private homes still ringed Statehouse Square. Many years later, Alice Fay Potter remembered what it was like:

> In the very early days, the fashionable part of the city was along High, Front and Third Streets between Spring and Rich and Broad Street between Fourth and Front. Governor Dennison lived on High between Gay and Broad and later near Chestnut Street. At the latter home Abraham Lincoln was a guest on his way to Washington for his first inauguration. . . . Mr. Alfred Kelley's house is one of the oldest. It has been the scene of balls and parties without number. The gayest house at this time was the home of Michael Sullivant in Franklinton, famed far and wide for its hospitality. The Virginia Reel, the Money Musk, the stately Spanish contra dance, the slow waltz without reverse, the schottische and the three step polka were popular. Numerous as the dances were they were not the only gaieties. Everyone rode horseback, and many a gay gallop did the young people have.

Not everyone approved of all of this frivolity. A young man named Isaac Appleton Jewett wrote home to Boston in the 1830s:

> The wine parties have been very numerous during the winter. It is here particularly that the "members" [of the legislature] show off. As to their morals they do not invariably furnish the purest models of propriety.

Alfred Kelley built a Greek Revival mansion for himself about four blocks east of Statehouse Square in 1839. One of the most famous houses in Ohio, it was carefully disassembled in 1963 and removed with the idea that it would one day be rebuilt. The stones are still waiting for a new home. (Columbus Metropolitan Library.)

> Nay it is a fact that they grossly violate in the evening and livelong night, the very laws which they were enacting during the day. You may perhaps be surprised when I inform you that in this village of the West, the capital of the state, are supported two billiard tables continuously open to the public, two roulette tables expressly for gambling, and at the first hotel, a room is occupied by a stranger who is risking his thousands or rather hundreds every night at a game of faro.

Yet across these years when Columbus was changing so rapidly and decidedly, the town's general tone continued to be one of more quiet and genteel elegance in the face of rapid and sometimes bewildering change. An example from the press of the day states:

> Young ladies of the seaside have made up their minds it is vulgar if not indecent to dress oneself in costumes and bathe before hundreds of spectators. Others were more daring and it was said that at Put in Bay, a comparatively new watering place that was attracting many Columbus residents, the conduct of the young ladies there seemed shocking. The fair ones were seen dodging about in low necked dresses, bare arms and slippered feet.

Closer to home, things were a bit more sedate. The American literary authority William Dean Howells spent some time in Columbus in the late 1850s and early 1860s. In 1914, as another way of life was about to end, he remembered fondly the town he left behind:

> Society in Columbus in that day had a pleasant refinement which I do not think I exaggerate in the fond retrospect. It had certain fixed ideals which were none the less grateful and becoming because they were simple old American ideals now vanished before the knowledge of good and evil as they have it in Europe, and as it has imported itself to American travel and sojourn. . . .The women dressed beautifully to my fond young taste. They wore Spanish hats with drooping feathers in them, floated on airy hoops and were as silken balloons sailing in the streets, and here we proudly leave them.

Howells left this Columbus of rare remembrance because the wider world was beckoning him to join in a great, violent, and turbulent adventure which would change Columbus and America forever. The people of Columbus and America were going to war.

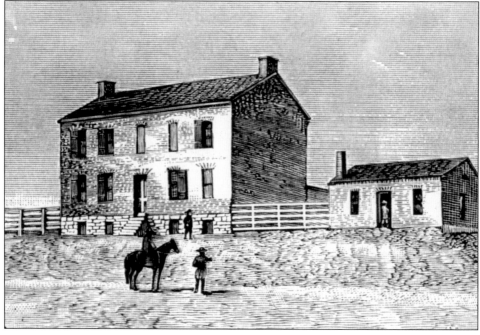

The first penitentiary was actually completed in 1813 before the Statehouse was built, saying something about local priorities. Located where the Cultural Art Center is today at Main Street and Civic Center Drive, the prison was overcrowded from the day it opened. (Columbus Metropolitan Library.)

6. THE GREAT STRUGGLE

In the summer of 1859, Abraham Lincoln made the first of what would eventually be three visits to Columbus. In this first instance, Lincoln was a moderately well-known Illinois politician who was most noted for having lost the race for the U.S. Senate to a Democrat named Stephen Douglas. Lincoln, a former Whig, was a rising star of a political party, the Republicans, that had only been born a few years before. One of the reasons he had come to Columbus was that Ohio's capital was a stronghold of that new party.

When Lincoln returned for the second time in early 1861, he was on his way to Washington to be inaugurated as the 16th president of the United States. On his third visit, four years later, he was returning to Illinois for the last time. This visit drew the largest crowds of any of the three, but Lincoln made no speeches as he had the other two times. He was in no position to do so, having been shot dead a short time before.

On all three occasions, the place where Lincoln came in closest contact with the most people was one of the great buildings of his time and ours: the Ohio Statehouse. Opened for use only two years before Lincoln's first visit and still under construction during his second, the building was substantially complete by the time the residents of a mournful state came to pay their last respects to a fallen leader.

In a real sense, the Ohio Statehouse was a symbol not only of Columbus but of America at the midpoint of the nineteenth century. Perhaps that is why its story and Abraham Lincoln's are so closely intertwined—both are stories quintessentially American, both almost never happened, and the link that holds them together is the struggle that literally tore the country apart and made us who we are today.

THE STATEHOUSE

When one visits the Ohio Statehouse today, it is not terribly hard to imagine what it was like when Lincoln was here. Thanks to exquisite restorations over most of the 1990s, the building looks the way it did in the 1860s. It was an almost achingly beautiful job of renovation, and it reflects a certain respect for a great building and

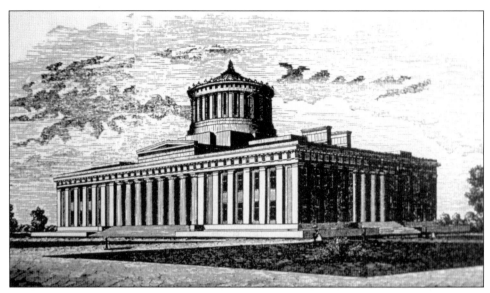

The Ohio Statehouse was begun in 1839. It was planned to take two years and about $200,000 to build. It took 22 years and $2.2 million to finish the job. But in early 1861, at long last, it was done. (Columbus Metropolitan Library.)

of all of the architects, artisans, and artists who worked on it. It also reflects the fondness of the legislators and officeholders who spend most of their days in and around the building. The throngs of people who daily visit the place reflect the genuine love most Ohioans have for the oldest standing public structure in the capital city.

It came very close to not being built at all. As we have seen, the first Statehouse was a stately but modest two-story brick structure that stood at the southwest corner of Statehouse Square at State and High Streets. It served the needs of the legislature well for a number of years with the House of Representatives on the ground floor and the Senate on the second floor. A cupola that served as a bell tower offered a nice view of the frontier capital city slowly rising out of the retreating forest.

But the rapid growth of the town and the state soon made it clear that the original Statehouse was becoming much too small much too quickly. By the mid-1830s, frequent complaints were being made about the cramped quarters and the need for a new and significantly larger statehouse. The construction of the adjacent state office building and a court building nearby eased some of the strain, but not for long.

On July 4, 1839, former governor Jeremiah Morrow laid the cornerstone for a quite large and quite grand building to be built in the middle of Statehouse Square. A contest seeking proposals for the new building had led to the acceptance of a plan conceived by Henry Walter, which called for nothing less than a version of a Greek revival temple in the heart of central Ohio.

By early 1840, the foundations were in place and work was proposed to begin by local artisans and convict labor from the penitentiary on the building's walls. The limestone that constitutes the exterior was locally quarried, and the brick for the interior of the walls was made locally as well. Then the work stopped dead. Some legislators and their constituents objected to the sheer cost of the building and wanted something simpler. It was planned to take two years to construct and cost in excess of $200,000. This was a huge sum at a time when many workmen only made $1 per day.

After the 1840 battle was won by the Statehouse proponents, the work proceeded in fits and starts, with periods of furious sustained activity followed by long languorous lulls where not much happened at all. But by the early 1850s, with the walls out of the ground, it was clear that the building would be completed sooner than later.

Then the work stopped again. Just when it seemed that the project might stall permanently, fortune intervened. In this case, fortune was ably assisted by a few persons still unknown to this day. These malcontents decided to force the issue by burning the old Statehouse to the ground on February 1, 1852. This forced the legislature into nearby inns where sessions were held under less than favorable conditions. But the destruction of the Statehouse did have one salutary effect. It expedited the construction schedule on the new building by a considerable margin.

By January 6, 1857, the building was ready to be opened to the curious public. One local writer described the scene as follows:

> There were differing estimates on the number present—from five to ten thousand persons . . . but such a crowd I never saw! The doors for admission were opened about seven o'clock and there was a perfect jam. As everyone had to show their ticket and only one door to get in at there was of course a great squeeze and the ladies [sic] whalebones suffered to an alarming extent. I heard of one lady that the whalebones in the waist of her dress all broken [sic] and then she fainted under the belief that it was her ribs. Hoops stood no chance whatsoever and ladies were very much removed in size by the time they got in.
>
> Tables were spread with refreshments and two bands of music were present to accommodate those who wished to dance. The dance was kept up until daylight, for it was impossible to clear the building as the greater part were strangers and the hotels being full, they had no place to stay, so they danced the night away. The State House, as far as completed, is perfectly magnificent.

And it was. Here in the heart of a recently settled wilderness, in a place where the streets of night were lit only by the flicker of oil lamps and the streets of day were seldom paved was one of the most magnificent buildings in North America,

if not the world. It was an astonishing place and a reflection of the confidence Ohioans felt in the future of a state only one generation removed from the frontier.

The first governor to occupy the new Statehouse was Salmon P. Chase. He would go on to become Lincoln's treasury secretary and end his career as chief justice of the Supreme Court of the United States. But what the widower governor and his witty and vivacious daughter and hostess Kate really wanted was for Salmon Chase to be President; however, this was not to be. Salmon Chase had made a long journey from New England to Ohio in his youth and then through most of the major parties of his day until he ended up with the Republicans. Along the way his point of view on many issues had changed, often more than once. But on one issue he remained adamant: the absolute moral depravity and evil of the institution of slavery. On this issue he would stand or fall—and eventually he fell to the more pragmatic and politically astute Lincoln.

Chase was not the only person of his time to see his career altered and his dreams abjured by the "peculiar institution." Because Ohio was located where it

Salmon Portland Chase was a good choice for Lincoln's Treasury Department after it became clear he would not be President. Cancelled out in his presidential bid by William T. Seward, the former governor of Ohio eventually became chief justice of the Supreme Court. Today his statue stands with those of other prominent Ohioans on the grounds of the Statehouse. **(Author's collection.)**

was and because so many Ohioans disagreed so vehemently about slavery, this issue threatened to tear the state apart as well as the country. It came quite close to doing just that. To understand how these enmities became so powerful and how the war they started became so terrible, we need to step back for a moment and look at the origins of the conflict.

THE UNDERGROUND RAILROAD

The Underground Railroad is neither underground nor a railroad. Yet it is Ohio's enduring myth. Many people in the East claim that George Washington slept in their home. Indeed, one sometimes gets the impression that George slept so long and in so many places that he must have virtually slept through the Revolution.

Similarly, the Underground Railroad is our great myth in this state. Many people honestly believe—without a shred of evidence to support it—that their house was a stop on the railroad. In fact, one sometimes gets the impression, if all of these stories were true, that some people were fleeing door-to-door on their fateful journey to freedom. The truth was a bit more prosaic and a lot more deadly.

The people who used the Underground Railroad were runaway slaves. Slavery as an institution was, for much of this country's early history, the shadow on the great experiment in freedom that the American Revolution had promised. Thomas Jefferson recognized it as the "fire-bell in the night" that, unheeded, would eventually bring great pain and suffering to his beloved country.

He was right. For most of the first 80 years of our history, Americans disagreed about many things: the tariff, the banks, the army, and even the appearance of the flag. But the thing they disagreed about most was slavery. Some historians would later argue that the Civil War was caused by a variety of problems—a growing sectionalism pitting an agricultural South against an increasingly industrialized North, concerns over states' rights versus the role of a central government, and, yes, the issue of slavery.

Of all of these reasons the primary and enduring cause of the American Civil War was slavery. From the earliest years of our history a few people had spoken out against the moral evil of enslaving another human being. Assuredly, they said, the Greeks and Romans and even the British had held slaves. But we were not those people. We were Americans and Americans did not do such things. The opponents of this view—slave holders in the North as well as South—answered that slavery was necessary, that it was helpful to all concerned, and that it was the law of the land.

Eventually, by the 1830s, the two sides had coalesced into contending factions: the antislavery advocates called themselves abolitionists and the most ardent pro-slavery defenders were often called fire-eaters. Although they only constituted a small part of Americans, between the two sides there was little agreement and no love lost. Ohio held advocates of both points of view. This should not be surprising since the state was settled by both North and South. If anything, the edge was held by people who opposed slavery. This too should not be surprising

since the state and the Northwest Territory that had preceded it had forever banned slavery north of the Ohio River. In Columbus, some of the notable families we have already met, like the Neils and the Deshlers, were antislavery supporters. So too were several newer families like the Keltons, the Westwaters, and the Gwynnes. But for each of these opponents there were also tacit (and sometimes open) supporters of slavery.

It all came to a head in 1846 in the case of a man named Jerry Finney. A black man who had lived and worked in Columbus for some 14 years, Finney had become well-known as a cook and waiter in many of the better restaurants and "public houses" of the town. On March 27, he was lured across the river to Franklinton to the office of Justice of the Peace William Henderson. Local historian William T. Martin described in his usual calm and quiet way what happened next:

> The necessary certificate, etc., having been previously procured, Jerry was forthwith delivered over by the justice, in his official capacity, to the decoying party; one of whom was Alexander C. Forbes of Kentucky, who held a power of attorney from Mrs. Bathsheba D. Long of Frankfort, Kentucky, to whom it was claimed Jerry belonged, and owed service as an escaped slave. Jerry begged for a fair trial but in vain. He was immediately handcuffed and put into a carriage standing at the door for that purpose, and drove to Cincinnati, from thence to Kentucky and delivered over to his former mistress.
>
> As Jerry was generally well known (having been cook and general waiter or servant at most of our public houses) his sudden disappearance from our midst, and the time and manner of his capture, created some excitement.

This was something of an understatement. Over the next several months, outraged friends of Finney and opponents of slavery brought criminal charges of kidnapping against Henderson, Forbes, and four others. All but Henderson were acquitted after a rather sensational trial and Henderson was later discharged on a technicality on appeal. Unable to free Finney any other way, his friends took up a collection and bought him from his owner. Returning to Columbus, Jerry Finney was happy but quite ill with consumption and, in a short time, was dead. But as his friends and supporters noted, he died free.

In time, as often happens in our country, the issue became the center of much of American politics. Time and again over the next generation, men like Henry Clay, Daniel Webster, and John C. Calhoun would craft compromises to keep the Union together as the debate grew hotter. The last of these great compromises came in 1850. In addition to dividing up the spoils of the Mexican War between free and slave states, it also put in place a Fugitive Slave Law that required northerners to return runaway slaves to their owners. To many abolitionists, this

was the last straw. Now they not only had to tolerate slavery, they had to actively support it. The loose network of friends and acquaintances, black and white, who had helped runaway slaves reach freedom in Canada now became much larger and more sophisticated.

Places like the homes of the Keltons on Town Street (now a house museum), the Neils on Indianola Avenue (now a fraternity house), and the Methodist Chapel on High Street (now a funeral home) became stops on an Underground Railroad. Many other houses and buildings in central Ohio—some gone and some still standing—served in the same role and quite successfully.

One of the political responses to the issue was a whole new political party. Composed of former anti-slavery Whigs, anti-immigrant Know-Nothings, anti-alcohol Prohibitionists, and anti-deflation Greenbackers, as well as an assortment of other anti- and pro- people of different sorts, the Republican Party found its strength in the Midwest in general and Ohio in particular. Its first try at the presidency in 1856 was a disaster. But success at the state level with people like Salmon Chase of Ohio and William Seward of New York promised another try in 1860.

In that year men like Chase and Seward cancelled each other out, and the party selected a compromise candidate: Abraham Lincoln of Illinois. Tall, gangly, and

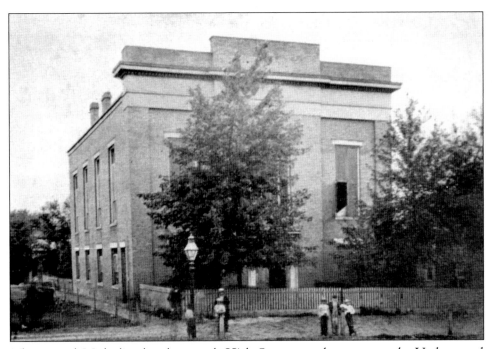

The original Methodist chapel on north High Street was also a stop on the Underground Railroad. This remarkable photograph is the oldest known exterior photo of downtown Columbus. The 1854 image also is the oldest picture found so far showing some of the African Americans who lived in Columbus. (Columbus Metropolitan Library.)

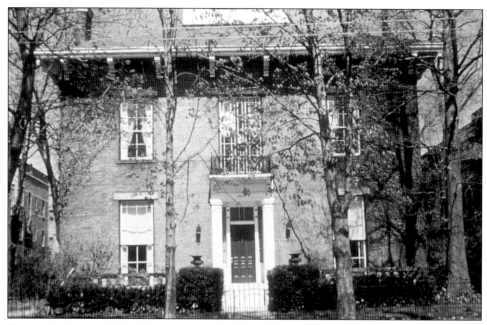

Fernando Cortez Kelton, a prosperous local merchant, built his family's dream house in 1852. Friends chided him for living so far out in the country. A stop on the Underground Railroad, the house stayed in the Kelton family until 1975. (Author's Collection.)

with a nasal twang that showed his humble origins, Lincoln hoped his policy of accepting slavery where it was but opposing its extensions would satisfy South as well as North. It didn't. Several southern states threatened secession if Lincoln was elected.

Lincoln was elected. He said there did not have to be a confrontation over his election. As states seceded, many people North and South looked for a way to stave off conflict. But the rift was too deep, the bitterness too great on both sides. On April 12, 1861, South Carolina secessionists opened fire on Fort Sumter in Charleston, forcing its surrender. The war came.

THE CIVIL WAR

It is difficult today to understand the enthusiasm with which both North and South welcomed the coming of the Civil War and its attendant mayhem and death, but they did. Unwilling to call the rebellious South the new nation or Confederacy it wished to be called, President Lincoln called for 75,000 volunteers for three months to subdue "combinations too powerful to suppress" by normal means. To save the Union, the small and poorly equipped U.S. Army would need some help. Within a few days, Columbus was overrun with volunteers seeking to serve their country. Hundreds of young men and then thousands flocked to the major cities of the North and South and, in many cases, literally fought to be the first in line.

Why did they do this? Actually there were several reasons. Many people, President Lincoln included, believed the war would be over quite soon. Also, the United States had not fought a major war for more than decade, and even that one—the Mexican War—had not involved most of the population. Many people were convinced that their side was right and the other side was wrong. Many young men simply thought it was a great adventure and would be a lot of fun.

They were wrong. The American Civil War turned into the nastiest, deadliest war in American history. By the time it was over in 1865, it had killed more men, North and South, than any other war in our history and had changed our country strikingly. It was, many would say today, the defining conflict in the American story. But no one knew that in the spring when the war began. As thousands of young men flocked to the call of their country, Ohio led the way in many important respects. Only the third largest state in the Union, it nevertheless provided more troops per capita than any other northern state. This prompted Lincoln at one point to say, "Ohio has saved the Union."

But Ohio's government was not able to do so easily. Men were housed in the hallways of the Statehouse, in every public building in town, including the penitentiary, and in the open on every bit of available downtown land. Contracts were let for clothing, shoes, and food supplies. After some stressful and occasionally amusing incidents, the situation began to sort itself out.

Goodale Park had become Columbus's first city park after the land was donated by Dr. Lincoln Goodale in 1851. It sparked a movement north of the railyards as it became a fashionable place to live near the newly constructed Capital University at Goodale Avenue and High Street. Now it was taken over for military use. Renamed Camp Jackson, it became a mobilization and training center for thousands of Union volunteers. A local newspaper described the scene:

> The gates of the high picket fence are guarded by sentinels who keep back the baffled and impatient crowd which surges to and fro from morning until night. and only now and then gets an eyeful of the inside by looking through the palings. The white tents are pitched in the plain in the center of the park beneath the yet leafless trees. . . . Wagons are continually coming and going and the camp is strewn with straw from a stack brought thither for bedding.

> All the faces are resolute and there is fight in them; some are gay—some are grave—as the temperament is, but all are determined. Physically the troops are of good size and in good condition; and having courage and muscle, a week's drill will fit them for active service.

To the chagrin of local residents, most of the mature trees in the park were cut down, but at least the problem of where to put people was solved. But only temporarily. In July of 1861, an army of poorly equipped and even more poorly trained Union soldiers marched south from Washington to meet the rebels. Led

by Columbus native General Irvin McDowell, the army fought bravely and reasonably well but was defeated. In the wake of this loss, the government realized that the war was not going to be short or painless. In calling for more men, it soon became clear that Camp Jackson was going to be inadequate. A new camp, named for Ohioan Salmon P. Chase, opened in June along Broad Street several miles west of the city. Soon it became home for more than 26,000 Union troops and one of the major Union army posts in the country.

Camp Chase was not the only Union army encampment in central Ohio. As the war continued, other posts were opened as well. Tod Barracks, an officers' dormitory, was opened along High Street near the railyards. Major encampments were made in what is now the University District and Clintonville and in adjacent counties as well. By 1864, the major training center for U.S. Colored Troops was located in nearby Delaware. On the farm owned by the Robert Neil family, the army established a post that would come to be called Columbus Barracks and later Fort Hayes. The Shot Tower in the middle of that site is one of the major surviving buildings in Columbus from the Civil War period.

Of all of these posts, Camp Chase was by far the largest and most elaborate. Perhaps for that reason, it was the site chosen in 1862 to house a Confederate prisoner-of-war camp as well. Built to house 2,000 prisoners, by 1864 it held more than 9,000. Of these, 5,000 died there from hunger, disease, and exposure and more than 2,000 of them are still buried there in one of the largest Confederate cemeteries in the North.

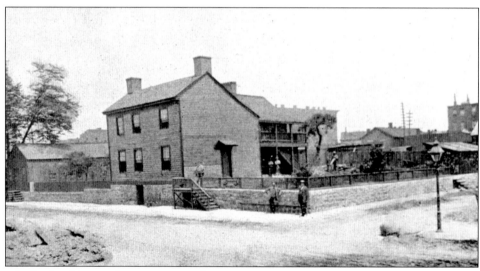

The boyhood home of Irvin McDowell became something of a shrine in the early days of the war when most citizens were understandably proud of the success of a local soldier. The house stood at the northeast corner of Spring and Front Streets, where the YMCA is today. The picture was taken much later but shows us what a nice residential street this was when McDowell was a child in the 1820s. (Columbus Metropolitan Library.)

Camp Chase was established in 1862 as a mobilization and training center for the Union Army. Located 5 miles west of Columbus on the National Road, the camp ultimately housed 26,000 troops. This made it a likely place to put a prison camp. (Columbus Metropolitan Library.)

Across the United States more than 600,000 had died. Of all of the causes of death, disease was a more frequent killer than gunfire. Living in close proximity to one another with inadequate food and clothing and often non-existent medical care, many soldiers died of infections that were eminently treatable even at that time. In a country of only 30 million people, more than 1 million men had been killed or wounded. And this did not count losses sustained by civilians in or out of the line of fire.

Often our most vivid accounts of the war and its local effect are of the human dramas that were played out through this long and difficult struggle. These dramas were many and diverse:

> Yesterday (June 19, 1863) a company of colored recruits marched through our city to the music of fife and drum. In the afternoon they assembled on the Eastern Terrace of the capitol to the number of sixty five, formed in line and dispatched their recruiting officer to His Excellency, The Governor, with a request that he address them. The Governor complied and was received with much enthusiasm. In his speech he gave them some good advice and said he had no doubt from present indications that in twenty days a full regiment of colored troops would be reported at headquarters.

This regiment was ordered to rendezvous at Delaware and eventually had its name changed from the 127th Ohio Volunteer Infantry to the 5th United States

Colored Troops. The 5th USCT went on to become one of the more notable and decorated units of the war.

In mid-1863, the threat of invasion had become quite real. General John Hunt Morgan led 2,000 Confederate cavalry on a rapid incursion across southeastern Ohio. Morgan's Raid accomplished its objective in drawing away Union troops from General Robert E. Lee's invasion of the North. Cut off and unable to return to the South, Morgan surrendered and what remained of his force was brought to Columbus. The enlisted men were placed in the Camp Chase prison camp. Morgan and a number of his officers were housed in the formidable Ohio Penitentiary. It took Morgan and his men a little more than six months to stage one of the truly great prison breaks in American history from the "escape-proof" prison.

After discovering an air shaft running under the supposedly escape-proof cells and making connections with friends and sympathizers on the outside, Morgan and 13 of his men negotiated the tunnels, scaled the walls, and made their escape. Morgan and one companion split away from the rest of the men and showed Morgan's usual bravado in completing their escape. Walking boldly into the train station in fresh clothing, Morgan boarded the train and purposely sat next to a Union officer. An account written many years later noted, "As the train pulled out, the officer said, 'That, sir, is our penitentiary, and just now, you know, it is the residence of the famous John Morgan.' 'Indeed, it's there, is it?' responded Morgan. 'Well, let us drink to the strength of its walls!' And pulling from his breast pocket a flask of old whisky, the officer joined in the toast."

The impression one might get from all of this Union Army activity is that Ohio was overwhelmingly a Union state throughout the war, but it was not really.

As the war dragged on, Union general after Union general fell in defeat to the Confederates and the number of men needed to fill dwindling army ranks grew. In the fall of 1862, the government instituted the draft. This was not well received by many people who saw wealthy persons able to avoid the war by sending substitutes or paying a bounty. In places as diverse as New York and the farm towns of eastern Ohio, armed opposition to the draft arose.

There were many persons who actively opposed the war from the time it began. Across the Midwest, a variety of secret organizations with quixotic names like the Knights of the Golden Circle met to plot resistance to the government. Generally called Copperheads for a copper penny used as an identification token, the militant opponents of the war had little if any effect. Political opposition to the war was more formidable. Clement Valandingham was an articulate opponent of Lincoln and the war until his banishment to the South in 1864. In Columbus, veteran publisher Samuel Medary published an antiwar newspaper called *The Crisis* until outraged Union soldiers stormed his office and shut it down.

On April 9, 1865, General Robert E. Lee surrendered his tattered but proud army of Northern Virginia to the armies of Union General Ulysses S. Grant at Appomattox Court House, Virginia. Although the last shots of the war would not be fired for several weeks, to most Americans, the end of the war had come. Large

celebrations in Columbus and across the North lasted for days and only ended when word came of the April 14, 1865, shooting of President Abraham Lincoln. From almost rapturous joy, the city and the country plunged into grief. For 22 slow and mournful days, the Lincoln funeral train moved across the country, taking the slain President back home to Illinois for the last time.

When the train arrived in Columbus, Lincoln was brought to the Statehouse for one last time on a catafalque drawn by a team of six matching white horses. In the Statehouse Rotunda, the casket lay open for a day.

> Many scenes during the day were affecting and impressive, but to chronicle them would fill a volume. All felt the sorrow and countenance and mirrored it with striking plainness. Thousands of persons stood in line on High Street, four abreast, the lines extending in either direction north from the West Gateway to Long Street and south from the West

When word reached Columbus of the death of Abraham Lincoln by an assassin's bullet, the town immediately fell into mourning. Here we see the First National Bank on the day after news reached Columbus of the assassination. (Columbus Metropolitan Library.)

Gateway to Rich Street, patiently awaiting their opportunity. For more than six hours a steady stream of humanity poured through the channel all eager to gaze at the martyred President.

During the time the Lincoln funeral was in Columbus, more than 50,000 people passed by the open casket in the center of the Statehouse Rotunda to pay their last respects to the man who had already passed from history into legend.

The war had begun in the spring and ended in the spring. With its passing, Columbus and the country had seen one world end and a new one begin. For Columbus and Ohio, the new time would be a time of growth as well.

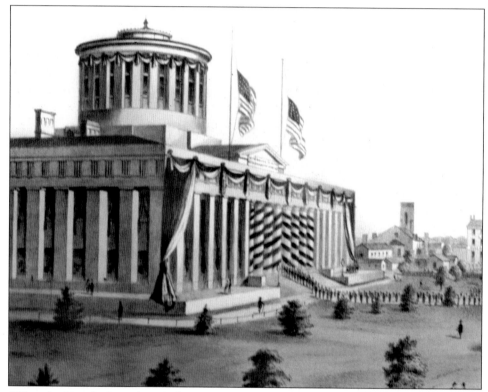

When the Lincoln funeral reached Columbus in 1865, thousands of people came from all over central Ohio to pay their last respects. More than 50,000 *people spent most of the day waiting in line for one last glimpse of the martyred leader. (Columbus Metropolitan Library.)*

7. The Buggy Capital
of the World

By April of 1865, Columbus had been greatly changed. The small town of 18,000 people more than doubled in size throughout the war. Large businesses had been formed to supply the Union armies and, most importantly, a government supported railroad construction program had greatly increased the railroad network. By war's end Ohio had one of the most sophisticated rail networks in the world. Also underway was a transformation as remarkable in its own way as the one that had earlier moved the city from a small isolated frontier village to a major center of transportation and trade. This change was called the Industrial Revolution and it was happening all across America.

Most of us are aware of the rough outlines of that revolution. By the end of the nineteenth century, the United States had emerged as the strongest single economic power on Earth. Its factories were making more steel, more machines, and more goods of all kinds than most of the rest of the world. Its agriculture had become mechanized, and the United States was feeding not only itself but a lot of the rest of the world as well. Americans were now an urban people as well as a rural nation, although more people still lived in rural areas than urban and would until the 1920s.

Along the way we changed as a people as well. We came from more places and spoke more languages. The differences between rich and poor were greater, and between the two was a new class—a middle class—that did not really exist in its modern form until the rise of the city. When the disparity between rich and poor and manager and worker became great enough, new movements to organize workers into unions sparked conflicts between those who favored them and those who saw them as another evil on the land.

Columbus, like many other medium-sized Midwestern cities, was extraordinarily successful in the years after the Civil War in making itself part of the new economy and society that emerged. Writing for *Harpers* in the late 1880s, a local resident named Deshler Welch described what the city had become:

> There are also in Columbus various other manufacturing enterprises—there are 365 in all. . . . There are thirteen iron foundries,

Prior to the Civil War, the riverfront had been a busy storage area for canal boats. Many frontier period homes were still located on or near the river. This all changed after the Civil War. By 1888, when this picture looked north from the State Street Bridge, the entire riverfront was a factory and warehouse district and the river an open sewer. (Columbus Metropolitan Library.)

two malleable iron works, a steel rail mill, a rolling mill and twelve galvanized iron works. Almost every convenience of ordinary use to be obtained can be found of home make. The facilities for this are almost unequaled, and the trade has extended largely abroad. . . . Most of the business buildings are large and substantial, ornamenting the streets upon which they are located.

Some of the things Columbus residents did were successes of national and international significance. Others showed the folly of standing at the precipice of success and reaching just a bit too far over the edge. Their examples are useful even now to see how close is the boundary between success and failure and of how the Industrial Revolution worked in towns unlike New York where most Americans lived. Let us look then at some of these people and the enterprises they fashioned.

SOME EXEMPLARY FELLOWS

Tunis Peters came to Columbus in 1830 and eventually settled with his family along a swift flowing creek that passed through a rather precipitous ravine south of Mound Street where Interstate 70 passes today. In time, the Peters family took the creek and made it their own so much that it came to be known as Peters Run.

Tunis Peters was a tanner and leather worker. He taught his trade to his sons, and they made a nice living as well in the years leading up to the Civil War. With the passage of time, a lot of their trade began to focus on the leather accouterments needed for the carriage industry: dashboards, seat covers, fold down tops, and so on. Like most entrepreneurial types in that period, two of the heirs of Tunis Peters—Oscar G. and George M.—dreamed of a way to make their fortune in the leather trade, the carriage trade, or both. But like many skilled craftsmen they lacked the vital chemistry of how to make a good business a truly great one.

Enter C.D. Firestone. Firestone had had an interesting career in a variety of businesses but was always looking for the line of work that would make his fortune. In Columbus he found it with the Peters brothers. Firestone realized Columbus had several advantages that others had not exploited. The sophisticated net of railroads created by the Civil War had reduced the actual costs of transportation of many goods. Furthermore, the opening of the Hocking Valley Railroad in 1870 meant that the immense coal, wood, and iron resources of southeastern Ohio could now be made available to Columbus businesses.

If one had a cheap source of all these resources and cheap labor to boot, one could make a quality product a lot cheaper than the competition. And what would

The largest single company in Columbus after the Civil War got its start as the Iron Buggy Company in this modest building at Hickory Alley and High Street in 1875. The company evolved quickly into the Columbus Buggy Company. (Columbus Metropolitan Library.)

that product be? It would be buggies. Beginning in 1875 as the Iron Buggy Company in a little High Street frame shop where Nationwide Insurance is today, the firm soon adopted the name by which the world would know it: the Columbus Buggy Company.

By the turn of the twentieth century, the Columbus Buggy Company was the largest buggy company on Earth. Employing hundreds of men in its extensive factories near the Ohio Penitentiary, the Columbus Buggy Company was one of the largest single manufacturing businesses in the city. It made its fortune by making buggies for everyone, rich, poor, and everyone in between.

The company was, in a few words, quite successful. A sales brochure proclaimed this success:

> Their sales, amounting to about $50,000 in the first year, have increased until they now reach the sum of about $2,000,000 per annum on an active capital of about $1,000,000. The products of their great factory are now exported to nearly all of the countries of the world. They employ over twelve hundred persons and have facilities for producing about one hundred vehicles and fifteen hundred carriage dashes per day. Their semimonthly payroll amounts to about $150,000.

Seeing the fortunes to be made with buggies, by 1900 another two dozen buggy companies of various sizes formed in the city. Among them, these companies made roughly one of every six buggies made anywhere. Running night and day, the factories cast a strange glow across the riverfront that mingled with the smoke of the factories, prompting at least one observer to note that the town seemed never to sleep "and even the river smoked."

So whatever happened to the Columbus Buggy Company? Certainly a company that big should have made the transition to the automobile. The company tried to do just that. But unlike buggies, which used a lot of iron, wood, and leather, automobiles used mostly steel. The factories closest to the sources of steel—cities like Detroit and Chicago and Cleveland—had a competitive advantage that landlocked cities like Columbus did not have. That competitive advantage, combined with the extensive damage caused by the flooding of nearby rivers, spelled the end of the Columbus Buggy Company before the beginning of the First World War.

Competitive factors played a large role in most Columbus businesses of any size. But in some industries, other factors intervened as well. Breweries are a good example. There had been breweries in Columbus since the 1830s. Large numbers of Germans arriving as the Ohio Canal and National Road were completed led to the construction of breweries to quench the thirst of immigrant communities. Most of these breweries were quite small and specialized. Beer in those days was unpasteurized and did not last long or travel well. By the time of the Civil War, a number of the smaller breweries had failed or merged with others. The survivors settled along South Front Street just west of the German neighborhood and

By 1900, the Columbus Buggy Company was in this giant factory complex and was the largest buggy company in America. Columbus was the home of no less than 22 other buggy companies and the town made one of every six buggies made anywhere. Columbus was the "Buggy Capital of the World." (Columbus Metropolitan Library.)

outside the city limits. Names like Hoster, Schlee, and Born came to be identified with the brewing business—a good business but not a great one.

All of that changed in the 1880s and 1890s with the forming of the Columbus Consolidated Brewing Company. Pasteurization and the rise of refrigerated rail cars meant that successful local brewers could now become national brewers, and many of the brewers we recognize today—Anheuser Busch, Miller, and so on—expanded their markets in this period. The Consolidated tried to do the same but did not quite make it. There were several reasons for the Consolidated's lack of success. One was the inability to obtain sources of supply and finance as expansive and diverse as the other regional contenders. One must also consider that the movement as opposed to drinking as the breweries were in favor of it had its heart in Ohio. The Woman's Christian Temperance Union was formed in Ohio, and the Anti-Saloon League of America, the most powerful prohibition lobby in America, was formed in Columbus and based in nearby Westerville for years. In the end, only one of the local breweries, August Wagner, survived. Pioneering a light beer called Mark V, the Wagner Brewery lasted until 1970 when it was bought out by a Pittsburgh brewery. Its Augustiner and Gambrinus labels still survive in that market.

While some businesses rise and fall on the basis of economic and social factors, others simply are made and broken by the force of personality of the people who made them. Peruna is a case in point. Dr. Samuel Hartman, a successful surgeon,

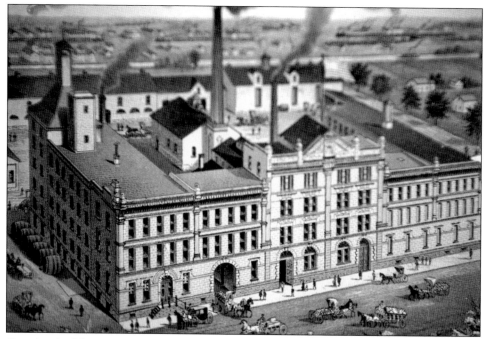

Brewing had been an important Columbus business since large numbers of Germans and Irish had begun arriving in the 1830s. But in a time without pasteurization, most breweries were small. All of that changed in the 1890s. Refrigerated rail cars made regional brewing a big business. And places like the Born Brewery, shown here, did quite well. (Columbus Metropolitan Library.)

came to Columbus in the 1880s and opened an orthopedic surgical hospital with reasonable success:

> The treatment rooms occupy the entire second floor of a four story brick building, seventy by one hundred feet. . . . A set of the latest improved mechanical and massage movement cures operated by steam power is in constant use by many patients under his treatment for paralysis, deformities and other ailments. Connected with his treatment room, he has a large three story brick building for the exclusive use of patients under his treatment.

But Dr. Hartman dreamed of greater success. As he later told the story, in one of those dreams, the ghost of a long dead Indian chief named Peruna came to him. For reasons not fully clear, the ghost decided to share with Dr. Hartman, and Dr. Hartman alone, several important truths. The first of these was that most of the diseases afflicting mankind were attributable to catarrh or congestion. Most of us are aware of congested sinuses or chest congestion. But the chief also said there could be congestion of the brain, congestion of the liver, congestion of the

88

kidneys, and so on. More importantly, the chief also revealed the formula for an elixir that would cure these ailments.

Dr. Hartman immediately made up a batch of the medicine and began selling it to his friends, asserting that two bottles would cure most of whatever ailed one. This ameliorative effect should not be too surprising since Peruna was found to consist mostly of alcohol and diverse colorings and flavorings. Hartman's medicine was popular and made him some money, but the business did not take off until Hartman received an order from El Paso, Texas, for a whole train car of the stuff. Wanting to meet whoever could sell Peruna this well, Friedrich Schumacher, a German immigrant and one of the truly inspired marketers of his generation, made the acquaintance of Dr. Hartman.

Ultimately Schumacher would settle in Columbus, mastermind the sales strategy for Peruna, and marry the boss's daughter. Schumacher pioneered many of the marketing ideas we take for granted today—paid testimonials by prominent figures, free samples, and saturation newspaper advertising, to name a few. In 1906, the federal enforcers of the newly passed Pure Food and Drug Act informed Dr. Hartman in so many words that he would need to either change his formula or open a liquor store. He changed the formula. Here is the most interesting part of this interesting story. Even after the formula was changed, the medicine

Dr. Samuel Hartman was a successful practitioner of orthopedic medicine when he came to Columbus and opened an office and hospital in the 1880s. Later the doctor made a fortune marketing an elixir called Peruna, whose secret recipe it was said was revealed in a dream by the ghost of an Indian chief of the same name. (Columbus Metropolitan Library.)

continued to sell well with many people claiming that it worked as well as it ever had. The concept of the placebo was seldom ever better demonstrated.

Dr. Hartman, Friedrich Schumacher, and a lot of other people made their fortunes with Peruna. Hartman bought several hundred acres south of the city. Hartman Farm became one of the largest farms east of the Mississippi, with its own rail line and its own power plant. In downtown Columbus, Hartman built, among other things, the Hartman Hotel, which still stands, and the Hartman Theatre, which does not. Dr. Hartman was often reviled nationally, but in Columbus he was generally admired. He gave a lot back to his city and was always particularly helpful to the poor and needy. And he was, by all accounts, a nice man. All of this simply goes to show that when a Native American speaks in one's dreams, it probably pays to hear him out.

While all of this was happening in the years after the Civil War, a number of important businesses came into being as well. More importantly, the focus of industrial activity was moving. The original factories, mills, and warehouses of the city had been located along the Scioto from the penitentiary south to where the Cultural Arts Center stands today. The expansion of downtown combined with the need for large amounts of space by industry eventually forced large businesses to the fringes of the city. Along the rail lines leading north and east of the city, a

The center of Dr. Samuel Hartman's business was his surgical hospital on Fourth Street between Main and Town Streets. Other buildings soon followed, including a larger hospital, a manufacturing plant for Peruna, and later a theater on Statehouse Square. Dr. Hartman's farm south of the city was one of the largest in the eastern United States. (Columbus Metropolitan Library.)

number of factories sprang up near the railyards. These included companies like the Kilbourne and Jacobs Manufacturing Company, makers of farm equipment, and the Jeffrey Manufacturing Company, maker of coal mining machines.

South of German Village, a whole new industrial complex began to be built that would eventually include steel mills and a large glass factory. One of the steel mills, Buckeye Steel Castings Company, was presided over by Samuel Prescott Bush, a man who posthumously earned the distinction of being the grandfather of one American President and the great-grandfather of another.

The business leadership of the city was changing as well. The earliest leaders of the business community had made their money in land, in transportation, and in agriculture. The families of men like William Neil, Lucas Sullivant, and David Deshler were still active in law, real estate, and banking. But a new set of powerful business leaders was emerging as well—men like Firestone, Hoster, Hartman, and Jeffrey, whom we have already met. On the fringes of greatness, as is always the case, were the beginnings of several other businesses, like the F&R Lazarus Company, about which we will hear more later. While all of this was going on, a movement of a different sort was underway. Laboring people were beginning to organize.

THE MARCH OF LABOR

Today it may seem to many of us remarkable that so many people put their jobs on the line and participated in strikes against the companies who employed them a century or so ago. This was done when people knew that most strikes were not only illegal but often failed miserably. What would cause people to risk so much when the odds against success were so high? The simple answer is that, for many American laboring people, working conditions were nothing less than abominable. Men, women, and even small children worked 10–14 hour days, six days a week, in dark, dirty, dangerous places that could maim or kill one very quickly and easily. And all of this was done for a few dollars a day.

It was in this context that the modern movement toward organized labor began. There had been unions of one sort or another—trade assemblies, guilds, and so on—since the Middle Ages. Many of these mutual benefit organizations of professionals and tradesmen had been brought to this country with immigrants from Europe. But most businesses successfully resisted efforts to organize. The biggest single business in America in the 1870s and 1880s was the railroad industry. It employed more people, bought more steel, and owned more equipment than many of the major nations of the world. So when the railroad workers struck in 1877 at the nadir of the 1873 depression, one could almost assume it would be serious. Striking simultaneously and violently in most major American cities, the railway unions virtually shut down the system and the nation with it.

Responding to violence in Columbus and other Ohio cities, former governor and now President Rutherford B. Hayes ultimately called out the army to keep

the railroads running, and the strike was suppressed. This was the first great strike in the city's history. It would not be the last. Over the years, Columbus developed a reputation as a town that was not terribly pro-labor but not viciously repressive either. With a good railnet and excellent location, Columbus became a place where labor met to organize. Thus in December 1886, a number of such groups met in Columbus. The event was noted by a local newspaper:

> The sixth annual congress of the Federation of Organized Trades and Labor Unions of the United States and Canada was called to order by President Gompers in Druid's Hall on South Fourth Street, at noon yesterday. . . . President Gompers returned the thanks of the Congress for the cordial welcome, referred to the mistakes of organized labor in the past, the good it had done and the purposes for the future. He discussed the eight-hour law, the struggles of the past year, and urges [sic] harmony in all meetings and cooperations.

The result was the American Federation of Labor. Four years later, the United Mine Workers of America formed in Columbus as well. Over the succeeding decades, a number of other powerful labor organizations gained strength and support from Columbus workers. For all of this dissension and difficulty, in the summer of 1888 an event occurred that brought the city together and gave it for a time the thing it had sought for the first 75 years of its history: an image of itself.

THE GREAT ENCAMPMENT

In the summer of 1888, Ohio celebrated the centennial of the Northwest Ordinance of 1787—a little late perhaps, but ebulliently nonetheless—with pageants, parties, and presentations around the state. One of the most elaborate of these was scheduled to be held in Columbus during the Ohio State Fair. Then as now, the Ohio State Fair was a very big thing. Held in various locations since its founding in 1851, the fair settled in Columbus in what is now Franklin Park until 1877 when it moved to its present location at Interstate 71 and Seventeenth Avenue. Always a major summer attraction, the fair in 1888 promised to be rather impressive.

This was appealing in a patriotic way to the Grand Army of the Republic. The GAR was the Union Army veterans' organization and a powerful lobby for veterans' rights and whatever other issues its members felt were important. In the summer of 1888, the GAR wanted to hold its biggest reunion since the end of the war. Ultimately, it decided to hold it in Columbus right after the end of the fair and centennial. And about 250,000 people would be attending. Once the people planning the event in Columbus recovered from the joy of hearing that the GAR (and a lot of money) would be coming, their elation was replaced by stark terror with the realization that 250,000 people would arrive in a town of a little more than 80,000 residents. By way of comparison, today's equivalent

Several major labor organizations were founded in Columbus because many members lived in the region and the city was easy to reach by rail. The American Federation of Labor was founded here in 1886. This plaque remembers the 1890 founding of the United Mine Workers of America in Columbus City Hall, which stood on the site of the Ohio Theatre until 1921. (Author's Collection.)

would be 3 million people arriving in Columbus and expecting to stay for a week or two.

As one might imagine, hotels simply were not going to be able to accommodate everyone. The answer was a series of tent cities that ringed the downtown and let the aging veterans camp out one more time with their friends while their families "roughed it" in tent cities of their own. The highlight of the GAR encampment was a grand parade of Union veterans down High Street. It was the largest parade since the Grand Review in Washington in April 1865. And there would never be a larger one again. It was one of the great moments in the city's history. A Cincinnati paper, not known for its partiality to Columbus, was positively rhapsodic:

> It was a perfect day. Not a cloud obscured the sun, which beamed benignly, and not too warmly, on the devoted heads of the fifty thousand patriots. Such delightful weather contributed greatly to the numbers and success of the parade. The arrangements for the affair could not have been more complete, nor more admirably carried out. Among the vast crowds of men, women and children, there was no disorder, confusion or accident. The citizens of Columbus proved themselves equal to the occasion, and no city in America could have managed an affair of such magnitude with more smoothness and order. All estimates agree that there were as many old soldiers in the city who did not take part in the parade as there were on the line of march.

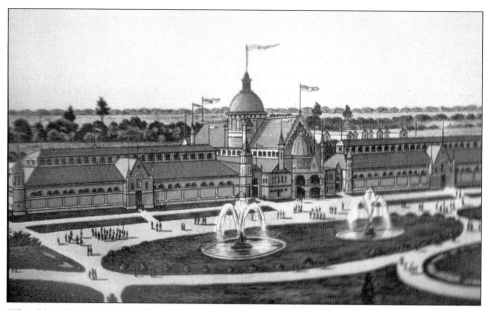

The Ohio State Fair moved around to several different Ohio towns until it settled permanently in Columbus. Outgrowing its first home at what is now Franklin Park, it moved to its present location along the railroad near between Eleventh and Seventeenth Avenues. This view shows the fairgrounds in the late 1880s. (Columbus Metropolitan Library.)

One of the things that made it so perfect were the arches. Every half block or so along the line of march on High Street was a wooden arch that spanned the street. Decorated with flags, bunting, and ribbon, the arches formed a triumphal processional avenue for the marching veterans. To add to the effect, each arch was furnished with a series of gas light fixtures that illuminated the streets.

Other than being a unique tribute to the GAR, the illuminated arches served an important practical purpose as well. Previously, the only streetlights in Columbus had been oil lamps mounted on poles at the major intersections. Lit in the evening and extinguished in the morning by a lamplighter, the oil lamps had been better than nothing but not by much. Until now, the streets of Columbus had been poorly lit, and one traveled on such streets after dark at one's peril. If the potholes did not do damage, the thieves and worse who hid in the alleys might. Now, at least along High Street, the night was lit as brightly as the brightest day. Crime rates fell precipitously during the stay of the GAR.

After the GAR left town, there was enormous public pressure to keep the arches and the safe streets they provided. So they stayed. When the streetcar companies later consolidated and converted from horse power to electric power, a way to string wires to provide that power was needed. The wooden arches lit by gas were replaced by metal arches lit by electricity. By the time this happened in the 1890s, Columbus was already known as the Arch City, and it would stay the Arch City for more than a generation. It was not until 1914 that city leaders decided that the

time had come to replace the arches. They were taken down and replaced with cluster lights.

For more than 25 years, Columbus presented an image of itself to the world that was not simply that of a capital city or a Midwestern city. We were the Arch City and a very special place indeed. Many years later, an aging lady recalled what downtown looked like on a rainy spring night when the wet streets reflected the lighted arches and up the street silently came the express streetcar Electra. Hung with looping strands of electric light bulbs, the Electra featured a large, five-pointed star on its front lit by electric lights and visible from many blocks away. It was, she remembered fondly, "almost like a fairyland."

High Street had become a street of dreams, but it was not the only street to do so. In 1888, William G. Deshler, the son of banker David Deshler and himself a banker, visited Havana, Cuba. Impressed by the tree-lined boulevards, he returned to Columbus and made the city an offer: if the city provided land along Broad Street, he and his friends would provide the trees to fill the space. The city did what it was asked, and William G. Deshler did what he had promised. For the next two generations, Broad Street east of Fourth for many blocks was lined with four rows of trees. There were two lanes of traffic and then a row of trees on each side followed by a service lane on each side of the street and then another row of trees along each curb. It came to be called Judge's Row and was, above all other streets, the Victorian Dream Street of Columbus, Ohio. Now Columbus was a new city, an Arch City, and not the small town it had once been. All could agree that it was a different place indeed. How different was soon to be discovered.

Probably the biggest single event in late 1800s Columbus was the 22nd annual encampment of the GAR in 1888. The Union Army veterans group brought more than 250,000 people to Columbus, a town of about 90,000. The people were accommodated in tent cities like Camp Neil at what is now Fort Hayes. (Columbus Metropolitan Library.)

8. THE ARCH CITY

Today when we look back on the 1890s in Columbus, we are met with enormous disparities. The differences between the "haves" and the "have-nots" were great and some would argue quite persuasively that they were becoming greater. But to the people who grew up seeing this great contrast between rich and poor, the real disparity in the world lay elsewhere.

When Peletiah Webster Huntington came to Columbus during the Civil War, he entered the employ of David Deshler in one of the banks owned by the cabinetmaker-turned-financier. The young man was a bright, energetic quick study and, by 1866, was opening his own bank (with some capital assistance from Deshler and his friends) near the corner of Broad and High Streets. It was a success, and in 1872 Huntington built a new bank at the southwest corner of Broad and High.

Shaped like a small castle, the banking house of P.W. Huntington and Company became something of a Columbus landmark for the next couple of generations. With aspirations to greater success, Huntington married and built a nice but not terribly ostentatious home on Broad Street just east of Trinity Church. A frugal man, as bankers often are, Huntington walked from time to time to Central Market on South Third Street (where the bus station is today) with his basket and personally bought items for his dinner table.

He walked each day to his banking house as well, stopping along the way to pick up sticks and scrap wood from the open gutters along the side of Broad Street. When he reached his office, he used most of the wood in his iron stove. But he always kept a few pieces to whittle on while he sat on his front steps and waited patiently for customers to favor him with their business. P.W. Huntington was a friendly fellow. By 1890, Huntington sat on the steps of his bank occasionally just to say that he did and to catch a bit of the city's pulse, but he did not do it often. By 1890, Columbus was a much different place than it once had been. The population had increased for three straight decades after the Civil War. The little Civil War village of 18,000 in 1860 now held almost 90,000 people in 1890.

These were the changes that people like P.W. Huntington and the pauper who paused to ask him for a bit of money when he was done whittling probably would have found more troubling than their own differences with each other. The fact

of the matter was that the pace of growth in Columbus actually declined somewhat in the 30 years following the Great Encampment of 1888. Population growth averaged "only" 40 percent or so at this time. But few people really saw it that way. As the population reached 125,000 in 1900, 181,000 in 1910, and 237,000 in 1920, most people saw Columbus as a successful place getting simply bigger and bigger. With this growth and success were coming a number of concerns that would not go away. Eventually they would have to be confronted. And they were. But confrontation is not necessarily resolution, as we shall soon see.

A WORLD MOVING LIKE THE WIND

By the 1890s, the city was growing spatially at a very rapid rate. The boundaries of the city were stretching out to well beyond the 2-mile ring one might draw on a map. To the north, the city approached and then passed by The Ohio State University campus while to the south, the boundaries were reaching the new industrial district arising south of German Village. To the west, the city had absorbed the frontier village of Franklinton and was marching toward the Hilltop where state institutions had fled in the 1870s. To the east, the city was expanding toward Alum Creek and the fashionable new neighborhoods that had grown up along Broad Street and around Franklin Park.

By 1879, P.W. Huntington was doing well enough in the banking business to be able to buy the southwest corner of Broad and High Streets, where he built a distinctive castle-like banking house. By the time Huntington died in 1925, this bank had moved down the street a bit to a building it still uses as banking offices. (Columbus Metropolitan Library.)

What was causing all of this? More than anything else, the streetcar was the cause. Through all of the growth and change of the nineteenth-century industrial revolution, Columbus had still stayed predominately a walking city. That is, people walked to work, to church, to market, and to play in the park. All sorts of people walked. Rich people like P.W. Huntington walked the same as the working people who labored in the factories along the river. This is not to say that people never rode. There were private carriages on the streets all the time as well as local jitney coaches that could bring people from the train station to downtown. Since 1863, there had even been a horsedrawn streetcar line on High Street. Soon, other streetcar lines followed, and by the 1880s many of the main streets of the city were carrying streetcars. The streetcars were hot in the summer, cold in the winter, and moved at about the same pace as a person walking. Sometimes they moved even more slowly. But they did change the way the city of Columbus looked and the way it worked.

Now a person of even modest means could live somewhere other than a block or two from where he or she worked. A working person could live away from the noise, smoke, and dirt of the downtown factories and in a neighborhood with trees and grass like more prosperous people were wont to do. So people began to move. The 2-mile limit was about the maximum for the horsedrawn transportation of the post–Civil War era, but it was enough to cause a revolution in how we lived and worked.

Then, in the early 1890s, the world changed again. The streetcars were electrified. Now the streetcars could move significantly faster and cool the cars as they moved in the summer. The heating in the winter was more efficient as well. Most importantly, the 30 minute journey to work could now carry one 3, 4, or 5 miles from the heart of the city. Whole new "streetcar suburbs" developed.

One might imagine that a technological innovation as transforming and beneficial as this might come with a price. Like many occupations of a century ago, the life of a streetcar worker was not all that pleasant. Streetcar motormen, conductors, and other employees worked extremely long hours in all sorts of weather for relatively low pay. The reasons for the low pay were that the job was not terribly complicated and streetcar workers could be replaced rather easily. But as the system got bigger, it became not only more vital to the city, it also became more easy to obstruct. In the summer of 1910, a newly formed streetcar workers' union proved just how fragile the system had become.

Striking for pay and benefits, the union took to the streets. Efforts to resolve the differences by local government and civic leaders did not work, and the strike soon became quite nasty indeed as tracks and empty cars were dynamited. In desperation, the city asked the governor to call out the National Guard, and the governor agreed. The enduring image of the summer of 1910 to many residents was of National Guard tents on the Statehouse lawn and soldiers patrolling suburban neighborhoods in automobiles with hood-mounted machine guns.

It was the most violent time Columbus had seen since the Civil War. Eventually, the strike ended in the union's defeat, and the city returned to a

This is East Town Street in 1885. It is emerging as a street of fashionable residences. Notice that the houses are quite close together. This is a "streetcar suburb" built with the idea that its residents would take the streetcar to work and leisure activities. (Columbus Metropolitan Library.)

semblance of normality. But the image of peace was at best illusory. In the fall of 1910, the Socialists—previously considered vulgar at best and subversive at worst—polled more than 10,000 votes in city elections.

THE FRIEND AND FOES OF CHANGE

In many respects, Columbus was no different than the rest of America in the late nineteenth century. The phenomenal technological changes that transformed commerce and made us a nation of factories as well as shopkeepers also had a social and cultural price. We have already seen that the clash of workers and employers occasionally became rather violent, but there were other prices to be paid for the benefits of the industrial and urban revolution. By and large, these prices were social and cultural. Just as the Industrial Revolution created new centers of wealth and power, it also created new centers of poverty and despair.

If we look at the people of "property and standing" after the turn of the twentieth century in Columbus, we will see a number of new faces. While the social and economic elite of the city still contained the descendants of several prominent families like Neil, Deshler, and Sullivant, there were several new names as well. Many of these people had made their fortunes in the new businesses of the Industrial Age—Joseph Jeffrey in mining machines, Samuel P. Bush in steel castings, and James Hallwood in paving blocks, to name just a few.

There were new fortunes in new areas as well. Two brothers, Fred and Ralph Lazarus, took their father's small menswear store and transformed it into the

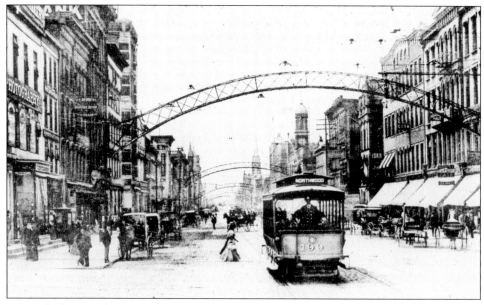

We are looking south on High Street at State Street. It is 1904 and a moment in the golden age of the streetcar in Columbus. In the background can be seen the metal arches that carried power to the streetcars and gave the city its nickname—Arch City. (Columbus Metropolitan Library.)

preeminent department store in the city. Soon it would become an organization of national significance. Another pair of brothers, Robert and Harry Wolfe, branched out from the shoe business into newspapers and built the beginnings of a media empire. Other fortunes were being made in banking, retail, and transportation as well.

The families with new money took their places in the older, established neighborhoods along East Broad Street as well as in new fashionable suburbs largely linked to downtown by railroads and streetcar lines—Grandview and Marble Cliff to the west of the city, Evanston to the north along East North Broadway, and across Alum Creek to the east along Broad and Main Streets.

As the city grew larger, so too did its poorer districts. The largest by far was a place called Flytown, located north of downtown and to the immediate west of Goodale Park. The story of Flytown is as elusive as its name. Some say the area "just flew up" to provide a home to hundreds of people. Others say the place got its name from the hordes of flies that drifted north from the stock yards and slaughterhouses along the rail lines to the south. In any case, Flytown and other neighborhoods like it—Middletown in the "Bottoms" between downtown and old Franklinton, Hickory Alley adjacent to the downtown warehouse district and the Badlands on the near east side of downtown—served as *entrepots* or entry points for dozens of people seeking a new life and opportunities in the city. Some of these people were part of the third great wave of immigration that washed across America in the late 1800s from Italy, Poland, and elsewhere in eastern and

southern Europe. But most were newcomers from rural Ohio and other states in the rural Midwest who simply came to Columbus to make the living they could not or would not continue to make from the land.

Some of the neighborhoods of the newcomers were predominately black, like the Long Street corridor from High Street east for several blocks. Others, like the neighborhoods just north of the railyards, were predominately white. However, many of these new neighborhoods, like Flytown, were racially mixed and would continue to be so until well into the twentieth century. What linked people in many of the poorest neighborhoods was not race or religion or ethnicity; it was the common condition of desperate survival in the face of all odds.

One of the people who saw this best and reflected it well was a man who was here by accident. William S. Porter had come out of the Carolinas to make his fortune in Texas. He ended up in Austin working for a bank and editing a literary paper. In the late 1890s, he was convicted (many think wrongly) of embezzlement and was imprisoned. The overcrowded Texas prison system sent Porter to serve his time at the Ohio Penitentiary. Will Porter was a model prisoner and was soon working in the pharmacy. He was permitted to take walks from time to time outside the walls. The people he met and the stories they told both inside and outside the prison became the characters of the stories he wrote while there and later. Upon his release in 1901, he went to New York, where he soon became quite well known by the name he adopted to shield his family name. He called himself O. Henry.

The world that O. Henry and others saw was a world where the odds against survival were great. In an age before antibiotics, childhood diseases like measles, mumps, and scarlet fever could literally be killers. While modern sewer and water systems had generally eliminated diseases like malarial fever and cholera, hundreds of adults as well as children still suffered from typhoid, tuberculosis, and whooping cough. And all of these diseases could be killers as well. The worst locations of these diseases were found in the poorly constructed, poorly maintained, and barely heated housing of working-class Columbus.

Complicating the already difficult problems of low- to moderate-income people in the city was the added difficulty of vice. Many people, unable to cope with the ferocity of their lives, turned to drink or worse to sustain themselves. The vicious cycle of poverty, alcohol, and vice played itself out in numerous forms in the vice districts that were often adjacent to and part of the poorer neighborhoods. Even if the resilient residents could deal with all of the problems of disease, depression, and decay that plagued these areas, there was still one other danger lurking in the neighborhoods built in many cases on low ground near the rivers. That was the danger of flood.

The Scioto and Olentangy Rivers had surpassed their banks on 11 separate occasions since Franklinton was founded in 1797. But none of these previous floods had prepared Columbus for the flood that struck the city in the last week of March 1913. Five inches of rain falling on mostly frozen ground had nowhere to go but through the 15-foot-tall earthen flood wall that had kept the worst

flooding away from low-lying areas for many years. Now the Near West Side of Columbus found itself under as much as 26 feet of swirling flood water. The entire city was shut down for six days, the West Side for six weeks, and more than 90 people died in what would be remembered as the worst flood in the city's history.

From the experience of working together, struggling together, and surviving together through this flood, many residents of Columbus vowed to do something not only about flooding but about the other problems facing the city as well. For more than a generation, a relatively small group of people had tried to find ways to cope with the increasing problem of poverty in the shadow of plenty in Columbus. Some early pioneers in the movement were community charity leaders, the direct and often lineal descendants of Hannah Neil's original work among the immigrant poor of the 1830s. Joining them was a new type of professional social worker who brought to settlement houses, like Godman Guild and Southside Settlement, the health, education, and other social services so desperately needed in these neighborhoods. Finally there was a new breed of religious leader as well. Most prominent among these in Columbus was a man named Washington Gladden. Brought to Columbus in the 1880s to serve the First Congregational Church at Broad and Fourth Streets, Gladden stayed in the city for the rest of his life.

For all of its prosperity, Columbus still had its share of slums. One of them, only a few blocks from the Statehouse, is shown in this 1908 photograph. (Columbus Metropolitan Library.)

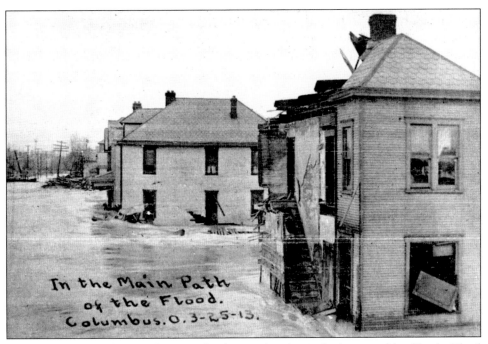

Columbus has seen flooding for most of its history, but the city had seen nothing like the Flood of 1913. On March 25, the levee broke, inundating the Near West Side of the city. The West Side was shut down for more than a month and 94 people died. It was a devastating catastrophe. (Columbus Metropolitan Library.)

The Kingdom of God, said Gladden:

> is going to take hold of the world in a way that will tell immediately and directly on the interests that are central and vital. It is going to register itself at the police court, at the city prison, at the work house, in the Council Chamber.

> Our cities are the battleground of Christian civilization; they are destined to become, more and more, the arena upon which our greatest conflicts for liberty and order and morality are to be waged.

Deeply committed to social justice and social change, Gladden always believed not only that the city could be saved but that it would be by the efforts of right thinking people. To Washington Gladden, the problem was simply getting people to think rightly from time to time. Over the years, the activist approach of Gladden and others came to be called a "social gospel," and Columbus, because of Gladden, was at the center of the movement. This by no means suggests that all churches in Columbus, or even most of them, embraced this movement. Most of the churches of Columbus were quite conservative and saw Gladden as well-

meaning but overly zealous. But enough people in enough churches agreed with Gladden to provide yet another source for change in the city.

By the early 1910s, this mixture of social reformers, political reformers, and believers in some sort of better society had become strong enough in numbers and committed enough in principle to begin to make some changes in how things were done. Committed to progress, they called themselves Progressives, and their time had come.

THE PROGRESSIVES IN COLUMBUS

Most of the people who came to call themselves progressive were committed to the American system. They were not revolutionaries out to overthrow the government or even to change it drastically. Benefiting from the success of industrial capitalism, many of the progressive reformers simply wanted to fix the system's worst problems. They optimistically believed it not only possible but likely to be able to do so. Some of the ways this might be done were rather simple in design and approach and in fact had been advocated for some time.

The women's rights movement in America is an old one and can be traced all the way back to pre-Revolutionary colonial society. In its modern form, it dates from the Seneca Falls convention of 1848 and the efforts of a number of dedicated women (and men) to build a more equal society. An impressive number of the movement's members came from Columbus. Two people worthy of mention are Elizabeth Greer Coit and her daughter Belle Coit Kelton. Spanning most of the history of the women's movement, the two fought long and hard for equal rights and specifically for the vote. The battle was joined quite early. Elizabeth Coit was once distressed to see her then eight-year-old daughter return home from school in tears. "Mother, are you strong minded and do you wear pants?" she asked. Mrs. Coit replied, "My dear, I hope I am strong minded. I should be very sorry to have had children if I were feeble-minded!"

As president of the first women's suffrage association in Columbus, Elizabeth Coit became friends with many leaders of the suffrage movement in America, Susan B. Anthony, Lucy Stone, and Frances Willard among others. Her home in Columbus was a meeting place for suffrage activists for most of her adult life. Eventually the tide of opposition to women getting the vote began to turn. By 1910, the goal of suffrage for women was tantalizingly within reach and being actively sought by a large and growing women's movement in Columbus.

Coordinated with the women's rights movement and often including many of the same people was the temperance and prohibition movement. Born as a movement to "temper" the rampant drunkenness of frontier Ohio, the battle against alcohol had slowly but surely transformed itself into a movement against any use of alcohol whatsoever. It too was a movement gaining more and more adherents in Ohio and seemed to be coming ever closer to success. By 1910, the reformers not only had a name (Progressives), they also had a program. In Ohio they found a place to test it. One of the interesting parts of the 1851

Ohio Constitution was the mandate to ask the voters every 20 years whether they wanted a Constitutional Convention or not. Since 1851, the voters had always said no.

Until now. Riding the surge toward reform spearheaded by Progressives across the state and the old and new social movements accompanying them, Ohio voters approved a call for a Constitutional Convention. Meeting in 1912, the Convention proposed several sweeping revisions to government in Ohio. Some of the proposals, like Prohibition and the vote for women, were not approved. But several new ideas were accepted. Important among them were a call for popular democracy through measures for initiative, referendum, and recall petitions and a measure granting home rule to cities. Building on this, Columbus voters approved the election of a home rule charter commission and, in 1914, approved a new form of government for the city. Since 1834, the city had been divided into wards and city council had been elected from the wards. As the city grew, the number of wards grew as well and council became larger and larger.

The plan most often advocated to replace the traditional ward system was either a city commission or a city manager form of government. In fact, today most American cities of less than 75,000 people do use one or the other of these ideas. But larger cities do not lend themselves politically as easily to these approaches. In Columbus, the compromise reached was to continue with an elected City Council but to reduce it in size to seven people and elect each of the members citywide. In this way, the political balance of the council system would be kept but the worst aspects of neighborhood cronyism would be removed. At least, that was the theory. For better or worse, and the argument still continues, it is the system in use today in Columbus.

By 1916, the tide of Progressive fervor that had swept across America for much of the previous two decades had begun to slow. Many of the reforms that had been so aggressively sought were now part of the fabric of the law and society of American life. Others, like the vote for women and the quest for Prohibition, were not yet accomplished but had taken on something of a life of their own. To many, it seemed that other issues were moving to the forefront—issues of peace and its desirability and war and its inevitability.

WORLD WAR I

To many people in Columbus as well as the rest of America, the thought of going to war in Europe of all places seemed pretty farfetched. The conflict that began in the summer of 1914 involved a series of old antagonists who had been fighting each other in one form or another for generations. Many Americans felt that a European war was simply none of our business and that, in fact, one of the main reasons a lot of people had come to America was to avoid such wars. Eventually, the United States came into the war, the Allies held out, and the American intervention spelled defeat for Germany. Along the way, Columbus, Ohio, like most of America, was changed in some important ways.

World War I was not the first war to bring America to the world stage. Arguably, the brief but significant Spanish American War had done that in 1898. But that war was over so quickly and with so little disruption that most Americans never really got that involved with it. World War I was different. From the time America entered the war in April 1917, it would be more than two and a half years before all of the Doughboy citizen soldiers returned home. In the meantime, the United States geared up for combat as it had not since the American Civil War. In fact, it could be argued that we geared up even more. For all practical purposes, the government took over the railroads and regulated wages, prices, and most citizen consumption in a way that it had not done in previous wars. Also, a conscription program with few exceptions affected more young men directly than at any time in our previous history.

To drum up support for the war and to sell the bonds to fight it, a propaganda machine also unprecedented in the American experience painted the German enemy as the devil incarnate. In Columbus, German schools and the last German newspaper were closed and never reopened. Several street names were changed in the German neighborhood to more patriotic or neutral names remaining today. In order to help build up patriotic fervor, a large pile of German books was burned at Broad and High Streets.

The simple fact was that there were not many German-Americans left in Columbus. Most of those who were left were not only loyal to the United States, they were often enthusiastically so. As a case in point, let us look at the only Columbus native whose home is listed as a National Historic Landmark. Edward Vernon Rickenbacker was born in Columbus in 1890 and grew up in a modest one-story home along East Livingston Avenue in a working class neighborhood. First as a mechanic and then as a test driver of automobiles for the Columbus Buggy Company, Rickenbacker developed a reputation as a fearless and fortunate driver of fast cars.

When the war came, this got him a job as a chauffeur for General John J. Pershing, the commander of the American Expeditionary Force in Europe. Tired of driving behind the lines, Rickenbacker yearned to get into battle. He got his wish. His 94th Aero Squadron, the so-called "Hat in the Ring" squadron, gained a fearsome reputation as a combat unit, and Rickenbacker, with 26 confirmed kills by war's end, was the squadron's and America's Ace of Aces. When Rickenbacker returned to Columbus in 1919, he was met at the train station by a host of friends and admirers and accompanied by his aging mother. A local paper noted that she was proud but not overawed by the World War I flying ace:

> To her it was not a rugged man who sat beside her. It was only her boy.
> . . . Had she not watched over him in his weakness? Why then should
> she be afraid of the great strength he possessed? Why should she tremble
> at his words, of fear the decision he might render. He could have his way
> with others. He could lord it over his opponents. But here—in this frail
> mother—was more than his master. And he felt it without knowing it.

Young, handsome, and popular, Rickenbacker idealized the end of the acculturation road that German America had followed over the previous century and stood as a symbol for what America was becoming. He would go on to a distinguished career in civil aviation and further service in World War II before his death in 1973.

By the time "Captain Eddie" returned to Columbus in 1919 for a hero's welcome, the city's population was approaching 230,000. The rate of growth had slowed somewhat in the decade since 1910, but at 30 percent it was still growing faster than most American cities. After counting itself fortunate in having missed most of the strikes, riots, and other alarums that plagued America in demobilization through the summer of 1919, Columbus was ready to settle into a well-deserved period of recovery and rest. As it turned out, the recovery was real enough, but the rest would have to wait.

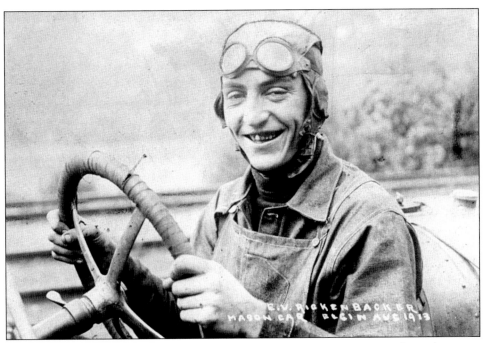

Edward Vernon Rickenbacker was the original World War I Flying Ace. He began his career working on and racing automobiles. In World War I, he learned to fly and went on to help form Eastern Airlines. (Columbus Metropolitan Library.)

9. Good Old Columbus town

George Karb was one of those people who tended to be a bit overwhelming at first impression. The son of German immigrants, he had grown up on the south side of Columbus but was about as thoroughly American in attitudes, tastes, and styles as one could be in his time. But Karb could be as German as he had to be when the situation called for it. He could be English, Irish, or Italian as well. Once, when speaking to a group of Welsh singers, he proudly sang "The Red Dragon to the Fore" in perfect Welsh to the group.

George Karb was a pharmacist, an oil company entrepreneur, and a part-time banker. Mostly he was a politician, and a very good one at that. Elected mayor from 1891–1894, Karb served as sheriff for a time as well as a city councilman. In 1912, he returned to the mayoralty and presided over Columbus's transition to home rule, city wide council elections, and an entirely new city charter in 1914. He was a good person to do the job. Not really a Progressive but not a reactionary either, Karb simply liked people, and he really liked being mayor. Striding down the streets of the city in his long black coat, wing collar, and pince nez glasses, he proclaimed "Good Morning, Colonel!" to every adult male he met, looking like a figure from the past. And since he had been born in 1858 and was old enough to remember Lincoln's funeral procession, it was fair to say he *was* from another era.

But he guided Columbus through the tumult of Progressivism, the Great Flood of 1913 and the rebuilding that followed, and served as a German-American mayor of Columbus during the virulently anti-German hysteria of World War I. At the end of it all, people still liked him a lot. It was George Karb who gave Columbus its new nickname after the arches began to come down in 1914. To everyone he met, he referred to the capital city as "Good Old Columbus Town." For most of the next generation and long after Karb's death in 1937, the name stuck.

The name stuck because it fit the place. Columbus in 1920 was a city of more than 237,000 people, but in many ways it was still more of a town than a metropolis. Coming to grips with change was going to be a major theme in the city for much of its history from this point on. As much as the city prided itself on its friendliness, neighborliness, and charm, the simple fact was that the city was changing quite quickly in the 1920s—the people, the place, and the things that happened here.

THE PEOPLE

There were many more people in Columbus than there had been a decade earlier. While the growth of the city had slowed to 30 percent from the 70 percent seen in the 1890s, almost a quarter million people lived in a city that was only about 5 miles in diameter. Many of these people were not only new to Columbus, they were new to Ohio and to life and living in any sort of American city. Some were immigrants. During the years just before and during America's entrance into World War I, more than 14,000 Italians had fled war torn Europe and shown up in Columbus. They came because a small existing Italian community had been here for some time and was ready to welcome the newcomers. Most of these people moved into the northern reaches of the old Irish district between High and Fourth Streets north of the railyards.

To the south was another new community along Long Street just east of High Street. Since the 1870s there had been a modest black commercial district. With the growth of downtown, higher rents had pushed that small black business district east so that by World War I it was located just east of the circle drives of the old East Park Place Addition. It was here in this new black neighborhood that hundreds of newcomers settled during the war. Lured by high paying factory jobs in northern industries, thousands of people, black and white, streamed north

George Karb, two-time mayor of Columbus, is shown here as he began his second term. A confident, assertive, likable individual, the mayor was a tireless promoter of the city, greeting every male he met with "Good Morning, Colonel!" (Columbus Metropolitan Library.)

seeking new lives and new opportunities. In Columbus, the black population doubled during World War I. Now a new neighborhood, the predominately black Near East Side sprang up with its own churches, theaters, stores, and other institutions. To serve the needs of this new rural black population, the Columbus Urban League was founded in 1917 to provide assistance in housing, employment, and education.

It was not an easy undertaking. Nimrod B. Allen was a young social worker hired by the League as its first general secretary. Many years later he remembered, "The work of the League in this city, especially in the early days, was work in No Man's Land." Complemented by the NAACP and the black churches, the new community began to become a force in Columbus society and politics, just as the settlement houses, community churches, and local organizations in the new immigrant neighborhoods helped the foreign newcomers adapt.

As might be expected, both in Columbus and across America, the welcome extended to the newcomers was not always pleasant. In the early 1920s, a group of eastern marketing consultants and southern traditionalists revived the moribund and almost extinct Ku Klux Klan. Revivified, the New Klan was anti-black, anti-Catholic, anti-Jewish, and anti-immigrant but 100 percent pro-American. In May 1924, several hundred Klanspersons—young and old, male and female, all hooded—marched through downtown Columbus on their way to burning a cross in a public park.

The Klan ultimately failed for a number of reasons. Several leaders of the Klan were caught with their hands in the till and other compromising places and ended up in prison. The outspoken opposition of people like conservative Democratic Ohio Governor Vic Donahey hurt the group as well. But mostly it failed because by the end of the 1920s, many people decided that marching in a bed sheet for almost any reason was really rather silly. The movement faded away, at least for a while.

Other social movements died harder. For more than 100 years, advocates of temperance and prohibition of alcohol had fought to make their views the law of the land. In 1919, they succeeded and the Volstead Act became law to enforce the Eighteenth Amendment to the Constitution. Over the course of the next 12 years, public officials and private groups valiantly tried to make a success of the Great Experiment. In the end, they too failed. But while these movements failed, others were succeeding and the city was changing as well.

THE PLACE

Columbus has been the center of state power and authority ever since it was brought into being in 1812, but the town never really had a center of its own. The first city hall was a shed behind the two-story state office building on Statehouse Square. Later, offices for city officials were built above the great Central Market at Town and Third Streets.

Tiring of competing with vegetable sales and livestock on the hoof, city officials built a reasonably useful City Hall in 1872 along State Street on Statehouse

Square's south side. It served quite well for a number of years but by the early 1920s was tawdry, crowded, and unsafe. It was so unsafe that it burned to the ground in a rather spectacular 1921 fire covered by then newspaper reporter and future humorist James Thurber.

In the wake of the fire, many civic leaders called for a Civic Center to house a new City Hall and other needed city offices. It was not a new call. Since the 1890s, a number of prominent citizens had said that the entrances to Columbus along National Road (East Main Street and West Broad Street) were not all that attractive and that something better was needed. Responding to the need for better public parks, the city paid for an elaborate City Plan in 1908.

The Report of the Plan Commission for the City of Columbus, Ohio, was issued in February 1908 in a glossy 55-page folio replete with maps, photographs, and boundless optimism. Its introduction concluded:

> The dreams were all coming true, or at least were being reduced to
> tangible form. It is notable in this connection that the Centennial of the
> establishment of Columbus as the capital of Ohio is at hand. In 1912, a
> hundred years will have passed since that event. Surely there could be
> no worthier celebration, appealing alike to state and city, than the
> realization of the vision of this city as the most beautiful and best
> ordered State capital of the Union.

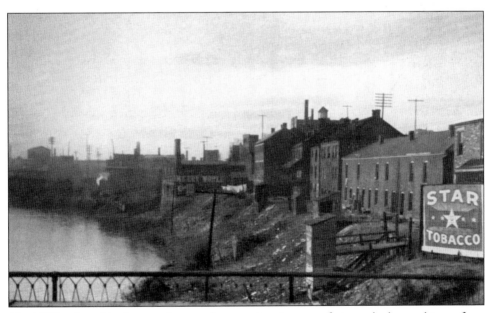

By 1907, when this photograph was taken, most major manufacturers had moved away from downtown. What was left behind was a deteriorating area of houses, stores, and warehouses that was rapidly becoming one of the worst vice districts in the city. Clearly something needed to be done with this area, and in time something was. (Columbus Metropolitan Library.)

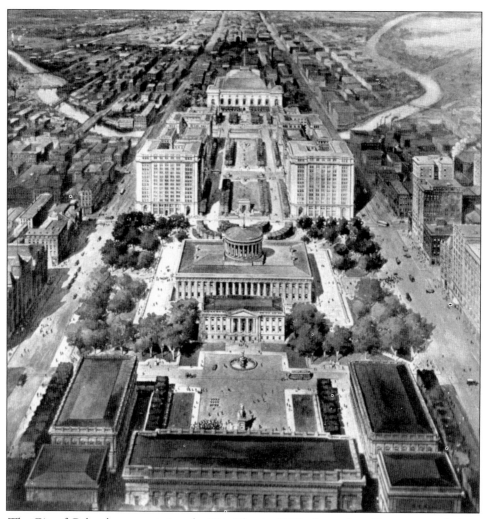

The City of Columbus commissioned a City Plan in 1908. A number of its recommendations for parks and other amenities were actually put in place. The elaborate mall proposed in this picture was never built, but it inspired what came to be called the Civic Center. (Columbus Metropolitan Library.)

The plan called for a comprehensive series of city parks, some of which were undertaken, as well as a whole new series of circumferential and crosstown boulevards, most of which would only be built much later. The plan also called for the demolition of most of downtown to build a grand mall from Statehouse Square down to and across the Scioto to other new public buildings as well. Most of this was never built at all.

But the idea of a new focus for downtown Columbus did not die. Spurred by people like architect and Chamber of Commerce President Frank Packard, a call to action continued to be made. In the wake of the 1913 flood, the Army Corps

of Engineers came to town and told the city that it could prevent future flooding by widening the Scioto as it passed through downtown. This also incidentally would remove an ugly warehouse and vice district that city fathers had been trying to get rid of for years.

The result was the Civic Center, new bridges, and a retaining wall along the Scioto between 1918 and 1921. Complementing them was a new City Hall in 1926; a new Central High School on a large levee on the river's west side in 1924; a new private skyscraper, now the Leveque Tower but originally the American Insurance Union Citadel, in 1927; and a new police station in 1930. By the time it was done, the Scioto River that had been the reason for being here at all was no longer an open sewer and was the center of the city again. While the city's core was being rebuilt, the rest of the town was also changing.

THE ROARING TWENTIES

If Columbus roared in the Twenties, it was not because of the speakeasies—of which there were several—or the "flapper girls" and their "flaming youth" boyfriends—of which there were not many and whose exploits were highly overrated. Rather it was because, like most of America, Columbus was growing rapidly in the 1920s. A modest postwar recession gave way to a period of unprecedented economic prosperity the likes of which would not be seen again for many years.

A whole new generation of automobile suburbs sprung up around the city beyond the 3- and 4-mile ring of the streetcar suburbs. Some of these new suburbs, like Bexley and Upper Arlington, were quite fashionable. Others, like Clintonville and the Hilltop, were more solidly middle class. But all of them were built around the automobile. While one could still catch a bus in these neighborhoods, they were obviously designed with the garage as an important part of the home.

Where did people drive to from these new suburbs? Mostly they came downtown. Downtown was where the best theaters were located—new, huge theaters like the Ohio for movies and the Palace for vaudeville. There were old places like the Southern and a whole strip of theaters near the Statehouse that dated back to the 1890s. If one tired of the stores, restaurants, and theaters downtown, there were always the great amusement parks—Olentangy, Minerva, and Indianola—that had been built in the 1890s but were still extraordinarily popular.

If parks and theaters were not appealing, there were a variety of other activities as well. Columbus had a zoo in one form or another since the early 1920s when a lonely set of reindeer obtained for a Christmas tableau needed a home and found one in Franklin Park. After moving from time to time, a brand new zoo opened in 1929 on city-owned land in Delaware County along the Scioto where the new O'Shaughnessy Dam had been built. It would soon prove itself a popular place for both local visitors and tourists alike.

Increasingly, the sport of preference in Columbus was becoming football at The Ohio State University. Ohio State was still relatively small in the 1920s. But its program in collegiate football had become quite popular, largely due to the legendary exploits of a young man named Chic Harley. Harley was a football prodigy. Small in size but ferocious on the field, he was a wonder to behold.

By 1922, Ohio State replaced its aging Ohio Field along High Street with a new stadium that could hold up to 80,000 people. Many thought it would never be filled. "The House that Harley Built" was filled and continues to be filled by people wanting to support the sport of preference in Ohio's capital city. And then the dream ended.

THE GREAT DEPRESSION

Looking back today, it is relatively easy to see why the downturn following the boom of the Roaring Twenties became the worst economic collapse in our history. Essentially, the average American was not aware of how important he had become to the economy's success. Although it did not lessen the pain of the collapse when it came, the average manager, proprietor, or partner in most of America's businesses was not much better enlightened.

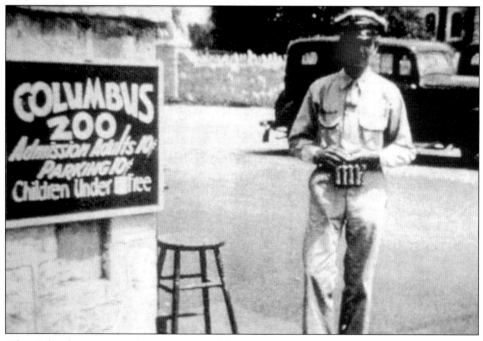

The Columbus Zoo was housed in several locations until it found a permanent home on city land near O'Shaughnessy Dam in 1925. This picture showing ticket taking at the main gate was taken a few years later. The zoo is known for a number of zoological firsts and for its reputation as a regional attraction. (Columbus Zoo.)

Chic Harley played electrifying football for both East High School and The Ohio State University. Drawing large crowds, Harley's popularity pointed out the need for a new stadium at OSU. The stadium was completed in 1922 and was called the "House that Harley Built." (Columbus Metropolitan Library.)

When an economic downturn began in the mid- to late 1920s in agriculture and certain key industries, most observers thought that the rest of the economy was healthy enough to carry the country along. And contrary to popular belief, the economy stayed relatively strong even after the great stock market crash of 1929. But the overextension of credit to both businesses and consumers, the increasing linkage of various world economies and currencies to that of the United States, and a lack of understanding of how critical consumer spending was to economic health led to a drastic economic slide in 1931 and 1932.

The welfare system—state and local in its traditional form—collapsed under the weight of unprecedented unemployment, as high as 66 percent in some American industrial cities. As communities geared up to provide assistance to out-of-work Americans, it soon became clear that private charity and limited government assistance was not going to be enough. Selling apples on street corners and offers to work for a meal soon were found to be insufficient when most of the people who might buy an apple or offer a meal were also out of work.

Over the course of the 1930s, government slowly but surely became involved in more aspects of the economic life of most Americans in agriculture, industry, and commercial and retail trade. After 1934, government took on a social mission with programs like Social Security, which are with us to this day. Through all of these programs, the federal government spent an unprecedented $33 billion to

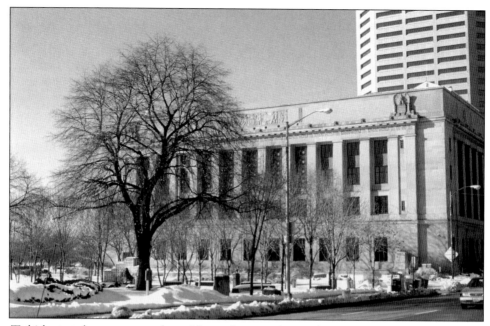

To kick-start the economy and provide employment during the Great Depression, the federal government undertook a number of public works projects. One of the largest and most impressive in downtown Columbus was the construction of a new Federal District Courthouse and Post Office Building in 1937. Now simply a courthouse, the building was recently named for long-serving Judge Joseph Kinneary. (Author's Collection.)

fight the worst problems of the Depression. And in the end, by 1940, we and most of the world were still mired in economic depression.

What was life like in Depression-era Columbus? It was pretty grim for many people much of the time between 1931 and 1941. To be fair, it should be noted that Columbus, and cities like Columbus, rode out the Depression in somewhat better shape than the industrial cities of the Northeast and Midwest such as Pittsburgh, Cleveland, Detroit, and Chicago. The reason for this is that the diversified economy of Columbus—more or less equally balanced among government, commercial, industrial, and service employment—tends to rise less quickly or less far in good economic times. But it also tends not to fall as fast or as far in economic hard times. This was a hard time. Many people changed their lifestyles. People drove less because they did not have the money to keep their cars running. The birthrate dropped significantly as many people put off starting families or having more children. Inexpensive pursuits replaced more expensive ones. More Americans began going to the movies more often than at any other time in our history.

Perhaps this was one of the greatest watersheds of life in the 1930s. We became more like each other. We watched the same movies, listened to the same radio shows, and shopped from the same catalogs and at the same chain stores. We began

to look more like each other, sound like each other, and, with the advent of national brands of mouthwash, toothpaste, and fragrances, even to smell like each other.

There were always events of surpassing importance, tragic or poignant, to hold the attention of the city in these years. On April 22, 1930, the deadliest single catastrophe in the city's history occurred when a fire set by inmates to provide a diversion at the Ohio Penitentiary got out of hand and turned several cell blocks into a death trap. By the time the smoke cleared, 319 inmates had died and a major effort to clean up Ohio's oldest prison was underway.

On a more pleasant note, sports at Ohio State were becoming more and more popular. In August of 1936, track star Jesse Owens returned home to a hero's welcome in Columbus after his triumphant performance at the Berlin Olympics, where he showed the myth of the Nazi Aryan superman to be just that: a myth. In the same year, the Ohio State University marching band presented for the first time what has since become its signature presentation: spelling out the word "Ohio" in a formation called Script Ohio.

But in this period, we stopped growing. For the first time since the 1850s when much of the city's population went west or back east or somewhere else, the growth rate dropped below 10 percent between 1930 and 1950. At the start of the decade, the city had 290,000 people; at its end there were only 306,000 people here. The city had ground to a halt. Residential growth stalled, commercial expansion faltered, and the city simply hung on.

Just as an example, if one walks about downtown Columbus looking for buildings built in the 1930s, one is likely to find the Ohio Departments Building at 65 South Front Street, the Federal District Courthouse along the Riverfront, and a number of bridges, sidewalks, and streets carrying the initials CAW, PAW, or WPA, all federal work agencies of the Depression era. These are all government projects, many of which were designed to keep Americans working when there simply was not much work.

It was a time when whole ways of life were ending. The high speed interurban trains that had been rocketing from city to city in central Ohio at speeds of 50, 60, and even 70 miles per hour since 1900 finally lost their struggle against the automobile. The last interurban left Columbus in 1937. In that same year, in the depths of the Depression, Olentangy Park closed. The largest of Columbus's amusement parks, it simply found itself unable to continue to operate.

So what finally brought Columbus and America out of the Great Depression? World War II is what brought America out of the Great Depression. And the price, when it was paid, was not only quite high; it was a price we are literally still paying.

WORLD WAR II

The people who lived through the catastrophic struggle that eventually swept through most of the known world between 1914 and 1918 called it the Great War. America's President Woodrow Wilson called it a struggle to "make the world safe for democracy." It didn't. And within 20 years, the greed of the victors and the

despair of the losers combined to give dictators of clashing ideologies in both Europe and Asia a fertile ground for new conflicts. When the conflict finally came in the summer of 1939, most people simply called it World War II. But it was truly a greater war than the first Great War had been. By the time it was over, more people were dead than had ever been killed in any war in human history.

Each generation has a moment that indelibly defines it and its time. For the people who came of age in the middle of the twentieth century, that moment came on December 7, 1941, when the United States was attacked at Pearl Harbor. Up to that moment many people had held out hope that perhaps the war engulfing Europe and Asia since the mid-1930s might still be avoided. After Pearl Harbor, it was clear that this war would be America's war as well.

World War II had a enormous impact on American life. In the first place, it brought us out of the Great Depression. To fight the social malaise of the 1930s, government spent the unprecedented sum of $33 billion. To fight World War II, we would spend $330 billion and most of the next three generations paying off the debt. More than 12 million men and women were mobilized to fight the war. Many volunteered but even more were drafted in the most effective and pervasive conscription system ever implemented by the United States.

To give these people clothing, food, tanks, and guns, a massive new war industry was created. The creation of this war machine changed Columbus profoundly. As just one example, the Curtiss-Wright Aviation Company came to Columbus in 1940 and built an aircraft manufacturing plant near the Port Columbus Airport. Port Columbus opened in 1929 along a rail line paralleling East Fifth Avenue. It had been built there because the first airline into town, Transcontinental Air Transport, used rail transport to cover distances that its planes did not reach. Curtiss Wright used the same rail lines to bring parts and raw materials to its new factory.

By the time the war was over, the factory was employing 25,000 people. Other factories in the city that made glass, steel, or machine parts converted to war production and similarly expanded in size. An entirely new military airfield near the village of Lockbourne was brought into being, and a military supply depot that had been in the city since World War I now found itself expanding to many times its previous size. And all of these factories and facilities needed people to work in them.

With so many men and women serving in the military and with so many jobs open in the new war industries, cities like Columbus acted like a magnet to thousands of people. Wracked by unemployment and despair, thousands of rural and small town people had been simply hanging on for more than a decade of Depression. Now the promise of new jobs and new opportunities drew them to the city. Many of these people came from the extraordinarily depressed rural areas of southeast Ohio, Kentucky, West Virginia, and Tennessee that we today call Appalachia. Together they would, by the end of World War II, constitute more than 30 percent of the Columbus population and comprise the largest immigration wave that the city had seen since the great Irish and German

World War II was certainly the largest, most far-flung and expensive war America has ever fought. It did not take as many lives as the Civil War, but it took more than enough. If one has any doubt about that, all one has to do is visit the World War II section at Green Lawn Cemetery south of the city. (Author's Collection.)

migrations of the nineteenth century. By the end of the war, the population of Columbus had increased by 20 percent to more than 400,000 people.

In spite of this new sense of national purpose and the economic prosperity that went with it, one should by no means assume that this was an easy time in America or Columbus. In retrospect, the eventual success of American production and military might seem almost inevitable. It did not seem so at the time. And while the blatant nationalism of the 1918 anti-German crusade was not repeated, it was still a time of trepidation as well as determination on the home front. George Wing was a teacher at West Junior High School on the Hilltop in Columbus in those years. In a volume of wartime reminiscences, he later remembered a scrap drive that brought in so much scrap metal that it covered one whole side of the school. He also remembered bomb drills were quite a common thing: "We gathered the little kids in interior halls crouched with their heads down. Thank goodness we never had to test it with the real thing."

Even with all of the immense production of America's war industry, there were still shortages. In May 1942, sugar began to be rationed. By November, coffee was rationed. And in 1943, meat, butter, and cheese were rationed as well as tires, gasoline, and nylon clothing. It was a time to make do or do without. But then most of the previous decade and a half had seen much the same experience.

In the spring of 1945 with the fall of Nazi Germany, the war began to wend its way toward an allied victory. By autumn, with the fall of Imperial Japan, the war ended. It had been a long, terrible struggle and, with more than 250,000

Americans killed, it was second only to the Civil War as the deadliest in our history. But at last it was over. As had been the case after World War I, there was a brief economic downturn after the end of World War II as those 12 million men and women in uniform returned home, seeking their old jobs in an economy no longer dependent on war production.

But the economy was essentially strong and bounced back relatively quickly. This was partly because those same 12 million men and women were all looking for spouses, houses, and motor cars. This generated enormous demand for consumer goods—consumer goods that were now available since wartime rationing had ended.

Of course, the other thing that generated demand was the natural result of this new home formation. The birth rate exploded, giving rise to what came to be called the "postwar baby boom," a phenomenon that began about 1946 and would not end until the mid-1960s. In Columbus, as throughout most of America, this extraordinary growth had enormous implications—some pleasant, some not so pleasant—for the future of the city.

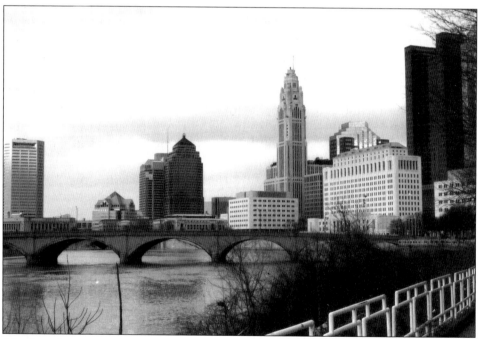

The Riverfront was a mess until the 1913 Flood. Then a Corps of Engineers proposal to widen it provided an opening for the creation of a new Civic Center. By the early 1940s, much of the work on new buildings, bridges, and other improvements was done. This is the way it looks today. (Author's Collection.)

10. A Clash of Cultures

The years immediately after World War II were eventful ones for Columbus. With the war and the Great Depression finally in the past, it was almost as if Columbus and its people were tired runners in a long race who finally had achieved the luxury of being able to look around and see how far they had come. Columbus and central Ohio emerged from this period as fundamentally different places than they had been in the years before the war and Depression. In the first place, Columbus was bigger. By 1950, there were 375,901 people living here, more or less, a 23 percent increase over the previous ten years. The snail's pace growth induced by the travails and hardships of the Depression had been left behind.

Many of these new people, black and white, were of Appalachian origin, and they flooded into the low- and moderate-income neighborhoods that now ringed downtown. They came because there were jobs here, lots of jobs. War industries had transformed Columbus. Furthermore, most of these new manufacturing jobs were with unionized companies, and the power of organized labor began to be felt in the politics and culture of the city.

In the view of one local observer at the time, it was almost as if the people of Columbus had bought all new furniture for their house that was the city and then belatedly realized that the roof leaked, the drains were overflowing, and the kids were all dressed in clothes three sizes too small. And just to complete the picture, the car wouldn't start. Because of the magnitude of the Great Depression's hardships and the shortages and sacrifices made by people during the war, a very long to-do list remained for the city. Because materials and manpower were in short supply, because funds were scarce and tax revenues were down, and because most people had other things on their mind, a lot of things were left undone.

The city woke up in the late 1940s and saw huge numbers of veterans returning home seeking to start families, buy homes, and make their way to the shops and stores of the city. Many people wanted new homes or at least better homes than the ones they had left. The traditional way to do this was to buy a lot and hire people to build a house on that lot. This was done time and again, lot by lot, across the city. It was true that some developers, like the Thompson brothers, had laid out whole planned communities like Upper Arlington, but the prevailing process was still to build each house one lot at a time. With the thousands of people

seeking homes, this method would not work. Eventually people like the Levitts in New York, the Hubers in Ohio, and dozens of other builders and developers across the country brought forth the concept of the modern housing subdivision with large numbers of relatively inexpensive and similar houses built to meet the public's needs.

In the meantime, there was Lustron. In the years immediately after World War II, the owners of a company making enameled sheet metal products—from roofing to whole metal buildings—was trying to find its niche as the war wound down. It decided to build and sell inexpensive starter homes made predominately of its enameled sheet metal product. An early promotional brochure succinctly described the advantages of a predominately metal home: "The all steel construction of the Lustron Home means not only speed and savings from straight-line factory production, but also cheerful living, easy maintenance, permanence and practically no depreciation."

Lustron houses were slightly ahead of their time. The houses took metal construction to the limits of the technology of the time. They were heated by radiant heat coils implanted in the metal of the building. The cabinets, closets, and framing were made of metal as well. It was a place that offered interesting challenges to people trying to hang a picture. But it was tailor made for the serious collector of refrigerator magnets. As one satisfied but sardonic owner put it in a letter to another Lustron owner, "It's like living in a lunch box!" Lustron houses sold quite well at first and many can still be found throughout Columbus and central Ohio. But ultimately they would lose out in the mass production housing wars of the 1950s and 1960s to more traditional "stick built" houses.

While people scrambled to find housing—old, new, metal, or otherwise—they were also looking for places to shop. At this point, downtown Columbus was still the retail center of the region. All of the big department stores were there—Lazarus, the Union, the Fashion—and so too were the major appliance, hardware, and home improvement companies. For that matter, most of the more fashionable restaurants, theaters, and other watering holes were still downtown, as were the better retail stores of most kinds. Downtown remained the center of things. But not for long.

A man named Don M. Casto took a close look at the rapid growth of new housing on the city's fringes and saw an opportunity. There is still some lingering debate as to who built the first shopping center in America. A case can be made for several places in the East as well as the Midwest, with Country Club Plaza in Kansas City in the 1920s always near the top of the list. But without question, the first major modern shopping center built in central Ohio was Casto's Town and Country in suburban Whitehall in 1948. Town and Country truly impressed its first visitors.

According to a company account of its founder's career, Casto remarked at one point, "Immediately after the opening of the first section of Town and Country, we knew a great industry had been born." Offering many of the major store names that people had come to trust in central Ohio, the shopping center

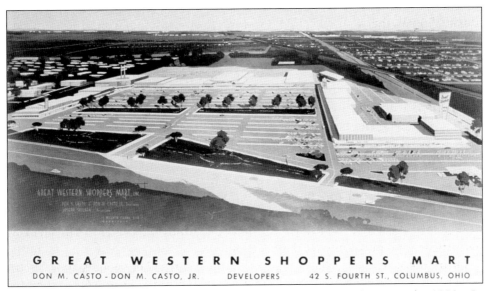

GREAT WESTERN SHOPPERS MART

DON M. CASTO - DON M. CASTO, JR. DEVELOPERS 42 S. FOURTH ST., COLUMBUS, OHIO

Don M. Casto had been developing small retail centers in Columbus since the 1920s. In 1948, he opened Town and Country, the first of the next generation shopping centers in Columbus. It was soon followed by a number of others, including Great Western on the far west side of the city, seen from the air in this view. (Casto Company.)

provided safe, convenient, nearby shopping with acres of free parking. It was quickly and incredibly successful. Soon Casto and others began to build more shopping centers in all parts of the city, as their names implied—Great Southern, Great Western, Great Eastern, Northern Lights, and so on.

Spurred by immense advertising expenditures in newspapers, on radio, and on the new and pervasive medium of television that brought three stations to Columbus by 1952, the shopping centers began to seriously erode the retail viability of downtown. A new series of shopping centers—bigger, more diverse, and eventually covered for convenient all-season shopping—would be built in the 1960s. Profiting from the experience of the original 1940s generation, Northland, Eastland, and Westland would be quite successful as well. Interestingly, many of these shopping centers have weathered quite well. With refurbishments and refittings, most 1940s and 1960s shopping centers are still around and still serving their communities, a continuing testimony to the power of the shopping mall on the postwar American mind.

While the people of Columbus were finding places to live and shop and play in this new postwar society, the tearing of the urban fabric begun in the 1930s continued. The potholes in local roads were becoming devourers of car parts. Backed up sewers in brand new homes were annoying, to say the least. And the continued deterioration of public buildings posed a clear and present danger to the safety of the people who visited them. Clearly, something needed to be done. As Columbus has always found when faced with its crises, something indeed was done.

THE METROPOLITAN COMMITTEE

Like so many of the people seeking a new life and new opportunities in the years of the Great Depression, James A. Rhodes had come out of the hills of southeast Ohio to the capital city. In ten short years, Rhodes made Columbus his adopted city. Originally arriving in town to attend The Ohio State University, he soon left the school behind and sought his future in politics.

In 1943, at the height of World War II, he sought the office of mayor of Columbus. Remarkably, at the age of 33 he became one of the youngest mayors in the city's history. Or perhaps it was not all that remarkable at all. By 1943, Rhodes had already been involved in several political campaigns, winning elections as a ward committeeman, school board member, and city auditor. And the city was in trouble. In addition to all of the problems that had built up over the years of Depression and war, Columbus was also wracked by scandals involving gambling and other vices and was almost $4 million in debt. It was clearly time for some new energy and activity at City Hall.

Jim Rhodes was nothing if not energetic and active. He moved rapidly to crack down on crime, put the city on a pay-as-you-go basis as to expenses, and actively recruited new businesses, wartime or otherwise, to come to Columbus. Ultimately, these actions proved successful. Crime diminished or at least became less obvious, the city's budget was reconciled, and by the end of the war General Motors and Westinghouse had built new plants and become major employers. In another important move, North American Aviation succeeded Curtiss Wright as the major tenant of the huge aircraft factory built near the airport at the start of the war.

In his usual self-effacing way, Rhodes credited not his own efforts but the people and place from where he came: "Ohio," he said, "has more things by accident than most states do on purpose." But none of these accomplishments attacked the major problem facing Rhodes and the city—the massive agenda of unfinished tasks requiring huge sums of money to complete. To move a city that was not partial to funding new projects, especially in wartime, Rhodes would need some help.

He found it. In 1945, Rhodes asked several civic leaders to meet with him in his office to discuss the formation of a committee to push forward an agenda that would deal with the problems the city faced. Earlier versions of such a committee had worked in the past to help win public approval of projects like Port Columbus and the Civic Center in the 1920s and 1930s. But such a committee had not been active for some time, and certainly no committee had faced a task quite as daunting as the one it now faced.

From these early meetings came a renewed and revitalized Metropolitan Committee that was to become one of the single most important forces for change in the modern history of Columbus. The premise of the Metropolitan Committee was simple. A citizens' committee of 100 prominent community social, political, and economic leaders was guided by an executive committee of 15 prominent civic leaders. Proposals for worthwhile projects requiring public

funding—from schools to roads to sewers to hospital construction—came before the committee. Not all of the proposals met with the approval of the committee by any means. But those that were approved the committee vigorously supported with money and with the world of people from the companies and organizations it represented.

In eight elections over the next 22 years, voters approved more than 45 issues to physically improve, rebuild, and repair the city. The value of the bond issues alone was more than $82 million, and the actual value of the work when combined with government matched moneys reached into the hundreds of millions of dollars. Paul Gingher, a prominent Columbus attorney and insurance executive, once summed up the impact the Metropolitan Committee had on the city: "Serving on the Columbus Metropolitan Committee has to be the highlight of my career. It demonstrated that here in Columbus, political, religious, competitive and personal differences could be put aside in the advancement of causes which serve the whole community."

James A. Rhodes came to Columbus in 1932 to attend The Ohio State University. He soon left that behind and embarked on a legendary career in Ohio politics—notably as mayor of Columbus, auditor of state, and four-time governor of Ohio. His statue stands in front of the Columbus office tower bearing his name. (Author's Collection.)

The National Defense Highway Act changed America as much as the canals, railroads, and National Road had ever done. A whole new wave of suburbanization began. This view looks west on I-70 from a freeway bridge in 1970. (Author's Collection.)

By 1958, the combined success of Columbus's private and public rebuilding efforts was enough to earn the city an All-America City Award from *Look Magazine*. For the next 20 years, Columbus, seeking a new identity since the 1914 removal of the great arches had deprived it of its Arch City name, became "Columbus—The All America City." Even with the positive accomplishments that followed, not all of these efforts were successful. And even the Metropolitan Committee could not persuade the voters in every instance.

MARKET MOHAWK AND GERMAN VILLAGE

By the early 1950s, the nation had generally recovered from the brief recession that followed the Second World War, and the economy was growing apace. Part of the reason for this growth was the continued expansion of government expenditures for a wide variety of purposes. Government subsidization of veterans' housing, education, and other benefits pumped enormous sums of money into many different aspects of the private sector. On top of this, the continuing perceived threat of Communist expansion around the world prompted the maintenance of a huge peacetime military and a growing nuclear as well as conventional arsenal. In many other ways, the activities and spending of government continued to grow in the 1950s. Liberal Democrats who felt the Republican Eisenhower Administration might limit the role of government were as surprised as conservative Republicans to see that war's end did not mean the end of big government.

Two major government programs in the 1950s directly affected both the look and the destiny of Columbus, as well as many other American cities. One built a new web of construction across America. The other tore down much of the existing fabric of that same landscape. One program brought freeways to the heart of the city. The other brought a new vision of what the city could be. For better or worse, Columbus and all of America live with the result of both programs to this day.

By the end of World War II, America's highway system, such as it was, was in pretty bad shape. A hodgepodge of local, state, and national efforts, the highway system worked quite well in some places and not well at all in others. But even on the best roads, traveling faster than 40–50 miles per hour took a certain courage. This contrasted with what invading armies found in conquered Germany: an autobahn expressway where speeds of 80, 90, and even 100 miles per hour were possible. To many Americans, the question became, if the Germans could do this, why couldn't we? So we did.

Between the end of World War II and the 1970s, federal subsidization of the National Defense Highway System virtually transformed America. Now the traditional 30 minute journey to work could be made from 10–15 miles away. A whole new series of suburban communities began to develop far from the center of cities. In Columbus, with no real impediments of lakes or mountains or seashores, the interstate highway system became one of the most sophisticated in America. Two major interstates cross in Columbus—the north-south Interstate 71 and the east-west Interstate 70. And circling the city at about 10–15 miles from the center is an enormous 55-mile-long Outerbelt called Interstate 270. By the time this was mostly completed in the 1970s, one could leave downtown and reach virtually anyplace in the county in 30 minutes. Everywhere, that is, except the airport, a problem that would be dealt with somewhat later.

The densely packed neighborhoods of streetcar suburb Columbus were emptying out, and with that emptying came a spiral of economic decline in the heart of the city. The answer to the problem seemed obvious to a generation of planners and policy makers who had rebuilt war-torn Europe and Asia after World War II. If certain parts of the city were too far gone to save, they would simply be leveled in order to start anew. In Columbus, the program came to be called SCAR, or Slum Clearance and Redevelopment. In several locations across the city—near Children's Hospital, the Ohio State University, and in the old Flytown district just north of downtown—whole city blocks were leveled and new construction was undertaken.

The centerpiece of urban renewal in Columbus was Market Mohawk. A 60 acre area near the century-old Central Market was leveled (including the Market). In its place was built a series of modern office buildings, a hotel, a bus station, and a new home for Franklin University (originally the business college of the Columbus YMCA). Market Mohawk and the other major projects of urban renewal in Columbus were in their own ways successes. They were honestly, efficiently, and effectively undertaken, and the final results were buildings of

tasteful design and commendable utility. To many people living in Columbus, they were also just plain wrong.

For several years in the late 1950s and early 1960s, efforts had been made by individuals and community groups to save great old buildings in the city's neighborhoods and downtown. Some of these efforts were successful. Old Memorial Hall, owned by the county, had been turned over to the Franklin County Historical Society when a new Veterans Memorial was built in the early 1950s. Eventually transformed into the Center of Science and Industry (COSI) in 1963, the building became a major attraction drawing visitors from around the world.

In the wake of losing the old residential neighborhoods near the Central Market, a small group of people committed to saving the German neighborhoods began a process of buying houses, fixing them up, and either renting or reselling them after they were rehabilitated. By 1960, they had organized as the German Village Society and, by 1963, had convinced City Council to enact protective legislation placing oversight over the exteriors of Village houses with a German Village Commission.

Today, German Village has several hundred renovated houses and is one of the largest privately financed rehabilitation and renovation districts in America. It is also one of the most successful. Inspired by this success, several other neighborhoods ringing the downtown began similar efforts with equal success.

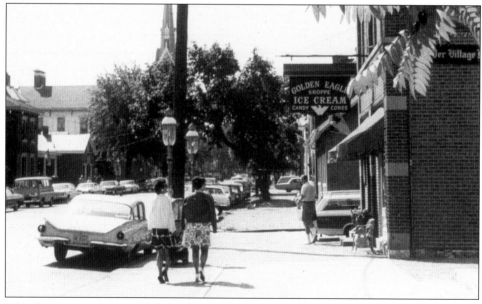

The German community of Columbus established itself in the Alt Sud Ende *or Old South End of the city beginning in the 1830s. In the late 1950s and early 1960s, a local effort to save the area resulted in the creation of German Village. As can be seen from this 1970 picture, in a few short years decided improvements were underway. (Author's Collection.)*

Working in concert with local historical organizations, these groups have become potent advocates of historic preservation and, interestingly, of sound new design compatible with the historic fabric of the city. Their story is one of the most dramatic of postwar Columbus, but it is not the only one.

Growth and the Price of Progress

With the notable exception of a man named Henry Worley in the 1930s, most mayors of Columbus between World War I and the 1950s had been Republicans. This reflected the general predilection of much of the population in this period. Then in 1953, along came Maynard E. "Jack" Sensenbrenner and everything changed.

For most of the 1930s and 1940s, the Democratic Party in central Ohio had been in the hands of the same people. Jack Sensenbrenner was not one of them. A self-made man from Circleville, he had been in business for himself on the West Side of Columbus for a time when he decided to seek the mayoralty. A person with roots in working class society and Depression America, Sensenbrenner was plain spoken, intensely patriotic, and obviously enchanted with his adopted "dynamic city." He won. After serving one term, he sat out four years because, as he later recalled, a little rivulet ironically called Dry Run left its banks in 1959 and put some of the West Side under water. Touring the West Side with some reporters, he once shook his fist at the creek as he passed it and said, "You daggone, stinkin' little stream. You cost me an election!"

Returning to office in 1964, he served until 1971. The accomplishments of the Sensenbrenner Administration were manifold. The stranglehold on powerful offices in both the city and the county was broken and a Democratic "Irish Mafia" made politics in the county bipartisan again. Most importantly, Sensenbrenner appointed good men and let them do their jobs. And they did. One of the jobs they did was convince the mayor that quick action was needed to save the city. Rapid suburban growth ran the risk of strangling Columbus with a ring of towns around its fringe, sapping its tax base and prohibiting further growth.

To stop this, Columbus adopted a policy of linking sewer and water hookups—desired by developers and homeowners—to annexation to the city. In this way Columbus grew to become the largest city in land area and population in the state and ended up by the 1970s beyond the immediate threat of encirclement. The legacy of this policy of sustained growth is Columbus's luxury of a tax base enabling it to expand its fire and police forces to meet the new demands of a growing city while keeping the majority of its moving population still within its city limits.

Another of the more interesting developments in Columbus in the years after World War II passed almost unnoticed by many people more caught up in the drama of annexation, freeway construction, urban renewal, and neighborhood renovation. That other story was the emergence of a renewed and unified black community. By the 1920s, a black central business distinct had established itself

along the Long Street and Mount Vernon Avenue corridors. With its own retail, commercial, and entertainment establishments, the black community of Columbus was vibrant and vital even in the face of Depression and war. Marvin Bonowitz many years later remembered being a part of that community with his family's clothing business:

> I remember clearly the atmosphere of the neighborhood, each building different from the next, none looking very modern. The Climax [store] was the classiest building, with a neat brick front, nice large showcase windows and a cast concrete lintel. When Dad enlarged our store, he chose a glazed brick front with stainless steel mullions.
>
> Other people . . . have noted the happy relaxed feeling of family. Walking the six or so blocks of the business area, you could feel at home, greeting most other people by name.

But what hard times and war could not do, the bulldozers came quite close to accomplishing. The construction of Interstates 70 and 71 split whole neighborhoods in the black community and isolated the primary black

A Democratic Columbus mayor, M.E. Sensenbrenner had grown up in the hard times of the 1930s and never lost his affinity for the common people. And many of his views on politics, morality, and religion were quite conservative. The combination was attractive to many and Sensenbrenner was quite popular. During his administrations, the city grew to be the largest in Ohio in land area. (City of Columbus.)

neighborhoods from downtown. Compounding the difficulties, the Near East Side became a testing laboratory for the widest variety of public housing and other public assistance projects. The result was the flight of much of the black middle class from the community, especially after the decline of restrictive covenants that had limited housing opportunities for many.

What emerged was a black community in economic, political, and social transition. In the midst of these changes, certain key organizations played a critical role in holding the community together. The NAACP, the Urban League, and especially the black churches provided continued assistance in these troubled times and, in fact, with new younger leadership, began to move the black neighborhoods in new directions. Some of these directions were peaceful and nonviolent, mirroring the experience of the Civil Rights revolution occurring in the South at this time. Other directions were not given to such equanimity and, on a few occasions (in 1969 memorably), violence erupted in the streets of Columbus. But for the most part, as it had and would through much of the long hot summers of the 1960s, black Columbus worked for change in less confrontational ways.

The other great story of the immediate postwar years is the coming into its own of The Ohio State University. *The* Ohio State University, as its spokespeople are always happy to remind the forgetful, has been around for quite some time. Born with the "Land Grant College Movement" of Civil War America, The Ohio Agricultural and Mechanical College was founded in 1870 and graduated its first class of seven in 1878. Housed on the old Neil Farm north of the city, the college grew quite slowly at first and was still a place of only hundreds of students at the turn of the century.

But even with a solid record of accomplishment, the 1930s and 1940s were not easy. Times were hard, enrollment dropped, and the war years caused problems for every public institution. Ohio State was no exception. However, if the years before the war were difficult in their hardship, the years after the war were trying in their very success.

At the end of the war, thousands of returning veterans, many with families, arrived in Columbus to seek a college education subsidized by the GI Bill of Rights. The campus exploded in size, with average daily campus populations reaching the tens of thousands. The Ohio State football team, under the inspired leadership of legendary Coach Woody Hayes, won national championships in 1954, 1957, and 1968. Other sporting teams were similarly successful and, just as importantly, Ohio State achieved national and international fame for several of its academic and research programs.

When the flood of veterans began to decline, a new wave of students arrived in the form of the postwar baby boom children of the selfsame veterans and others of that generation. The new flood of students was even larger than the postwar one, and the campus grew to its current size of more than 50,000 students. Rapidly trying to build classrooms, dormitories, and other facilities, the institution did a good job providing comfort and amenities to its students. It did

not do as well in addressing the political and social concerns of an increasingly discomfited student body. With increasing frequency, the tides of social and cultural change began to roll over the campus. The Civil Rights movement of the 1950s was followed by the Free Speech Movement of the early 1960s. Then growing student disenchantment with the war in Vietnam caused increasing friction with members and friends of one of the largest ROTC contingents in America. In the back ground of all of this political turmoil was a widening cultural divide over issues of dress, language, and appearance as well as strikingly different opinions and attitudes about the recurring issues of the 1960s: intimacy, drugs, and rock and roll.

For many years, long before the 1960s, students had gathered in large groups each spring to take pleasure in each others' company and to blow off steam after a long winter. Sometimes the partying got out of hand. Most times it did not and was harmless enough. But in the 1960s, the Rite of Spring became more politicized and with that came a hard, gritty, serious edge to spring gatherings that became more troublesome with each passing year. On April 28, 1970, a series of protests at Ohio State drew more than 20,000 people to the center of campus. Over the next few days, the protests grew larger and more confrontational for the same reasons that would ultimately lead to "Four Dead in Ohio" at Kent State on May 4, 1970. The campus protests were the largest individual events of civil unrest since the 1910 streetcar strike and led to more arrests and violence in the city than at any time since the Civil War.

The 1960s and 1970s were decades of change and controversy. And nothing reflected those times better than the rise of the button as a mode of expression. All of these buttons were worn by people in Columbus during those years. But they were not, as one might imagine, worn by the same people and usually not at the same time. (Author's Collection.)

A young instructor at the university at the time later remembered what those days were like:

> I had just started my teaching career the month before at the start of Spring Quarter. I was teaching in an old building facing the Oval—the main green in the middle of the campus. We could hear some sort of noise building outside. It sounded like the roar of the sea at a distance. I finally had to stop and look out the window. I had never seen that many people in one place other than at a football stadium. There were thousands of people out there and they were not happy. I told my class they could leave or stay but I was going to finish my remarks.
>
> Later I went out onto the campus to see all of this for myself. I saw incredible things. Police officers pulling their guns and aiming them at students. Tear gas canisters were tossed into roving crowds and the cans were tossed back. I was quite surprised to learn later that no one was seriously hurt that day.

It was a terrible time. Unable to contain the protesters with state and local police, the university saw combat-equipped National Guardsmen—many as young as the students they faced—called to riot duty. Ultimately the university closed, reopened, and then closed for the rest of the academic year. And while many were arrested and not a few were injured, miraculously, no one was killed in the weeks of continuing confrontation that came to be simply called "The Riots."

Some good did come out of these awful days, although certainly it was not easy to see at the time. The war went on, the summers continued to be long and hot, and the clash of cultures continued. But the paroxysm of violence had convinced both protesters and authorities alike that each had to talk with the other, walk with the other, and learn to live with and share the life of the other. In Columbus, Ohio, at least, over the next several years, that is precisely what the city learned to do.

11. The Discovery City

The 1970s in Columbus were in some sense difficult years. Many of the problems that had assailed the country and the region continued unabated and new issues and concerns loomed on the horizon. Nationally, the country was still embroiled in what one song of the period called "that nasty Asian war" in Vietnam and the cycles of urban protest, confrontation, and violence that accompanied it. Throughout Ohio and much of the Midwest a whole other set of problems was emerging as well.

The industrial heartland of America—the powerhouse center of American economic power and prosperity for more than a century—was slowly beginning to wind down. There were a number of reasons for this. Our concern over expanding Communism combined with our basic humanitarian decency induced us to rebuild much of the economic infrastructure of wartorn Europe and Asia. Now these new factories, shops, and other businesses were outperforming our own. Once "made in Japan" had been a symbol of derisive inferiority. Now it was becoming the hallmark of fierce competition in cars, electronics, and a wide variety of other consumer goods. Europe had similarly recovered and, with its Common Market, it too was offering considerable competition to American goods.

Storm Clouds Gathering

Responding to increased costs and competition, many companies left Ohio and the Midwest for the rapidly developing South and West. It was in the 1970s that a two-decade trickle of businesses and workers leaving Ohio for the Sunbelt states of Florida, Texas, and California became first a stream and then a veritable river of lost production and productivity. And it was not hard to see why the exodus was underway. In the predominately rural Sunbelt, labor was cheaper, the climate was nicer, and the cost of business was lower. Or so it seemed. In fact, the costs of labor began to rise inexorably in the South as much as the North over the decade. The much touted lack of snow was more than made up for by torrential rains and devastating droughts. And taxes? As populations rise and economies expand, needs arise with them. Taxes must rise as well to meet those needs.

But this is what we know now after the fact. At the time, it seemed to many as if the industrial heartland of America was slowly becoming a "rust belt." Certainly this was happening with remarkable speed and depressing uniformity to former industrial giants like Cleveland, Cincinnati, Youngstown, Akron, and Toledo as well as Pittsburgh, Detroit, and Chicago. Compounding these regional problems, a number of issues on the national scene also gave people cause for pessimism. The long, tortuous, and frustrating resolution of the Watergate affair with a President's resignation left many people with a distrust of government no matter what their view of Richard Nixon might have been.

The downtown area was becoming an emptier and emptier place. In 1971, the Hartman Theatre and office building at the corner of State and Third was torn down. Over the course of the next several years, many of the classic downtown restaurants closed as well—Marzettis, Kuennings, Mills, and even the venerable Maramor. Soon they were followed by the hotels. For many years, small hotels had dotted the downtown landscape, providing single room occupancy to transients and low- to moderate-income people. Now they too began to fall to the wrecking ball—the Jefferson, the Normandie, the Columbus, and the Fort Hayes. With the loss of these places a new problem appeared: people whose only affordable home was gone and who now formed a new class, the homeless.

In time, some of the major hotels would follow—most notably the Neil House in 1974 to make way for the Huntington Center. In one form or another, the Neil, home to governors and visited by kings and commoners alike, had been on that same spot across from the capitol building since 1818. With the earlier demolition of the Deshler Hotel at Broad and High in 1969 and the loss of the Chittenden Hotel, it seemed to some as if gaping holes were appearing in the smile that had been the image of downtown Columbus.

Perhaps the final crowning blow came with the loss of Union Station. Columbus had been a center of transportation and trade for most of its history. Critical to that centrality for more than a century had been the web of railroads entering and leaving the city. But like much of the industrial northeast, the railroads were suffering in the years after World War II. The enormous success of automobile travel on government-financed interstate highways combined with cheap and efficient air travel to spell the end of America's golden age of rail. Some of the last vestiges of that former glory were the great terminals, the T&OC on West Broad Street and the magnificent Union Station on North High. Acquired by the authority constructing a new convention center nearby, it had originally been assumed that at least the facade of the old terminal, designed by architectural master Daniel Burnham, would be saved.

But on an October night in 1976, the wrecking ball began quickly and efficiently to level what remained of the station. By the time local preservationists got a restraining order, all that remained standing was one lonely arch. Saved by a quickly formed committee, the great arch was removed and eventually rebuilt at a nearby site appropriately called Arch Park. Later moved to a more visible location on the near North Side, the arch remains a tangible reminder of the

railroad center that Columbus once was. Also out of this adventure, a more permanent preservation organization, the Columbus Landmarks Foundation, was formed in 1977 to try to prevent future repetitions of such losses by "preserving and celebrating our city's architectural legacy and supporting community action in historic preservation and design of our built environment." It says something about how Columbus has changed that a group few people thought much about 25 years ago is now such an integral part of the city.

A LIGHT BREAKING THROUGH

For all of the gloom and negativity that seemed to be enveloping the Midwest in these years, both residents and observers from afar began to notice something remarkable about Columbus. This city, this state capital, was not faring as badly as the rest of its rust belt neighbors. In fact, in a number of ways it was doing just fine.

While the other major cities in Ohio were losing population, Columbus was gaining people. While the other big cities were either staying the same size or losing territory, Columbus was actually increasing in size. By the early 1990s, Columbus was the largest city in population and land area in the state. Clearly something positive seemed to be happening here. What was happening was a complex process of growth and change that nevertheless consisted of a number of recognizable reasons. Some were old and had been part of the capital city's story for some time. Others were a bit newer.

Union Station was designed by noted American architect Daniel Burnham, who also designed the Wyandotte Building—Columbus's first skyscraper. In its time, such as when this 1890s postcard was made, it was quite the place to be. (Author's Collection.)

After Union Station was removed in late 1976, the only surviving remnant of the once magnificent building was one rather lonely arch. Erected first on a nearby plot of land appropriately called Arch Park, the arch was later moved to a new park near the Nationwide Arena. There it stands today as a reminder of the rail heritage of the city. (Author's Collection.)

First and foremost, Columbus succeeded in the 1970s and 1980s because it was a diversified city. As was also the case with similar cities like Indianapolis, St. Louis, Kansas City, and Atlanta, no one single industry or business, public or private, dominated the economy. Only about one worker in five worked in industry. A significant part of the population worked in the retail sale of goods and services. Another large group of people worked in government—federal, state, and local. In short, a balanced economy is a better economy. And Columbus has been that sort of place.

Secondly, the continued growth of the city in size was due to the farsighted program adopted during the 1940s and 1950s to tie water and sewer availability to annexation. This kept the city from encirclement by prosperous independent suburbs and kept the tax revenues of a growing middle class coming into city coffers. With the growth of the city in size and the addition of these suburbs to the city inevitably came a population increase. But something else was happening here as well. The great success of Columbus was not just due to shrewd annexation and a diversified economy. There was a pattern to the growth of the city that inevitably spelled success as well. Columbus was becoming a different city and arguably a better one.

Nothing perhaps illustrates this change better than the evolution of Columbus as a "Test City." Marketers and retailers have valued Midwestern cities as test markets for their products for more than a century. As we slowly but surely

For more than a century and quarter, a Neil House Hotel had stood on High Street across from the Statehouse. Then in the mid-1970s, Gerald Hines Interests developed a new and distinctive highrise office building on the site called the Huntington Center. (Author's Collection.)

became more of a consumer society after the American Civil War, it is no accident that major mail order companies like Sears and Roebuck and Montgomery Ward based themselves out of Chicago and marketed to the Midwest. Even in an age when most people lived in rural America, the majority of those rural dwellers lived within 500 miles of cities like Chicago and Columbus.

By the late 1940s, Columbus had become a test market for the widest variety of consumer goods. Marketers recognized that in cities like Columbus they could find a good cross-section of America—its wealthy as well as its working people, blue collar as well as white collar, and black as well as white. For most of the next 20 years, Columbus was such a good place to test things that it often called itself "Test City USA." It was little wonder that several of the nation's new ideas in dining, from White Castle in the 1920s to Wendy's in the 1960s got their start in Columbus. If you wanted to know if middle America would like your product, here was the place to test it.

But by the 1970s, Columbus had changed. It was still a test city to be sure. But it was no longer the "universal" test city it once had been. Columbus was increasingly younger than the norm and better educated as well. It was also a city where the average person made more money than the national average. Clearly something was changing in the economic and social make-up of the city. What was changing was the way the economy worked in Columbus.

Some new industries, like Worthington Steel, were making traditional products like fabricated steel in new ways. Others like Ross Laboratories—the makers of Similac baby formula among other things—brought new methods to the mass production of new products. And a young retailer named Leslie Wexner was changing, with his growing number of Limited Stores, the way America bought clothing and accessories. But whole new sorts of businesses were born as well.

Chemical Abstracts, a reference service spin-off of the American Chemical Society, became one of the world's largest repositories of scientific information. The Ohio College Library Center, transformed into OCLC Inc., became a large computerized bibliographic cataloging company. Compuserve, founded to help businesses share time on computers, began to become one of the most successful online computer services in the country. And in 1976, Warner Amex, on its way to becoming AOL Time Warner, began its experimental interactive cable television service called Qube in Columbus. In short, Columbus was becoming a place where new forms of successful post-industrial businesses were forming and succeeding. Why here? Partly it was because of that diversified mix of talent and economy we saw earlier, but primarily it was because there was a history of success with these kinds of businesses in the city.

Perhaps the granddaddy of all research organizations in the city was Battelle Memorial Institute. John Gordon Battelle had made his mark in nineteenth-century Columbus in the steel business. When his son Gordon died at a relatively young age, Gordon's will asked for the formation of a nonprofit organization dedicated to metallurgical research and other scientific research. Over the years since it was founded in 1929, Battelle did a lot of metals research but became increasingly involved in other research as well. A man named Chester Carlson came to Battelle seeking help perfecting his idea—an idea that eventually became Xerox. Batttelle became involved in atomic research in the years during and after World War II and became an international leader in the field. In many other areas as well, the Institute not only excelled but set a new standard for scientific research. By the 1970s, with branches in Europe and across America, the Battelle Memorial Institute was arguably one of the largest if not the largest private reserarch organization in the world.

It was no accident that its headquarters were right across the street from The Ohio State University. With more than 50,000 students in Columbus by the 1970s and another 20,000–30,000 faculty and staff, the main campus on an average day was one of the largest concentrations of people in the state—a city within a city. And it was a city of very young, very bright, and very motivated people, just the sort of people that the new and old businesses of Columbus (and the world) were seeking. In short, if one were growing a business requiring more brains than brawn, Columbus was a good place to do it. For these reasons then, while the rest of the Midwest suffered under the burden of rusting urbanity, Columbus not only held its own, but actually grew in the 1970s and 1980s—in people, in size, and in wealth and innovation.

COMING TO GRIPS WITH GROWTH

While Columbus coped well with change in the 1970s and 1980s, the process was by no means easy. A new set of civic leaders arose to meet the challenges. For most of the period from the 1920s to the 1960s, the urban leadership of the city had been in the hands of a relatively small group. The traditional gatherings of the leaders of the largest manufacturers, retailers, banks, universities, and media had been augmented by new actors from the burgeoning areas of economic enterprise in the years of the Metropolitan Committee after World War II

In the 1950s and 1960s, the leaders of the major utilities, real estate developers, and the managers of major public institutions like local hospitals had become increasingly involved in civic affairs. So too had representatives of organized labor and major social service organizations. Now the new businesses became involved as well and efforts began to be made to try to deal with some of the major problems facing the city. Presiding over all of this were two men who served as mayor during these years. At first glance they may not seem to have had much in common, but they did.

Tom Moody, a Republican, was elected mayor in 1971. The amiable, relatively quiet, pipe smoking former judge was a marked contrast to the "dynamic" style of his Democratic predecessor, Maynard Sensenbrenner. The Sensenbrenner years had seen enormous growth but increasing social change as well. This was not the mayor's fault any more than the 1959 flood was his fault. But the man in charge accepts the blame as well as the credit for what happens in his city. Mayor Moody brought a quieter, more cerebral style to City Hall and a reduction in volume to the political dialogue. But for all of this, he was nevertheless committed to the continued growth and prosperity of the city. This was not always easy in times of economic uncertainty. Yet it was happening in Columbus whereas in other Ohio cities, it was not either probable or possible.

Many years later, Tom Moody reflected on what made Columbus and its economy special in the time when he was mayor and after:

> The hallmark of Columbus has been stability. Perhaps we have come to exalt stability because we have no truly earthshaking economic developments, although we have had our share and more of good things. I do not think the good things have been accidental. . . . The wonderful combination of mostly good things and mostly good people has made this the biggest and most comfortable small town in America.

After three terms in office, Mayor Moody was succeeded by the Republican county treasurer, Dana G. "Buck" Rinehart. Where Mayor Moody had prided himself on being "quietly effective," the Rinehart years from 1984–1992 were anything but quiet. Relentlessly energetic in every one of his activities and not one to suffer plodders gladly either in the public or private sector, Mayor Rinehart brought an energy to the office that it had not seen for some time.

When asked on a later occasion to characterize his years in office, Mayor Rinehart remembered:

> If you want people to be excited about where they live and how they live, then you have to be excited as well. They have to sense that in every single thing you do. You have got to catch the breeze. You have got to catch the tone and pace of the city. And when I was in office the tone and pace and demands of the job were huge. It was easy for me to be excited.

Many observers at the time felt that the only thing the two men shared was an allegiance to the Republican Party, also shared by the governor through many of these years, former mayor James Rhodes. But to hold such a view mistakes personality for performance and style for substance. The farther we remove ourselves in time from both men, the more apparent it becomes how much they and the city over which they presided had in common. Both men had substantial dreams of what the city could be. On balance, they and the city they led were extraordinarily adept in not only overcoming the adversities of this era, but in succeeding in moving the city forward.

The challenges were as diverse as the city itself. Still recovering from the oil embargo and the inflation that followed, Columbus managed to throw a

Dana G. Rinehart succeeded fellow Republican Tom Moody as mayor of Columbus in the mid-1980s and early 1990s. Energetic and committed to progress in Columbus, Mayor Rinehart presided over a city he called "The Sunspot in the Rustbelt." (Dana G. Rinehart.)

reasonable celebration of the occasion of the Bicentennial of the American Revolution in 1976. Not only was a new park along the river built and named for the Bicentennial but the July 4 celebration along the river was so successful that in the years to come Red White and Boom would become the major event in the city's calendar. At times nature seemed to try its best to compound difficulties, with a blizzard in 1977 and some of the deepest snows the area had seen for years in 1978. But as the city recovered its composure, plans went forth to transform the downtown area and the economic fortunes of the city in general.

DOWNTOWN COMES BACK

As we have seen, downtown Columbus was in rather desperate straits in the years after World War II. By the 1970s, a significant part of downtown was streets, vacant lots, and parking lots. When it came, the solution was relatively simple. If the private sector cannot bring back downtown on its own, then it would get some help from the public sector. The Capitol South Community Urban Redevelopment Corporation was founded in 1974 to acquire three city blocks south of Capitol Square for urban redevelopment. By 1978, some land was acquired and a lonely facility for roller skating and ice skating called the Centrum had been built on the site, mostly to show that something was being done there.

With citizens anxious to find some use in the cleared area of Capitol South, the Centrum was built in 1979. The combination ice rink and roller rink was not very successful since there was little else to do downtown at the time. The Centrum was removed when City Center was built. (Capitol South Community Urban Redevelopment Corporation.)

It was a nice idea, but with not much else happening downtown, the Centrum was a bit too early to last very long. By the early 1980s, plans were underway to develop a major multi-story shopping mall on the site, linked by a covered walkway to the existing Lazarus department store. In 1989, the mall was completed and City Center opened to great economic success. In a twenty-fifth anniversary retrospective, John W. Kessler, one of the original managing trustees of Capitol South, reflected on the significance of the project:

> In the beginning, Capitol South didn't have much money or staff, and not much support in some quarters. I think a lot of people believed we were just out there dreaming. But we stuck with it and became a good partner with the City of Columbus. None of us who were involved in Capitol South were in it for the kudos. We've just tried to make it a vehicle for helping accomplish things that Mayors and City Councils have wanted to do to benefit our city.

The further evolution of the interstate system with the opening of Route 315 in 1981 and the completion of the Outerbelt I-270 might seem to be moving the city centripetally toward the suburbs, but such was not actually the case. The commitment of both the public and private sector symbolized by Capitol South and City Center was seen elsewhere downtown as well. Nationwide Insurance had been in the city since 1926 and in a large building on High Street for many of the years thereafter. By the late 1960s it was outgrowing its space. Faced with the choice of moving out of downtown or staying, Nationwide chose to stay, building a huge office building at High Street and what is now called Nationwide Boulevard. Over the years, Nationwide continued its commitment to downtown, building two more office buildings and much more.

Across the street from Nationwide, Battelle made its own commitment. As part of the settlement of a lengthy proceeding to determine how it should allocate its charitable assets, Battelle formed a self-extinguishing foundation that gave huge sums to social and cultural groups. Also as part of the settlement, it developed the former site of Union Station into a much needed convention facility for the capital city. These quite large projects were complemented by continued growth in the renovation districts ringing the city, in the rehabilitation of some major downtown landmarks like the Palace Theatre, and in the construction of some new buildings—public like the Riffe Center and private like the One Columbus building at Broad and High.

One challenge that the city found itself facing was met with clear conviction. In 1979, Judge Robert Duncan found the city's schools to be segregated and ordered busing for the purpose of school desegregation. It was a difficult time. But unlike so many cities, Columbus desegregated peacefully and on schedule to the satisfaction of friends and foes of busing alike. Columbus used busing for desegregation for a number of years until the court order was lifted. Through all of those years, as the debate over busing raged nationally and locally, the process

The centerpiece of the Ameriflora exhibition was the renovated and greatly expanded 1895 Franklin Park Conservatory. Here it is seen at dusk with special illumination. (Franklin Park Conservatory.)

continued apace and peacefully in Columbus. As Judge Duncan noted in his Final Order, information provided by the Columbus schools showed that the "defendants have had significant success in doing what many view as impossible." It was one of the era's most important achievements and one of its most memorable.

By the early 1990s, Columbus had begun to turn itself around. The challenges of a declining downtown, rapidly growing suburbs, and the crisis in public education had been addressed if not always resolved. And in 1992, on the occasion of the 500th Anniversary of Columbus's epic journey, the city decided to celebrate. It celebrated with Ameriflora—a sanctioned international floral exhibition and exposition in Franklin Park. Ameriflora provided the excuse for a major renovation of its site and a major renovation and expansion of the Franklin Park Conservatory. In addition, a replica of the Santa Maria was constructed along the Scioto and a number of other civic events marked the year-long celebration.

There were critics of the celebration. Many Native Americans have a rather unflattering opinion of Christopher Columbus, arguably with some reason. Throughout the 1992 Quincentennial Year, their voices were heard in Columbus and elsewhere. But the example of Columbus—his strength and daring and his passion for discovery—was celebrated as well. In the end, the success of Ameriflora, modest by the standards of fairs and expositions but significant as a symbol of Columbus's coming of age, helped America discover Columbus.

12. Looking Ahead

As the Ameriflora exhibition successfully concluded, Franklin Park on the near east side of the city returned to some semblance of normality, albeit with a considerably larger conservatory and other amenities on the site. For all of that, the city was still attempting to stave off the worst effects of an economy tending to favor the South and West of the United States rather than the North and East. Even the quick and successful conclusion of a war in Kuwait, while uniting most Americans in a common purpose, did little to dispel many of the most pressing economic problems facing the country.

In 1992, the Jeffrey Manufacturing Company—a Columbus industrial mainstay since 1877—turned out its last mining locomotive. In the same year, The Jaeger Company also went out of business. It had been the maker of the world's largest readymix cement truck among other things. The century-old Lennox furnace manufacturing site closed in 1994, and the Central Ohio Paper Company closed its doors in 1997. Clearly the manufacturing sector in the Midwest was still having hard times and the road to recovery would continue to be difficult. In the course of the next several years, the Jeffrey site on north Fourth Street was cleared of buildings and sat empty and waiting for some sort of redevelopment. It would take quite some time for that to happen.

Looking Outward

Part of the reason for this delay was that Columbus's attention had turned somewhat away from downtown to focus on other concerns. To be sure, the downtown area continued to get some attention. The aging and empty Ohio Penitentiary site was acquired in 1995 by the city from the State of Ohio and plans for what to do with the place began to be discussed. The Riverfront Commons Corporation had a bold and challenging agenda of its own: remake, restore, and revitalize the Scioto Riverscape not only as it passed through downtown but for some distance above and below it as well.

But the major interest of planners, policy makers, and influential community residents tended in the early 1990s to move away from downtown and more toward the region as a whole. After all, City Center was opening and doing quite

Muirfield is the realized vision of a number of people, among them Jack Nicklaus, whose idea of a community centered around a championship golf course was really the beginning of it all. The annual Memorial Tournament has brought both attention and recognition to the Dublin, Ohio area. (The Memorial Tournament—Jerry Wisler.)

well, the flight of offices and shops from downtown had slowed, and by 1993 the economy was beginning to look up. So a major planning effort of the mid 1990s was not an effort at downtown revitalization but rather an attempt at a comprehensive plan for the city.

As noted in its introduction, "The Plan is intended to serve as a guide with which to protect and enhance the quality of life in Columbus. It accomplishes this by fostering orderly, manageable, and cost-effective growth and establishing a framework for future land use decisions. This will enable residents to enjoy the qualities that make Columbus a great place to live." The plan was a noble effort to involve the widest variety of local groups and citizens in a process to set generalized goals for Ohio's largest city. The result was an overview and general vision of what the city might become. But because it was so general in its orientation and because it did not deal with subjects like education, it did not have enormous impact on the public mind at the time it was issued. For what it was and for the time in which it was prepared, it was an impressive effort to look broadly at the city and many of its recommendations still guide public policy today. But it left a lot unsaid.

Dublin, in the northwest corner of the county some 10 miles from the Statehouse, had developed explosively in the 1970s largely because of the success of Jack Nicklaus's vision for the area. The Columbus native and internationally

successful golfer had returned to his hometown to build his ideal residential golfing community, Muirfield, and crown it with a national golf tournament of its own, The Memorial. Now in the 1990s, nearby communities like Hilliard and Powell were also beginning to be built out with new subdivisions. On the other corner of the county, a different sort of development was underway. As Columbus learned, Limited Company founder Leslie Wexner had a vision of his own, which he shared with developer John Kessler and others. The idea was to develop a new community in the country in and around the existing rural village of New Albany. Soon New Albany became the watchword for the very latest in exclusive residential living in Columbus.

Between Muirfield and New Albany was the Route 23 corridor north to Delaware. During the years immediately after World War II, the suburban village of Worthington seemed, like Upper Arlington, to be a fashionable distance from the city. With driving conditions on two-lane roads being what they were, it probably was. Then I-270, the Outerbelt, was completed and Columbus surrounded the frontier settlement turned bedroom suburb. By the early 1990s, an entirely new edge city was emerging along the Route 23 corridor, anchored by the Crosswoods Office Complex on the south and marching north toward Powell Road in Delaware County and beyond.

It was not a new pattern. The same kind of rapid and disjointed development marked the evolution of the Morse Road corridor near the then-new Northland Mall in the 1960s and to a lesser extent the Route 161 corridor in the 1970s and along Sawmill Road in the 1980s. Now it was happening again in the 1990s. The difference was that county lines were being crossed with increasing regularity and the issues for planning and development were much more regional than municipal. An example illustrates this point rather well. In the 1980s, a group of real estate developers managed to assemble a rather sizable parcel of land adjacent to Interstate 71 north of the I-270 Outerbelt and across the county line in Delaware County. Their hope was that the development of the large piece of land into offices and commercial and residential uses would act as a focus and magnet for further development into southern Delaware County.

The developers faced numerous challenges, not the least of which was the identity of the government that would benefit most from the development. The Olentangy School District in southern Delaware County wanted to see some of the tax revenue generated by the site. So too did Delaware County. And so too did the City of Columbus, which argued that it could efficiently provide a variety of public services to the new complex. Eventually a rather complicated deal was worked out that gave many of the aforementioned parties something of value from the new project.

The new development was called Polaris. Today it is many of the things its promoters envisioned, a substantial office, residential, and commercial area. It is also the home of the Polaris Fashion Mall—a major multi-anchor shopping center that brought a variety of new stores to central Ohio. Despite vigorous competition with other new shopping opportunities like the Mall at Tuttle Crossing and

147

Easton Town Center, Polaris Fashion Mall and the rest of this new generation of shopping places did quite well in the good economic times of the 1990s. But when the economy faltered toward the end of the decade, it was the new malls that continued to prosper while older malls suffered.

Columbus, like many other cities, had simply overbuilt its retail base in the confident expectation of further economic success. When it didn't happen, the older shopping places were hardest hit. By 2002, Northland Mall was suffering so much that it was forced to close and its property was acquired by the city for redevelopment. The lesson from all of this was that further retail and commercial development would be increasingly regional and the competition engendered would be regional as well.

RETURN TO DOWNTOWN

By the end of the 1990s, it was fair to say that regionalism's challenges were at least being addressed if not resolved. For most political, economic, and social leaders in Columbus and central Ohio, it was time to return once again—as had been the case so many times in the past—to downtown.

Throughout these years, a number of people had not lost their commitment to downtown. They included businesses like Nationwide Insurance and the F&R Lazarus Company. They counted among themselves the local banking community and especially the leaders of locally based banks such as Bank One and The Huntington. The old and quite large law firms, brokerage houses, and accounting firms and the major utilities (electric, gas, and communications) that had their offices downtown were involved as well. Equally committed were the

The Polaris Fashion Place is the latest multi-anchor, multi-level, multi-function shopping mall in the central Ohio area. Competing favorably with existing upscale malls like Tuttle Crossing and Easton, Polaris has been quite successful in its own right. (Author's Collection.)

media in general and the *Columbus Dispatch* newspaper in particular, which had been located downtown since its founding in 1871 and on Statehouse Square since 1925. All of these organizations had been downtown for many years and wanted to see it prosper.

So too did a variety of cultural and social organizations. In the 1960s, the ornate and unabashedly spectacular Ohio Theatre was threatened with demolition. A community coalition saved the building and put in place an organization called the Columbus Association for the Performing Arts (CAPA) to promote and manage it. Over the years, the Ohio became the official "state theatre" and was quite successful. In time, the success of the Ohio was duplicated by the renovation of the 1926 Palace Theatre by its owner, Katherine LeVeque, and the 1893 Great Southern Theatre. Eventually all of these theatres came to be administered by CAPA.

They were not the only cultural organizations to commit to a downtown presence. The Columbus Museum of Art had been on its current site on East Broad Street in one form or another since 1877. When the time came to decide whether to move or not in the late 1990s, it made a decision to stay downtown near its neighbor, the Columbus College of Art and Design. Similarly, the Columbus Center of Science and Industry (COSI) had come into being in 1963 as an outgrowth of the Franklin County Historical Society, in Memorial Hall on Broad Street. When its success caused it to seek new quarters as well, the decision was made to stay in the downtown. Taking over the empty Central High School site along the river, COSI saved part of the historic building and added a whole new futuristic structure to it. The new COSI opened to the public in late 1999.

In one very real sense, COSI was something of an exception, a very successful one to be sure, but still an exception. Over the course of the twentieth century, a number of institutions chose to make their homes on what one might call the Very Near East Side of Columbus. These organizations included Columbus State Community College and Franklin University, as well as the already mentioned Museum of Art and Columbus College of Art and Design. In addition, the Main Branch of the Columbus Metropolitan Library and Grant Hospital formed formidable institutional presences in the area.

There were a number of smaller organizations as well. The Columbus Junior League acquired the home of Grace Kelton in 1975. One Kelton or another had lived in the Federal Revival house since it was built in 1852. And they seldom threw anything out! Knowing a good thing when it saw one, the League adopted the home, made it its own, and turned it into one of America's great house museums. To make things even more interesting for the casual visitor, there is another house museum just a half a block away. In that same year of 1852, Philip Snowden built a magnificent Italianate Revival mansion literally just a stone's throw from the Kelton family's new house. Eventually the house became the national headquarters of the Kappa Kappa Gamma Fraternity (which is really a sorority). The Kappas have made the house into a museum as well as an office, and it too is worth the admission price.

Elected in 1999, Michael Coleman is the current mayor of Columbus. Pledging to improve the quality of life in the city in general and its neighborhoods in particular, he has had to face unanticipated challenges. But then, facing the unexpected has been a recurring theme in this story. (Office of the Mayor of Columbus.)

All of these places—schools and hospitals and museums and such—came together and decided to jointly market themselves as a cultural nexus, calling itself the Discovery District of downtown Columbus. It has worked out quite well, and the District has become something of a tourist attraction in recent years. But for all of these successes, corporate and cultural, it was still commonly recognized through most of the 1970s and 1980s that Columbus did not have a truly sustainable downtown like the major metropolises of New York, Chicago, or San Francisco.

The general perception was that Columbus had nice places to visit, like the Statehouse and the museums, theatres, and shopping attractions of downtown. The city also had pleasant nearby neighborhoods like German, Victorian, and Italian Villages to visit and even perhaps in which to reside. But it was not a vibrant downtown every night of the week. It was a nice daytime downtown in a city that did not draw people on weekday nights very much. What Columbus did well was stage and present special events.

Many people growing up or coming of age in Columbus came to understand as a matter of course that weekends in downtown were a lot of fun. And it was easy to believe that every city of any size must also have a similar variety and number of special events in their downtown. Not really. Over the course of the past 30 years, Columbus made the special downtown event almost into an art form. Beginning with First Night on New Year's Eve, Columbus rings in the

New Year with a lot of panache and absolutely no alcohol. Over the course of the next few months, the city hosts a variety of special events highlighted by the riverfront-based Greater Columbus Arts Festival in June and the truly impressive Red White and Boom as part of the July 4 holiday. These two events regularly draw about a half million people each to downtown. They are not the end of things. The Ribs and Jazz Festival in late summer and Oktoberfest in early fall also draw huge crowds and have done so for many years. In short, on special occasions and for special events, Columbus can and does attract enormous numbers of people to its downtown.

But what about the other times? That indeed was the problem the city faced in the 1990s. For more than a generation, it had been confidently asserted that one could unlimber a field gun at Broad and High on a Tuesday night, aim it in any of the four major directions, and not hit much of anything. And there was an element of truth to this piece of bombastic hyperbole. However, in the 1990s things begin to change. They changed because of the corporate and cultural commitment we have already seen. And they changed because the economic good

The Discovery District is a successful joint marketing venture of several cultural, educational, and other institutional partners in the immediate east of downtown. (City of Columbus Department of Development.)

times of the 1990s made a lot of capital available to people with energy and enterprise. But they also changed because of the political leadership shown by two very different men.

Gregory S. Lashutka succeeded Dana Rinehart as mayor of Columbus from 1992 to 2000. A Republican like his predecessor, Greg Lashutka had a much different experience than Rinehart. Where Rinehart was compact, Mayor Lashutka (6 foot 6 inches) was tellingly tall. A former player on the Ohio State football teams of the legendary Coach Woody Hayes, Lashutka was no simple athlete turned politician. A capable lawyer, Lashutka previously served as Columbus city attorney with distinction. He brought talent, energy, and commitment to the mayor's office.

At the end of his two terms in office, he summed up his administration, addressing a number of continuing issues and noting:

> Our most important challenge as government leaders is to continue to work to make Columbus a diverse community, tolerant of all. . . . We must look to the enriching aspects of our varied cultures, races, ethnic and social groups. I strongly believe that we have been a model community of understanding, but have not been without our challenges. Respect and caring for each other will cause others to do the same for each of us. . . . I believe that hope is the most important goal for all of us to pursue. Hope allows all of us to have optimism for tomorrow.

Gregory Lashutka played football for Woody Hayes at Ohio State before going on to a successful career in business and law. Elected city attorney in 1972, Lashutka went on to serve two terms as mayor of Columbus before returning to the private sector in 2000. (Gregory S. Lashutka.)

Lashutka was followed by Michael Coleman, who was elected as the first African-American mayor of Ohio's capital city in 1999. The first Democrat to be elected mayor in more than a generation, Coleman came up through the ranks of city government, serving first as a council aide and then as a city councilman before reaching the mayor's chair.

But for all of their differences—and they were significant—Lashutka and Coleman shared common concerns and common commitments. Mayor Coleman stated what some of them were in his most recent State of the City address:

> I see a Columbus where:
> Our residents can hold a good job and raise a caring family
> Where our residents can afford a good home
> Where our neighborhoods are safe
> Where our streets are free from the blight of abandoned houses, vacant lots and run down buildings
> And where all of us . . . citizens, businesses, labor, churches and civic groups are doing their part to make this city the best place in America to live, work and raise a family.
> We are Columbus—America's 21st Century City.

A major concern the two men shared was that downtown was in difficulty but that it could be saved. These two men, like the men who came before them in the previous generations, put together coalitions of business and labor, arts organizations and social agencies, and people who cared about the fate of downtown to bring about a new downtown.

By the turn of the millennium, their efforts had begun to show results. Nationwide Insurance, long a mainstay supporter of downtown, made a new commitment with its pledge to develop the former Ohio Penitentiary site and nearby blocks into a major mixed-use development anchored by an arena to house Columbus's first professional sports team since the 1880s—the Columbus Blue Jackets of the National Hockey League.

South of downtown, new office, commercial, and residential projects were developed in the Brewery District adjacent to the German Village historic area. They promised to complement on the southside what the Arena District, the North Market area, and the Short North were doing to revitalize the northern part of downtown. On the near west side, the completion of a federally funded flood wall promised to free old Franklinton from the fear of floods that had haunted it throughout its entire history. Incidentally, the flood wall made the area what it had not been in some time—speculatively desirable.

In the center of things, the State of Ohio completed a massive renovation of the Ohio Statehouse. The great building was planned to be built in two years for $200,000, but had actually taken more than 22 years and $2.2 million to complete. But over the previous century, the building had been divided, subdivided, and

153

Nationwide Arena, another example of the continuing commitment of the Nationwide companies to downtown, is the home of Columbus's first major professional sports team in the modern era—The Columbus Blue Jackets of the National Hockey League. (Nationwide Arena.)

then divided again into a rabbit warren of small offices and work spaces that simply didn't work. By the early 1990s, it was clear that the only way to save the building was to virtually take it apart and put it back together again. Over a six year period, that was precisely what was done, at a cost of more than $100 million. Most people would agree that the result is worth every dollar. Restored to its nineteenth-century grandeur, the Statehouse is once again what it was intended to be—the preeminent symbol in Ohio of state power and authority and one of America's great buildings.

It was against the background of this successful growth and development that city, county, and state government combined with corporate and civic leaders to try to find ways to make the capital city's downtown an active one every night of the year. The result was a series of plans and development efforts over the next ten years that have promoted the construction of new housing, the increase of commercial and retail development, and the creation of new entertainment and social opportunities. It has been a daunting and challenging undertaking. Even as new housing opportunities developed for low- to moderate-income people as well as the affluent, the economy began to sputter and cough. New commercial office buildings opened with great fanfare in the mid- to late 1990s found

themselves competing fiercely for tenants in the slowing economy of the new decade. And many of the social and cultural venues that had hoped to ride to success on the boom economy of the 1990s found themselves in trouble as well.

It is still fair to say that the balance seems to have shifted toward the successful revitalization of downtown. In an era when the economy continues to falter, Columbus continues to grow. Downtown housing continues to be built, retail trade continues to evolve, and the city continues to grow in population and size. There are many, many places in America once more successful than Columbus that cannot say the same. What accounts for this success? Some of it without question is due to the forces that made Columbus successful for most of its history. The diversified economy tends to spread out both the prosperity of the good times and the pain of the bad ones. The central location of the capital city and its adjacency to most of America's population is undoubtedly an important factor as well.

But just as important as any of these is the strength and spirit of its people. To each generation in the story of Columbus, of America, and perhaps of elsewhere as well, there has been a moment that defines and delineates us as a people. To the generation growing up in the 1980s, that moment was the fall of the Challenger spacecraft. To the generation of the 1960s, that moment was the fall of a President.

Since the arches began coming down in 1914, many people have wished that they would return. On December 6, 2002, the arches truly came back to High Street as the Short North Business Association illuminated a whole new series of lighted spans marching north from Goodale Avenue. A bit of Columbus is once again the Arch City. (Author's Collection.)

To the generation before that in the 1940s, that moment was the fall of bombs on a sunny Hawaiian morning. For each person of each of these generations, it is easy to remember what one was doing at that moment. To this generation, that defining day was September 11, 2001. To many it seemed that the world had changed forever on that day. Perhaps it had. But after a poignant memorial service on September 15, 2001, like most of America, the city moved on.

By the end of 2002, Columbus witnessed something else it had not seen for a generation. Its Ohio State University football team beat its arch-rival Michigan. Then in a heart-stopping contest of legendary proportions, the underdog Buckeye football team beat its post-season opponents and won the national championship for the first time since 1968. It is sometimes difficult for some to understand why so many people in Columbus take football this seriously. Perhaps the better question is, when so much of America does take football seriously, why is there any doubt about its importance?

Between those two defining moments—one of sorrow and one of joy—lies an understanding of who we have become as a people in the last 200 years or so. Ohio and Franklin County both enter their 200th year in 2003 and will celebrate the event with barn paintings, bell ringings, and parades, among other things. It is well to remember that across all of those years there has been frailty and sorrow and not a few tears. And there has been courage and hope and not a little laughter. That is who we have been and that is who we are.

The Ohio Bicentennial is being celebrated in 2003 with barn paintings and commemorative bell castings in each of Ohio's counties. Franklin County celebrated its Bicentennial in 2003 with parades, exhibits, and a major Homecoming Event. The City of Columbus came forth with an extended "Red White and Bicentennial Boom" celebration in July. The Franklin County Bicentennial Barn is seen here. (Ohio Bicentennial Commission.)

BIBLIOGRAPHY

Aronoff, S. and V. Riffe. *James A Rhodes at Eighty*. Columbus, 1989.

Blackford, Mansel. *A Portrait Cast in Steel: Buckeye International and Columbus, Ohio, 1881–1980*. Westport: Greenwood, 1982.

————. *The Columbus Buggy Company*. Columbus: Columbus Buggy Co., 1888.

Blue, Frederick J. *The Men and Women of Camp Chase*. Columbus: Hilltop Historical Society, 1989.

Bonowitz, Marvin. *Mt. Vernon Avenue: Jewish Businesses in a Changing Neighborhood 1918–1999*. Columbus: Z Enterprises, 1999.

Boryzka, Ray and Lee Cary. *No Strength without Union: An Illustrated History of Ohio Workers, 1803–1980*. Columbus: Ohio Historical Society, 1980.

Burgess Patricia. *Planning for the Private Interest*. Columbus: Ohio State UP, 1994.

Coleman, Michael. "State of the City Address." Columbus: City of Columbus, 1999.

————. *Columbus Comprehensive Plan*. Columbus: City of Columbus Department of Development, Planning Division, 1993.

Cummings, Abbott Lowell. *Ohio's Capitols at Columbus, 1810–1961*. Columbus: Ohio Historical Society, 1991.

Dorn, Jacob. *Washington Gladden: Prophet of the Social Gospel*. Columbus: Ohio State UP, 1967.

Duke, Basil, Orlando Wilcox, and Thomas Hines. "A Romance of Morgan's Rough Riders—The Raid, the Capture and the Escape." *Century Magazine* LXI (1883): 9–31.

Egger, Charles, ed. *Columbus Mayors: A Bicentennial Presentation*. Columbus: Columbus Citizen Journal, 1976.

Franken, Harry B. *Columbus: The Discovery City: A Contemporary Portrait*. Chatsworth, CA: Windsor, 1991.

Franklin, Peter B. *On Your Side*. Columbus: Nationwide Mutual Insurance, 1994.

Garrett, Betty, with Ed Lentz. *Columbus: America's Crossroads*. Tulsa: Continental Heritage, 1982.

Grant, H. Roger. *Ohio on the Move: Transportation in the Buckeye State*. Athens: Ohio UP, 2000.

Harden, Mike. *Columbus Celebrates the Millennium*. Montgomery, AL: Community Communications, 2000.

Homan, Lynn M. and Thomas Reilly. *The Tuskegee Airmen*. Charleston: Arcadia, 1998.

Hooper, Osman C. *History of the City of Columbus, Ohio*. Columbus: Memorial, 1920.

Jacobs, Gregory. *Getting Around Brown*. Columbus: Ohio State, 1998.

Jeffrey, Robert H., ed. *Jeffrey Service: Special Millennium Edition*. Columbus: Jeffrey Co., 2000.

Knepper, George. *Ohio and Its People*. Kent: Kent State UP, 1997.

Lafferty, Michael, ed. *Ohio's Natural Heritage*. Columbus: Ohio Academy of Science, 1979.

Lashutka, Gregory. "State of the City Address." Columbus: City of Columbus, 1999.

————. "The Dream—The Reality." New Albany: New Albany Realty, 2003.

————. "Company History." Columbus: Don M. Casto Organization, 2003.

Lee, Alfred E. *History of the City of Columbus: Capital of Ohio, 2 vol*. Chicago: Munsell, 1892.

Lentz, Ed. *As It Were: Stories of Old Columbus, Vols I and II*. Delaware: Red Mountain, 1998, 2001.

Martin, William T. *History of Franklin County, Ohio*. Columbus: Follett, Foster, 1858.

Moody, Tom. Letter to Author, January 31, 2000.

Moore, Opha. *History of Franklin County, 3 vol*. Topeka: Historical, 1930.

Parkman, Francis. *The Conspiracy of Pontiac and the Indian War after the Conquest of Canada*. New York: Library of America, 1991.

Portman, Maurice. *The Time of My Life*. Columbus: Quality Design Express, 1997.

Reid, Whitelaw. *Ohio in the War: Her Statesmen, Generals and Soldiers, 2 vol*. Columbus: Eclectic, 1893.

Rinehart, Dana G. Interview with author, November 11, 2002.

————. *3000 Days: The Progress of an American City*. Columbus: Dana Rinehart, 1992.

————. *25th Anniversary—Capitol South*. Columbus: Capitol South Community Urban Redevelopment Corporation, 2000.

Rippley, LaVern. *The Columbus Germans*. Columbus: Columbus Mannerchor, 1968.

————. *Of German Ways*. Minneapolis: Dillon, 1970.

————. *The German Americans*. Boston: Twayne, 1976.

Roseboom, Eugene and Francis Weisenberger. *A History of Ohio*. Columbus: Ohio Historical Society, 1967.

Schlegel, Donald. *Lager and Liberty: German Brewers of 19th Century Columbus*. Columbus: Schlegel, 1982.

Siebert, Wilbur. *The Mysteries of Ohio's Underground Railroads*. Columbus: Long's College Book Company, 1951.

Studer, Jacob. *Columbus, Ohio: Its History, Resources and Progress*. Columbus: Studer, 1873.

Sullivant, Jos. *A Genealogy and Family Memorial*. Columbus: Ohio State Journal Book and Job Rooms, 1874.

Thomas, Robert, ed. *Columbus Unforgettables, Vols I–III*. Columbus: Robert Thomas, 1983, 1986, 1991.

Weisenberger, Francis. *Columbus during the Civil War*. Columbus: Ohio State UP, 1963.

Warner, Hoyt L. *Progressivism in Ohio 1897-1917*. Columbus: Ohio State UP, 1964.

Welch, Deshler. "The City of Columbus." *Harpers* Vol LXXVI No. 455 (1888).

Wittke, Karl, ed. *The History of the State of Ohio, 6 vol*. Columbus: Ohio Historical Society, 1941 et seq.

White, Ruth, ed. *We Too Built Columbus*. Columbus: Stoneman, 1936.

INDEX